Sylvie (

The Song of False Lovers

Translated by Christine Donougher and with
an introduction by Dr Victoria Best

Dedalus

Dedalus would like to thank Grants for the Arts in Cambridge, The Burgess Programme of the French Ministry of Foreign Affairs and The French Ministry of Culture in Paris for their assistance in producing this book.

LOTTERY FUNDED

Published in the UK by Dedalus Ltd,
Langford Lodge, St Judith's Lane, Sawtry, Cambs, PE28 5XE
email: info@dedalusbooks.com
www: dedalusbooks.com

ISBN 1 903517 25 7

Dedalus is distributed in the United States by SCB Distributors,
15608 South New Century Drive, Gardena, California 90248
email: info@scbdistributors.com web site: www.scbdistributors.com

Dedalus is distributed in Australia & New Zealand by Peribo Pty Ltd,
58 Beaumont Road, Mount Kuring-gai N.S.W. 2080
email: peribo@bigpond.com

Dedalus is distributed in Canada by Marginal Distribution,
695 Westney Road South, Suite 14 Ajax, Ontario, LI6 6M9
email: marginal@marginalbook.com web site: www.marginalbook.com

Publishing History
First published in France in 2002
First Dedalus edition in 2004

Chanson des Mal-Aimants © *Editions Gallimard, 2002*
Translation copyright © Christine Donougher 2004
Introduction © copyright Dr Victoria Best 2004

Printed in Finland by WS Bookwell
Typeset by RefineCatch Limited, Bungay, Suffolk

A C.I.P. listing for this book is available on request.

CHRISTINE DONOUGHER

Christine Donougher was born in England in 1954. She read English and French at Cambridge and after a career in publishing is now a freelance translator and editor. Her translation of *The Book of Nights* won the 1992 Scott Moncrieff Translation Prize. Her translations from French for Dedalus are: 6 novels by Sylvie Germain, *The Book of Nights, Night of Amber, Days of Anger, The Book of Tobias, Invitation to a Journey* and *The Song of False Lovers, Enigma* by Rezvani, *The Experience of the Night* by Marcel Béalu, *Le Calvaire* by Octave Mirbeau, *Tales from the Saragossa Manuscript* by Jan Potocki and *The Land of Darkness* by Daniel Arsand. Her translations from Italian for Dedalus are *Senso (and other stories), Sparrow* and *Temptation (and other stories).*

DR VICTORIA BEST

Dr Victoria Best is Lecturer in French at St. John's College, Cambridge. She specialises in nineteenth and twentieth century French literature with a particular interest in women's writing and the relationship between identity and narrative. She has published widely on authors such as Colette, Marguerite Duras and Assia Djebar, and her most recent book is *An Introduction to Twentieth-Century French Literature* (Duckworth, 2002). She is currently engaged on a book about fantasy and dream.

institut français

French Literature from Dedalus

French Language Literature in translation is an important part of Dedalus's list, with French being the language *par excellence* of literary fantasy.

The Land of Darkness – Daniel Arsand £8.99
Séraphita – Balzac £6.99
The Quest of the Absolute – Balzac £6.99
The Experience of the Night – Marcel Béalu £8.99
Episodes of Vathek – Beckford £6.99
The Devil in Love – Jacques Cazotte £5.99
Les Diaboliques – Barbey D'Aurevilly £7.99
Milagrosa – Mercedes Deambrosis £8.99
The Man in Flames – Serge Filippini £10.99
Spirite (and Coffee Pot) – Théophile Gautier £6.99
Angels of Perversity – Rémy de Gourmont £6.99
The Book of Nights – Sylvie Germain £8.99
The Book of Tobias – Sylvie Germain £7.99
Night of Amber – Sylvie Germain £8.99
Days of Anger – Sylvie Germain £8.99
The Medusa Child – Sylvie Germain £8.99
The Weeping Woman – Sylvie Germain £6.99
Infinite Possibilities – Sylvie Germain £8.99
Invitation to a Journey – Sylvie Germain £7.99
The Song of False Lovers – Sylvie Germain £8.99
Parisian Sketches – J.K. Huysmans £6.99
Là-Bas – J.K. Huysmans £7.99
En Route – J.K. Huysmans £7.99
The Cathedral – J.K. Huysmans £7.99
The Oblate of St Benedict – J.K. Huysmans £7.99
The Mystery of the Yellow Room – Gaston Leroux £7.99
The Perfume of the Lady in Black – Gaston Leroux £8.99

Monsieur de Phocas – Jean Lorrain £8.99
The Woman and the Puppet – Pierre l ouÿs £6.99
Portrait of an Englishman in his Chateau – Pieyre de Mandiargues £7.99
Abbé Jules – Octave Mirbeau £8.99
Le Calvaire – Octave Mirbeau £7.99
The Diary of a Chambermaid – Octave Mirbeau £7.99
Sébastien Roch – Octave Mirbeau £9.99
Torture Garden – Octave Mirbeau £7.99
Smarra & Trilby – Charles Nodier £6.99
Manon Lescaut – Abbé Prévost £7.99
Tales from the Saragossa Manuscript – Jan Potocki £5.99
Monsieur Venus – Rachilde £6.99
The Marquise de Sade – Rachilde £8.99
Enigma – Rezvani £8.99
Micromegas – Voltaire £4.95

Anthologies featuring French Literature in translation:

The Dedalus Book of French Horror: the 19c – ed T. Hale £9.99
The Dedalus Book of Decadence – ed Brian Stableford £7.99
The Dedalus Book of Surrealism – ed Michael Richardson £9.99
Myth of the World: Surrealism 2 – ed Michael Richardson £9.99
The Dedalus Book of Medieval Literature – ed Brian Murdoch £9.99
The Dedalus Book of Sexual Ambiguity – ed Emma Wilson £8.99
The Decadent Cookbook – Medlar Lucan & Durian Gray £9.99
The Decadent Gardener – Medlar Lucan & Durian Gray £9.99

To Marie-Hélène SABARD

Introduction

Sylvie Germain possesses those most outstanding of literary qualities, a unique narrative voice, and a range of thematic concerns that set her apart from the majority of contemporary European writers. The widespread critical acclaim for Germain's novels is testimony to the richness and originality of her writing. She burst onto the French literary scene in 1985 with her first novel, *The Book of Nights*, which won six literary prizes. Her third novel, *Days of Anger*, won the prestigious *Prix Fémina*, *The Book of Tobias* won the *Grand Prix Jean Giono* in 1998, and this most recent novel, *The Song of False Lovers*, has already collected two prizes. Not bad for a writer who, as she herself claims, came to writing fiction by accident after completing a doctorate in philosophy. In the twenty years she has been publishing she has accrued an impressive body of work including nine novels and a number of meditations on art, literary and historical figures, and spirituality. These latter texts resist generic classification, combining critical analysis and philosophical argument with Germain's trademark lyricism. Yet they are also inseparable from her fictional narratives, offering lengthy disquisitions on themes that repeatedly structure and inform her novels.

Fundamental to her writing are concerns with suffering and the divine, with the power of fantasy and dream, with the magical properties of language and the imagination, and with the convergence of the supernatural and the real. Yet against the central preoccupation with profoundly personal epiphanies we find, weaving in and out of her tales, the march of history, and the traumatic, violent events that have marked the twentieth century. Like the work of many of the greatest authors of our time, Germain's novels combine in significant ways the individual and the universal; intimate stories of love, loss and reconciliation played out within and through the

ongoing drama of historical time and producing elegiac meditations on the eternal themes of destiny and desire.

Her work has been compared many times to the other great magical realist, Gabriel Garcìa Marquez, but the soulful, alienated, fantastic quality of much of her writing owes more of an allegiance to the great Russian writer, Dostoevsky. As an academic who has made the transition to fiction, a popular route to take on the contemporary French literary scene, she is a self-aware author with an intellectual foundation to her richly baroque and fantastic tales. There is a certain coherence, then, to the corpus of Sylvie Germain's work whereby her concerns with love and suffering, with the place of God in the modern world, with the passage of time and the heart-stopping events of history reappear in different, but mutually informative, contexts and formats.

The Song of False Lovers is no exception to this rule, picking out and elaborating certain textual threads that are woven into the spread of Germain's literary works. The narrative charts the erratic progress of the orphan, Laudes-Marie, through her sin-gular life. Abandoned on the doorstep of a convent, it will be her fate to pass through a series of marginal, dispossessed lives, all marked by tragedy. Her place is repeatedly that of a servant, but the servitude she offers comprises an unusual dimension. The intense involvement she experiences in the lives that sur-round her results in an extreme empathy for the suffering and pain of others. The poverty and perpetual displacement of her own life is thus enriched by the profound insight she gains into the heart and mind of humanity, and the madness that often slumbers there. The novel is a lengthy journey through the vagaries of existence, and a lifetime's study in the particular form of alienation so prevalent in the modern age. The break-down of traditional kinds of community is transcended here, and healed, in the forging of new bonds between individuals, and in a different understanding of subjectivity as being porous to others. The narrator who knows that 'nowhere that I belonged, nowhere that anyone cared about me' ultimately becomes 'a family vault. A very disparate family, whose mem-bers had no other blood tie between them than the blood that

ran in my veins.' The gift of compassion, the subtle but insistent thread that binds Laudes-Marie to all her unlikely friends and employers, becomes, quite literally, the saving grace that, as the critic in *Le Nouvel Observateur* put it, 'succeeds in discovering gold in the gutters of society'.

The narrative is equally a journey across a multiplicity of landcapes, both urban and rural, and a wide range of social contexts, from the shelter of the widow Adrienne's rustic cottage in the Pyrenees, to the orgiastic eroticism of a swingers hotel by the ocean, to the suburbs of Paris and employment as a writer's secretary. Landscape has always had a dominant influence over the characters in Germain's novels, and it is interesting to note how her fiction has developed as her geographical range has increased. Her earlier novels, such as *The Book of Nights* and *Days of Anger*, were set in *la France profonde*, the most untouched of rural areas in France where myth and superstition held sway. Far from presenting an idealized or idyllic view of life in these primitive back-waters, Germain portrayed a harsh, cruel existence touched by both madness and magic. This was a land that the advances of science and knowledge had passed by, but her characters were nevertheless drawn into the series of brutal and bitter wars which marked France's modern history, violently interrupting the otherworldly domain in which they lived.

Subsequently, Germain's texts moved location to explore life in the city. The Parisian tale, *Opéra muet* (published in 1989), began a series of cityscapes that included *The Weeping Woman on the Streets of Prague* (1992) and *Infinite Possibilities* (1993). Prague, where Germain lived and taught for seven years, became a cherished location and one that was richly evocative and symbolic. In her texts Prague shimmers with the surreal; peopled by ghosts, phantoms, guardian angels, it becomes, like the labyrinthine waterways of the marais before it, a place where the supernatural runs rampant. Prague is a palimpsestic city, whose layers of bloody and troubled history lie close to the surface, their traces readily glimpsed in shadows and dreams. It is also a city that wears its suffering heavily, where poverty, misery, loneliness and heartache are etched into the very fabric of

its architecture. But beauty and tremulous joy are also embedded in its heart, and the very play of its contrasts provides Germain with a dynamic, kaleidoscopic vision of a city searching to make peace with its past and to move forward to embrace a more radiant future. In this way, Prague assumes the characteristics and qualities of many of Germain's most significant protagonists, prey to the traumas of the past that determine the inheritance of its children, but inching slowly towards a longed-for resolution with conflict and violence.

Across the development of her work, and in the move from rural to urban, we can trace a subtle shift being enacted in the fate of Germain's fictional protagonists. Often in her novels of the country, violence becomes embodied in a character to the exclusion of everything else, and it is a corporeal, aggressive violence that impacts on the lives of others. Germain's city-dwellers, by contrast, are plagued by inner demons that wreak more psychic havoc, leaving them paralysed by fears and anxieties. It is an intriguing development in *The Song of False Lovers* that the narrative plays out across both kinds of location. But it is clear to see that Sylvie Germain's focus has shifted from her previous novels, too, so that rather than portray the history of a family or a slice of time taken from the life of a city, this text charts the inner, spiritual development of one individual. It is fitting then, that the heroine of this most recent novel is subject to a perpetual and aimless *errance*, as Sylvie Germain has suggested in interview that 'whether it be on a moral, spiritual or artistic front, it is often by zigzags, by unforeseen detours, and by wrong turns that progress is made.' The erratic transition from mountains to seaside to city which would seem so randomly accomplished produces a heroine quite unlike any in Germain's other texts for the degree of resolution and understanding she achieves in her existence.

Like a latter day Emile Zola, Germain has portrayed her charaters as fundamentally determined not only by environment, but also by heredity. Over the last decade, Germain has gradually moved away from the clutches of supernatural family inheritances, with the exception of *The Book of Tobias*, towards more patchwork narratives of multiple, heterogenous

lives. Yet her early fascination with repetitive patterns of madness, with the physical continuation of the past within the present remains a concern of her writing that has taken on different, and intriguing new forms. Her first novel, *The Book of Nights*, set a template that was to be followed in many of her subsequent texts. The narrative focuses on the life of Victor-Flandrin Péniel, a powerful anti-hero, whose story provides the bridging point between the inheritance he carries from his ancestors and the consequences of this inheritance on his children. His father, Théodore-Faustin Péniel is profoundly changed by a war injury when his face is slashed in two by the sabre of an uhlan. What might have been a superficial wound becomes something more fundamental, as the attack leaves him psychically torn in two as well, prey to a form of schizo-phrenia that will forever mark his grandchildren. All four of Victor-Flandrin's wives will give birth to twins with the exception of one great-grandchild, born a humpback, who is understood as carrying his sibling within him. When his father dies, Victor-Flandrin notices seven tears rolling down his cheeks, the colour of milk. But when he reaches out to touch them, they roll off and bounce on the floor. These seven pearls he will subsequently wear around his neck. These magical moments are entirely typical of a narrative structured by a series of events where the past becomes material, where loss and memory become transformed into something real and tangible. Germain's earliest formulations of the problem of owning the past and keeping in touch with the dead all followed this structure of making the abstract essence of what had been lost into something visible and symbolic.

Germain's extraordinary inventiveness has earned her much critical acclaim and a wide readership, but the impact of her magic realism is more significant than mere entertainment. Each of these events provides a transformation of loss or trauma into something which the protagonist can possess. Germain's unique interpretation of the links between a subject and his or her life history produces a subject who is literally marked by history, who possesses their history by the act of its being written on the body, part and parcel of their

flesh. All of Germain's novels will tackle the effects of loss and trauma on the individual, but these epic family narratives stand out for the way that violence and grief are continually assimilated through this kind of fantastic transformation, assimilated, reconfigured and displayed in a way that denies the finality and absoluteness of the past. It is interesting to see how Germain's concern with suffering develops over the course of her writing career, with a series of texts in the 1990s that maintain the magic realist tone, whilst incorporating the reconciliation of her characters with their troubled pasts into what will eventually become more spiritual forms of resolution.

The problem of family madness, and the violent events it can cause is given a different slant in the 1992 novel, *The Medusa Child*. Here Germain explores further the breakdown between the supernatural and the real in the face of traumatic events, in the story of a young girl's sexual abuse at the hands of her half-brother. Ferdinand is an astutely drawn villain, a replacement child brought up by his doting mother to take the place of his father who was killed in the war. Ferdinand is as much a victim as the little girls he assaults and strangles, but like other perpetrators of violence in Germain's textual universe, he is locked into a repetitive pattern of behaviour, unable to overcome the legacy of his mother's intrusive and manipulative love. Lucie's experience of rape leaves her disgusted by her own body, anorexic and neurotic, with no means of expressing what has occurred to her. She embodies at this point the kind of problem with which Germain will be increasingly concerned. How to move towards the resolution or reparation of trauma when the means to express its experience and consequences are radically lacking? Lucie discovers, in her rage and misery, that she is not without weapons, but they are fantastic ones. Drawing on the rich life of the imagination she has always led, she marshals a wide range of pagan myths, Christian legends, fairy tales and in the crucible of her imagination conjures from them a 'Medusa stare', a look so terrible and wounding that Ferdinand is rendered senseless, locked into a coma from which he does not recover. The child becomes an important vehicle in Germain's texts, for it is clear that the all-encompassing

fantasy world of the child, which does not distinguish between imagination and reality, is closely allied to the magical vision that informs these narratives. What might be considered naivety becomes instead an understanding of the primal forces still at work in the human psyche, a belief in the power of the mind and its abilities that transcends rational thought.

Equally important is the myth or the legend, which Germain has said she favours as a means of expressing reality for it does not circumscribe or limit experience, gesturing instead towards the enigma and mystery that form a significant component of existence. At the heart of Germain's texts we find a fascination with the borderline between the invisible and the visible, between fantasy and reality, between the everyday and the marvellous. For Germain, combining these apparent dualities provides us with a more profound and intense understanding of reality. She has spoken in an interview of her belief that life is a dream, and that it is necessary to dream with vigilance and tenacity in order to truly perceive reality. Repeatedly in Germain's texts we find pain and love, suffering and transcendence explored through the dimension of the marvellous in ways that make us alive to the extraordinary quality and depth of human emotions; their miraculousness, their intensity, their essential strangeness.

We can trace this interrelation of suffering and the fantastic in *The Weeping Woman on the Streets of Prague* (1992). In this lyric and macabre text Germain creates a legend of her own, a phantom woman of gigantic proportions, a kind of Gargantua of the Night, whose appearance in the cityscape of Prague memorializes suffering and bloodshed. The weeping woman becomes a material metaphor for the pain of the city's inhabitant through history. Her never-ending sorrow encompasses within it all grief and unhappiness in the form of whispers, visions and fragments of memory which she keeps alive in her ghostly appearances. Once again the body, in distorted, wounded fashion, expresses what cannot be easily articulated. The weeping woman becomes a metaphor for the sorrowful, invisible centre of any community, as Germain writes: 'There is no city, no place, which does not have its disembodied heart,

unique, unnamable and immorial.' The weeping woman stands as an enigmatic symbol for the past that has been silenced but that remains essential to the ongoing life of the city. Yet it is interesting that the weeping woman, much like the characters in her family sagas, remains forever fixed in her bodily expressions of the traumatic past. Lucie in *The Medusa Child*, is one of the few characters in these early works to find some resolution of her childhood traumas, and this she achieves through gentle, accepting patience, and an unexpected communion with an image of the Nativity. In the texts that are published subsequently, the artistic image and a mystical form of Christianity will become increasingly essential to Germain's work.

This becomes apparent in the non-fiction work that Germain publishes from the second half of the decade onwards. She writes a series of texts that are essentially spiritual meditations, *Les Échos du silence* (1996), *Etty Hillesum* (1999), *Mourir un peu* (2000) and *Célébration de la paternité* (2001). But before I consider Germain's religious perspective, there is a productive detour to be made via her intriguing study in 2000 of the work of Vermeer, the Dutch painter whose works portray with remarkable serenity seventeeth century city life. This text tells us, in oblique fashion, how spirituality and art can coincide, an art history critique which can, I think, be applied to Germain's own highly visual and spiritual literary writings. Her lyric exposition of Vermeer's images hovers lovingly over the quality of light that gilds the faces of his young women as they read their letters or try on pearl necklaces. For Germain this light reveals its own plenitude. It is 'splendour and perfection', yet it is precisely in its fullness of being, rather like fruit at the peak of ripeness that must henceforth decay, that Germain reads a gesture towards the enigmas the paintings hold, the questions they pose that remain unanswered. Her interpretative approach is to read the quality of stillness and silence that his pictures manage to convey, understanding it as trembling on the brink of an elsewhere, drawing the spectator's attention towards the invisible elements of the painting that are nevertheless apparent, embodied perhaps most readily in Vermeer's pregnant

women, who are quite literally gestating their secret other life. As for the other young women, what thoughts fill their heads? What are the contents of the letters they read? Looking at Vermeer's pictures is an education in a certain method of study, according to Germain. An education in looking at nothing and listening to silence, in allowing thoughts to become dreams and above all to wait patiently for an enlightenment that may never come. Germain has spoken elsewhere of the gradual transition in her work from the fascination with darkness to an equally intense fascination with light. This poetic analysis of Vermeer, *Patience et songe de lumière*, is a crossover moment, the very plenitude of light in Vermeer's painting gesturing for Germain towards the invisible darkness and its enigmas that lie beyond. But it is also a crossover moment between art and spirituality, for the education that Vermeer's paintings offer the spectator is expressed in identical terms to the religious experience that Germain elsewhere puts forward, as the only one available to the devout in the modern age. Furthermore, this kind of mystical religious experience will be essential to the redemptive conclusion of *The Song of False Lovers*, the next novel that she will publish.

Several years before the publication of this novel, however, the concept of listening to silence becomes increasingly significant in the spiritual dimension of her texts. As resolution and reconciliation becomes ever more important for her protagonists, and as her focus falls more intently on the suffering individual, so the place of God in the modern world becomes an issue that is explicitly articulated. Germain's texts have always been bound up with the search for God, but there is a noticeable shift across her work from the early angry denunciations of God in novels such as *The Book to Nights*, to an oblique but salvationary form of spirituality in *The Book of Tobias*. Her understanding of the spiritual bears the influence of Emmanuel Levinas, the French philosopher who directed her early studies in philosophy. For Levinas, God becomes an ultimate form of alterity or radical otherness that exceeds our capacity for conceptual thought. This ties in with Germain's own leanings towards mysticism, the experience of God as an

overwhelming vision that coincides with a fundamental loss of self. In her text *Les Échos du silence* Germain explores the contemporary turn away from religion as a problem bound up in a perception of God as absent and silent. In the time of genocide, where is God when we call for him? How to reconcile the image of a loving God with the horrors and atrocities of warfare in the twentieth century?

Germain begins her argument by holding the Book of Job up as an example to be dismissed. The idea of God as an omnipotent stage manager, able to make Job suffer and then to repair the damage has captured humanity's imagination in ways that can only be detrimental to true spiritual communion. For Germain, God does not come when he is called; instead he can be heard only in the echoes of silence, in the quietest most intimate parts of the human soul. Germain posits a vulnerable God, abandoned by the children to whom he gave the world, and misunderstood by them in the manner of King Lear, with whom she draws an explicit comparison. Germain finds a powerful image of Christianity in the figure of Etty Hillesum, a young Jewish woman deported to Auschwitz whose diaries were recovered. These repeatedly speak of the solidity of her faith, even if there is no response to her call for rescue, for the voice of God, she says, is rather the very act of listening. Listening to silence produces an invisible space, and for Germain, these kinds of paradox provide the essence of spirituality, which again and again informs her work.

The image of a divine whisper borne out of patient, attentive listening is one which concludes *The Song of False Lovers*. This text offers the culmination of many of the themes which have preoccupied Germain over the twenty years of her writing career, and true to her continual creativity, find themselves reinvented here in new formulations. It is possible to read this latest novel as the rewriting of the Book of Job for which *Les Échoes du silence* appeals. The errant trajectory of the heroine is structured by a series of painful losses, for every life that becomes entwined with hers is lost, every love she knows deserts her. Her story is fraught with trauma and violence that resist assimilation, leaving her wretched, ill and close to the edge of

her sanity. However, no text by Sylvie Germain is free from the redemptive power of magic, only in this narrative the magic is to be found in the imagination of its heroine. Germain's fascination with the marvellous takes the form of a series of visions that appear to Laudes-Marie at crucial moments in her pathway through history. These visions, oblique, enigmatic but extraordinary in their beauty present her with messages that defy conventional intelligence but which offer miraculous symbolic transformations of anger and suffering. Laudes-Marie comes into the world with nothing and leaves it with nothing, but the experiences she has undergone, the memories of those she has loved, and the hard-won relationship with God result in a serene transcendence of loss and trauma, and a harmony with the world that is touched by the divine.

Writing in the introduction to *The Weeping Woman on the Streets of Prague* just over ten years ago, Emma Wilson wondered what the next decade of Sylvie Germain's work would hold. The French would perhaps call it an *approfondissement* of her themes, a patient and measured penetration towards the heart of the issues that concern her; suffering, trauma, the marvellous and the spiritual. *The Song of False Lovers* marks one definitive transition, however, from the magic realist texts of the eighties and early nineties, where the violent past was reconfigured by fantastic means onto the bodies of her protagonists, to the spiritual salvation of her more recent work, where the magic that transforms suffering into serene acceptance works within their souls. Spirituality has become increasingly important in Germain's work, but it never intrudes upon the rich creativity of her language, and she remains known and celebrated for the beauty, vivacity and eloquence of her superb imagery. Her novels have also become increasingly bound up with a reality of life in the twenty-first century that is immediately recognizable, her interest in history ever more caught up in the violent conflicts that have occurred since the Holocaust. There remains, then, any number of directions in which Germain's work could develop; we can only hope for another decade as prolific and rich in insights as this one has been.

It was my own destiny
All my life I limped after it till I was breathless.
JAROSLAV SEIFERT

I

My solitude is an open-air theatre. The play began more than sixty years ago, in the middle of the night on the corner of a street. Not only did I not know any of the lines, but I came on to the stage alone, in the dark, to universal indifference. Not even a tree or a bird to grace the set.

From birth, I was consigned to chance. Certainly not the most reliable of wetnurses, but not the worst either. Father and mother, by unsynchronized common dissent, declined to have anything to do with me. The former must have done a bunk very early on, the latter abandoned me on the pavement less than an hour after her delivery. She wrapped me in a cloth, sole gesture of solicitude on her part, and left me in a crate that had contained raspberries. This nicety was undoubtedly inspired by urgency and need. Is it because of this fruity cradle that I have always had a particular liking for raspberries, for their taste and smell?

But to return to my parents, the story of whom is soon told for want of any details about them. Two runaways who appear to have felt little remorse, their disowning of me having remained constant to this day. My geneaological tree is a bonzai completely lopped of any branches, with truncated roots. Time is now running out, by now my absconding procreators must be drawing their last breath, if not already departed elsewhere. Whether they are dead or still alive does not make much difference: I have been grieving for them ever since my unwelcome birth.

My mother brought me into the world one August night, beneath a magnificent shower of shooting stars. Did she give birth alone, writhing under the stars, with a handkerchief stuffed in her mouth to muffle her cries? Cries as much of fury as of pain at having to deliver this unwanted offspring.

And her cries surely redoubled when she saw me. For not content with being a bastard, I was a physical anomaly, and moreover have remained so ever since. Not that my body, head or limbs were in any way deformed, nothing was lacking from my human frame and it was all put together correctly. It was the colour that was not right. As white as curdled milk, as the skin between your toes – that's how I turned out. In a word, an albino.

My disgraced mother wasted no time in dumping my fruitbox-cradle on the pavement at the foot of a lamp post. Being still so new to the world, I did not realize what a dirty trick was being played on me as I dozed in complete trustfulness, intoxicated by the smell of raspberries, which I mistook for that of the maternal body. There are more disastrous mistakes, that at least was one to relish.

Gnawing hunger woke me at dawn, and I bawled. Someone came, alerted or rather exasperated by my ill-timed miauling, which he believed to be that of a pleasure-seeking tomcat. The fellow got a shock, instead of a lovesick mog, it was a spectral newborn baby that he found, wrapped in a red-stained cloth. A cowardly though nonetheless decent man, he carried me briskly to the entrance of a house in which a community of nuns lived. He rang the bell with the energy of a watchman sounding the alarm as death closes in. The extern nun came running to the door and opened it a crack. The good man at once explained the situation and before she had time to say anything he had shoved the crate through the gap into her hands. Then he was gone. Although the part played by this nameless character at the very beginning of my first act was an extremely fleeting role, it was nevertheless crucial. What if he had not picked me up and a scavenging dog had finished me off, or if he had placed me in other hands? It is he who, without knowing it, determined the key in which my story was to be played.

The extern nun returned to the cloister, bewildered, with the bundle in her arms. She could not decently throw me back out on the street. And suddenly some thirty women

came and gathered round me, apprentice angels of all ages, with flowing wings of black and white, folded for what was only indoor flight and rustling from dawn to dusk.

Straightaway I sowed panic among the nuns. Like the fellow who had only just found me on the pavement, they thought at first the crimson with which my improvised swaddling clothes were stained was blood, that the sinner who had abandoned me had previously stabbed me all over with a knife. But a stabbed newborn baby would not have wriggled and wailed so vigorously. They removed me from my crate, stripped me naked, and established that I was in perfect health. And a perfect albino. So they were only half reassured. Some of them suspected my extravagant whiteness of being an ominous peculiarity, others on the contrary saw it as a sign of purity, and in whispered words they devoutly squabbled among themselves. But I was hungry and drowned their pious arguing with my yells. One of the recluses, Sister Radegonde, had the sensible idea of interpreting my cries in a down-to-earth manner, and deserting the theological ring that had formed round my problematic small person, she carried me off to the kitchen to give me my first feed.

The bell for the office of lauds rang. That is how I ended up with the first name Laudes, with that of Marie joined on to it – perforce, as this was the month of the Assumption. Then a family name had to be invented for me when my birth was registered. I do not know whose idea it was to give me the outlandish name of Neigedaoût, but I have to thank whoever it was for having spent my whole life spelling it out, for it gives rise to confusion: *Neige d'août* – August snow – or *Neige doux* – soft snow – or even *Neige d'où* – snow from where?

So, Laudes-Marie Neigedaoût is my name. Later on, a mass of nicknames sprang up like weeds wherever I went, beginning with Eyesore. There was also Milk-pudding, Moon-head, Chalk-stick, the Ghost, Pasty-face. . . Failing to awaken any tenderness, I abundantly excited the malice of fools and tickled their pathetic imagination.

At the convent, clans of a kind formed because of me –

those for and against. Sister Clothide headed my supporters, with Sister Pancras at the forefront of my adversaries. Sister Pancras had taken her name as a nun from a young martyr beheaded on the Via Aurelia, on the orders of the Emperor Diocletian in the year of grace 287. A saint with a fierce attachment to justice and truth, this young Pancras, so much so that plaintiffs and defendants had long been made to swear on his relics in a trial where uncertainty prevailed. Woe betide the treacherous and guilty who dared to perjure themselves touching his tomb: they were struck down on the spot. Sister Pancras considered herself as clairvoyant as her namesake's miraculous tomb, and she maintained that a bastard the colour of whitewash must surely be imbued with hidden vices which would germinate before long and sow disorder. She was in fact more like Diocletian than the adolescent martyr. Her fervent soul was no less short-sighted, it identified with the wrong person.

In her defence, I ought to say that I opened my eyes the morning of my baptism, at the very moment of anointment, which in itself was rather positive, but the drawback was that my irises were pink and my pupils blazing red. Two burning embers in a death-pale face. Another mark of the Devil, the superstitious said to themselves. Even my godmother, Sister Clothilde, felt a certain unease. So just imagine the effect on Sister Pancras!

And then, to make matters worse, shortly after my unexpected arrival in the convent, a catastrophic event took place. War broke out, no less. The Second World War, the great slaughter. I really had not chosen the best moment to sneak into this world, given that no one desired my presence in it anyway. But is there any auspicious moment for entering the world? In short, Sister Pancras, who detected in me an incarnation of original sin and a harbinger of disaster, vowed a mystico-patriotic animosity towards me to which she remained true ever after.

*

It was thanks to the war that I stayed at the convent: no one

knew where or how to get rid of me. A small bed was set up for me next to the infirmary, and I was soon inculcated with the art of silence. I learned to keep quiet before I could speak, then to prattle in Latin and burble in Gregorian chant. I also made the sign of the cross before I could walk. A peculiar education, but everything was peculiar in those days, even the war, which got off to what was described as a phoney start. But that did not last long, the phoney grew febrile and soon turned vicious, while I was content to remain a strange but calm and docile little girl, until the day I was accused of being a she-devil and expelled from the convent.

A day of triumph for Pancras, was the day of my downfall. She it was who led the investigation and exposed me. I had committed a theft. The worst theft of all, in the eyes of the sisters. I had pinched the little statue of Baby Jesus from the crib on Christmas Eve, just before High Mass. The 24th December 1944. I was just a little over five. Not old enough to understand everything and above all to explain myself, but quite bright enough to reflect on things, in my own way, and to act accordingly.

I had heard that the Jews were being persecuted, extermin-ated, from the old to newborn babies, worse than in the time of Pharaoh, as in the days of Ahasuerus and the treacherous Aman. The talk was vague, the words not always at my level of understanding, but despite everything I had grasped the essen-tial: people were being massacred, including little children, simply because they were Jews. Well, Baby Jesus was Jewish too, like his mother, like Joseph and his cousin John, and all his disciples. I had sacred history at my pale little fingertips: in fact, in the depths of my mother convent, that was all I knew. And this history was timeless, in fact everlasting, so always actual. I took it literally, I confused the soldiers of Herod with those of Hitler. The worst thing is, I was not wrong.

I was a child, not much older than Jesus in the crib. And different from others, like that little Jew from Bethlehem. It was only a step from the manger to the fruit-crate, and I made

25

that leap. You have an impulsive sense of solidarity at that age, ingenuous and spontaneous. That is why I pinched the statue – a sweet little blond thing made of plaster, with pink cheeks, as chubby as you could wish for – and I hid it in a nook in the pantry, behind some sacks of potatoes. I took care to wrap it in a bit of woollen cloth and to give him a cradle similar to mine. Since it was not the raspberry season, I made do with an apple-crate. Apples are good, too, they have a sweet, penetrating smell. I had no doubt this smell would suffice to console the Child, to comfort him in his loneliness, to illuminate and warm him in secret, and even to nourish him. No more than I had any doubt of the danger that threatened him if I had left him there, in broad daylight. It was all very well saying that France was liberated, you never know, some wicked men could be lying in ambush, hidden in some corner, and could suddenly emerge on Christmas night to kidnap the Child and put him to death. So I made the first move.

I could equally well have stolen a crucifix, they were all over the place, of all sizes. But there was no point: that Jesus was grown-up and thin. He had become a man, and what is more he was already dead. Helping him, at that stage of his strange story, was beyond my competence. That was God's affair. Whereas the Baby was within my reach. To each according to his means. You do not compete with God. And, all things considered, God does not compete with men either.

And besides, I said to myself at the time, my dear mother had done the same for me, when I was born. It was in order to save me from a terrible danger that she had parted with me, that she hid me in a fruit-crate, for murderers were surely coming after us both. I owed it to myself to imitate her, to prove myself equal to her maternal selflessness. It did not occur to me that for a hideaway, you could do better than a fruit-crate left under a lamp post on a public highway. But in those days I attributed every virtue, every glory to my unknown mother, and I awaited her return with a trusting heart.

So, I stole that Baby Jesus, the colour of sugar candy, because I muddled History with a capital H with my own, very much

lower-case, history; the tragedy of a people abandoned by humanity with my distress as a little bastard rejected by her parents; divine mysteries with human folly. But try explaining all that to grown-ups when you are only five and a bit! I therefore remained silent, obdurate, before my mothers' pained and scandalized expressions at this sacrilegious theft. Neither gentleness nor firmness nor guile prevailed over my silence. Then came the verdict: out I must go! My presence caused far too much trouble in this house dedicated to prayer and never intended as a nursery, and on the face of the evidence I seemed to be more of a thief-in-the-making than a meek budding nun.

But I had more than one trick up my sleeve. Since I was wary of Pancras who went ferreting everywhere, I found another place of concealment for the clandestine Child. An opportunity was suddenly offered to me, unwittingly, by one of the sisters. One morning at the beginning of January, I saw my mothers running with noiseless tread in all directions, conveying to each other in agitated whispers a great and solemn piece of news: Mother Mary-Joseph of the Eucharest had died in the night, at the age of eighty-seven. But in a house of religion, you do not use the word 'die', you say 'go home to God', or 'be born to God'. Lovely expressions that turn death inside out like a glove and give old folk a wonderful rejuvenating bath. It opened up a wonderful horizon for me: aged Mother Mary-Joseph of the Eucharist was going to be born in the bosom of God.

The deceased's body was laid in an open coffin, in the chapel choir. She thus attended several offices among her sisters. I was allowed to see her. This made little impression on me, I had known her only as an old lady lying in the bed to which she had been confined by illness for years. So, I saw her lying there, for the last time admittedly much more cramped, all shrivelled up in an ugly wooden bed-box. Her complexion was dark and sallow, her cracked lips, of a purplish white, were drawn in a rictus, markedly to the left, giving her a wry, slightly cross look.

During the night before the coffin was sealed I came to entrust Baby Jesus to her. I buried the statue under her robe. Since she was going to be with God, she could take the little one back to his Father. At least He would be able to protect him. And as my messenger, she was unlikely to betray my secret. A trustworthy ferrywoman, this old nun on her way to God.

The next day, after morning mass, the lid was screwed down and the coffin carried to the cemetery. The newly deceased and the newborn were buried together. The crossing of the border between this world and the next took place in secret. I was so relieved I clapped with joy when the last shovelful of earth covered the trench. Pancras shot me a withering look.

And my mothers, the fond and the hostile, said their goodbyes, some weeping, the others with sighs of relief.

Were they really mothers to me? More like angel-nursemaids full of compassion, kindliness, tactlessness and lack of understanding too, with sensitive souls and a firm hand. I owe a lot to them: a taste for silence and contemplation, a weakness for liturgical Latin, a deep affection for the feminine universe, madness included.

When I left, I thought I was being taken on holiday. It was the first time I had ever been outside the convent. I was taken to a village in the Pyrenees.

And there began the patchwork story of my life as an outcast. I emerged from a missal illuminated with naive images, and entered an eventful penny dreadful, illustrated with grey prints, and also a few garish images, sometimes as wild as those that bedaub nightmares, or appear when reality turns into a conflagration.

II

The war was over, and my right of abode among the brides of Christ expired at the same time. But war never delivers its final word, at least not entirely, the echoes of its clamours and groans rumble on long after its vulture's beak has been made to close. And where I found refuge, these echoes still resounded, and, what is more, they were superimposed on each other, in layers – those of the First World War ever moaning beneath the fresh echoes of the Second.

It was one of my mothers from the clan well disposed towards me, Sister Elisabeth of the Trinity, who came up with this landing place, less dismal than an orphanage, she thought. That remains to be seen. In any case, it was an orphanage, on a small scale. And above all, in distillation.

Sister Elisabeth of the Trinity had a cousin, Léontine, who, though already elderly, was looking after several children separated from their parents by the war. There were four when I arrived. Jeanne and Hélène, twins of about ten years old, blonde with green eyes, who held hands all the time. As I was incapable of telling them apart, I called them Jeannélène, with their names run together. They would respond to this joint first name without protest, they themselves being inclined to get each other mixed up.

There was a young girl of sixteen, Estelle, as dark of hair, and colouring, and eyes as she was of temperament. She intimidated me, there was something grave, at once sorrowful and irascible, about her beauty. And there was a little boy of my age, Louis, nicknamed Loulou, with whom I immediately fell in love. He was a featherweight, Loulou: with his huge bronze-flecked hazel-coloured eyes, out of all proportion in his small triangular face, he looked like a baby owl. He lisped and every time that Léontine or Estelle, who jealously watched over him, chided him for eating almost nothing at

meals, he would reply unperturbed, 'I'm eating thlowly. . .'
And when you told him that if he carried on eating like a bird
he would not grow up, he would simply concur: 'Yeth I know,
yeth I know!'

At first it puzzled me. Growing up was in the order of
things, and I did not understand why he wanted to be an
exception to the rule. I myself would have so much liked to
be like everyone else, infused with colour. To become tall
and dark like fiercely shy Estelle. But Loulou confessed his
secret to me, and to me alone, precisely because I was the
same age and the same height as he was. It was nearly two
years since his parents and older brothers had gone and he,
who resolutely awaited their return, was afraid his family
would not recognize him if he grew too quickly. So he
strove to slow down his growth, suspending himself in time. I
admired the idea and regretted not having thought of it
myself, but it was already too late, I should have remained a
babe-in-arms. So I consoled myself with the thought that
I had a perfectly adequate distinguishing feature and my
parents would have no difficulty in identifying me when
they came to fetch me.

For I fell in line with the other children who were all waiting
for their parents, and I dreamed of a family reunion. At the
convent, lulled by the rustle of cassocks and veils, my imagin-
ation wandered elsewhere. I lived inside a beautiful book of
prayers and chants, on the verge of silence, in a dream with
foretastes of Heaven, and I did not suffer – well, not really –
from having been abandoned. I had mothers aplenty, and a
wonderful Father, albeit invisible and untouchable. But living
at Léontine's, among these children who all scanned the hori-
zon and counted the days in the hope of seeing their parents
and brothers and sisters arrive, my view of things shifted a
hundred and eighty degrees. Yet, unlike those little watchmen,
I had parents who had been absent since my birth and I had
never known them, as Jeannélène pointed out to me with
cruel candour – the two little girls speaking with just one
voice. But I was far too young to be able to draw the

appropriate conclusions and I cheerfully took my place in the watchtower.

Jeannélène were the first to leave. One fine day a car turned up in the yard and a couple climbed out. I thought they were magnificent, the father as blond as his daughters, the elegant mother with eyes like those of her little girls. No mistake about it, the twins were the children of those two for sure, and their hugging and kissing swelled my heart with a joy I had never experienced, and with equal pain. Soon, I tirelessly repeated to myself, my parents will come, of dazzling whiteness like the angels watching over the empty tomb, and their eyes will be the colour of raspberries and their kisses will taste of fruit.

But Jeannélène's parents had not rejected their offspring, they had only made sure the girls were in a safe place when joining the Resistance compelled them to take this precaution, and as soon as victory had been won and peace re-established, they came hurrying back to reclaim their daughters. Léontine wept when the car disappeared. So did Loulou, and I likewise. Estelle did not cry, the war had dried up her tears. Her greatest hope was to be next on the list of departures, and she became terribly impatient, irritable. Loulou said nothing, increasingly he just picked at the food on his plate, anxious to remain a baby owl, anxious to return to his nest as soon as possible. And I grew madly excited.

But no other car made a triumphant entry into the courtyard. The weeks, the months, went by. And Estelle, who had insisted on resuming her real name, Esther, from which it had been changed for as long as the Occupation lasted, grew more dejected day by day.

One morning I saw her leave the house, with her face distorted; it looked as if it had been cast in a vat of lead. She ran to the bottom of the garden, stood facing the mountains, and let out an astonishingly raucous cry. That cry, she kept up for hours, with her arms held rigid at her sides, her fists clenched. Terrorized, Loulou and I took refuge in Léontine's kitchen. She wrapped her arms around us and told us a story I did not quite understand at the time. Esther had just found

out that her entire family had been wiped out in the camps, that no one would be coming to fetch her.

No one, no one. The world was empty and heaven even more so for the young girl Esther whose heart suddenly aged to rocklike antiquity. And she howled her sorrow, her fury in the face of God, like a fatally wounded animal, a human pierced to the soul. Léontine could comprehend this reaction, but for me it was all confusing, frightening. My mothers had taught me to praise the name of God, to glorify Heaven, to bless every creature, to give thanks for everything, and here was a young girl, as beautiful as a winter's night, screaming like a wildcat, against God and man, cursing the world and cursing life. Underlying my immense sense of terror at the time, I nevertheless felt, powerfully, obscurely, total sympathy for Esther. More than that – empathy. Albeit wordless. Esther's howling, as stark and desperate as it was, was not unfamiliar to me; there was, buried in some corner of my being, some perceptive capacity for hearing it. And a phrase that I had heard at the convent came to my lips. To my lips, yes, shortcircuiting memory, and consciousness. To my lips, like a clot of blood, of tears.

Mane nobiscum, Domine, advesperascit.

Abide with us, Lord, evening falls.

Esther introduced a great patch of darkness into my life. A rugged patch of darkness, in which Our Lord was as slow to arrive as my parents. A molten darkness, too, as soft and black as peaty soil, stole into the depths of the earth, making the world unstable, and unsure. Untrustworthy.

Esther departed from us, all the same. She went off to Palestine. I never saw her again.

I was left with Loulou. He too changed his name, or rather readopted his own name, Elijah. I did not know what to call him any more, I was always getting it wrong, and it would come out as Louli, Elou, Lili . . .

And what about my own real name? Who was going to come and reveal it to me, and when? I persisted in believing myself

to be in the same boat as my companions in misfortune. For want of knowing anything else, I gave myself the names of towns, ones that I had heard of from the Psalms and Gospels: Sion, Bethlehem, Nazareth, Ninevah, Jerusalem. . . They sounded good, I was delighted, I had a sense of belonging, albeit incidentally, to Esther and Loulou-Elijah's scattered family. But you do not smuggle your way into other people's families, especially when it is a family of many missing members, evaporated into smoke.

Sion, Canaan, Samaria, Jericho, Tiberias, Jerusalem, Jerusalem. . . My imagination was fired, my heart glowed — and I was unaware how far from reality I gambolled.

When you stray too far from reality, it reclaims your attention abruptly and harshly, like a slap across the face. The fire and glow inside me were all of a sudden reduced to nothing. Someone eventually came knocking at Léontine's door, a shadow of man. He did not stay long. That very same evening he was gone, carrying Loulou-Elijah away in his arms.

A tall thin man with lacklustre eyes. No, not lacklustre — his eyes had the same strange and disturbing greyness as the sky during an eclipse. Loulou and he gazed at each other in silence, for a long time, as if the father read in the eyes of his child the haunting questions the child asked of him while sucking his thumb, and the son read the unutterable answers that burned in his father's eyes. Then the man crouched down to bring himself to the little boy's level, he timidly reached out his hand to the child's face, and had scarcely touched it when his shoulders shook. Thus he remained, with one outstretched hand close to the little boy's cheek, his body racked with silent sobs. Loulou bowed his head, pressed it to the hand, whose quivering stopped, and he smiled. Then the man rose, picking up his son.

Nor did I did ever see Baby Owl again. I watched him leave in his father's arms. I had just turned seven, said to be the age of reason. But my reason was in tatters that day. And again that phrase rang out inside me, not in my mouth this time, but deep in my gut. *Mane nobiscum, Domine, advesperascit.*

★

Darkness did indeed fall upon me, and did not lift again for quite some time. A foggy darkness settled inside Léontine's house, casting a gloominess you could cut with a knife. The old age this woman had until now managed to keep at bay all of a sudden overtook her. The seemingly happy end of this war reopened deep wounds inflicted on her by the previous one. In fact, it did not so much reopen them as ulcerate them, for these wounds had never ceased to remain fresh in Léontine, who was widowed by the 'Great War', as if wars could be distinguished between great and small.

Not only did Léontine deny all grandeur to that vast carnage of 1914, but she thought it cowardly and shameful. For her husband, Victor, whose portrait presided over the kitchen, contemplating with a placid expression, with a touch of dreaminess, the stoves and the table at which we ate, had not died on any field of honour, killed by the enemy, but on one of dishonour, shot by his compatriots after a sham trial. To forestall any serious investigation into the reasons for the bloody fiasco of an attack launched in defiance of good sense, the military authorities had randomly selected a number of soldiers from the regiment that was routed, courtmartialled them, and in less than no time, without the slightest proof accused them of insubordination, condemned them to death, and executed them forthwith. For years, Léontine, the widow assailed with sickening murmurs behind her back, fought to try and establish the truth about this affair and to obtain justice. She eventually won, her Victor was cleared, but so belatedly, at the cost of so many proceedings, delays, humiliations, that her sense of rebellion had not abated.

In the name of this inward rebellion, Léontine said no as soon as war returned. What a joke! An elderly widow in some godforsaken village shouting no to war – no one cares, and the warmongers gorge themselves with new corpses, laughing in her face. Nevertheless, an old woman of her metal, capable of lying, of cunning, of devilish nerve in juggling with danger,

can prove effective. Léontine sheltered under her roof children who had lost their own homes, lost even the right to live. She cut her bread into as many slices as were needed, unfolded her sheets and created makeshift beds in every nook and cranny, she told stories to sustain the child casualties of war, and others, to adults who came rooting about with their ogre snouts, that had them running round in circles. In the most unassuming way, she worked countless little everyday miracles.

She collapsed once the danger had passed, and especially when the extent of the destruction that had been wreaked on the planet started to be revealed. Then it was life to which she said no.

But life had devised one last dirty trick to play against Léontine, and indirectly against me. It did not let the poor old woman go just like that, it took its time before releasing her. She suffered the long slow torture of crippling rheumatism, which in the end confined her to an armchair. And I, by then the only lodger in the house, the unwanted forgotten package left uncollected, assumed the role of nanny, housemaid, sick nurse.

Léontine directed me from her armchair, introducing me to household tasks and supervising my educational progess. Educational confusion would be a more accurate description, for the education I received during those postwar years was odd to say the least. I did not go the village school. It was an old man called Antonin, a former schoolteacher, who gave me lessons several times a week. Antonin had been the late Victor's best friend, and he extended his grieving friendship to Léontine. He was a survivor of the First War, from which he returned decorated, but also completely deaf and having lost one arm. He taught me the rudiments of algebra and geometry, history and geography, and did his best to teach me the rules of grammar and syntax, and also to improve the outlandish Latin I had imbibed in the cradle. He delivered his lessons in a booming voice, issuing avalanches of numbers, dates, names and declensions, which I had to recite correctly

at the next session. Not being able to hear, he would lip-read, and woe betide me if I made a mistake, he would then slam the wooden tabletop with the flat of his hand, which was all the stronger for doing the work of two, or else shake me like a duster. This would make me dizzy, and the figures and words would then dance inside my skull like a cloud of hornets. Apart from that, he was quite kind. Anyway this curious mental exercise, which meant having to absorb large doses of multiplication tables, dynasties of the kings and queens of France, the départements and their administrative centres, major and minor rivers from source to estuary, together with all their tributaries, the dates of revolutions and battles of all kinds, and Latin declensions, left me with an extraordinarily retentive memory

This teacher of mine, Antonin, had a hobby-horse, which was history. And one obsession in history, the war of 1914. Every time he broached this subject his thundering voice would start to quiver, to semi-lyrical, semi-tragic effect. It always began the same way, with a harsh, furious cry: 'Sarajevo!' He would repeat this strange name several times, then another name would be emitted, whistled between lips pinched with rage. 'Princip!' Then came the tirade. 'All the misfortune of our century stem from there, Laudes, the 28th June, 1914, when that Gavrilo Princip shot at Archduke Franz-Ferdinand. That bullet rebounded in thousands upon thousands – what am I saying? – in millions of places, on millions of bodies! It wiped out an entire generation, it turned into a hailstorm and ravaged the whole of Europe. It killed Victor, among others, but also my brother, my cousins. . . It brought down empires and smashed borders to smithereens. But don't think its mad course ended at Rethondes, oh no! It merely went into hibernation, and gathered strength, which increased by ten-fold. It was Princip's bullet that came shooting back again in 1938, then set light to the powder keg in '39, and then, then. . .' At this point he was at a loss for words to describe the crazy trajectory followed by that damned inexhaustible bullet. Distraught, he would eventually conclude: 'Princip,

Princip – one of the horsemen of the Apocalypse. He liber-
ated the Beast. He fathered Hitler.' And he would clench his
fist as though to crush that diabolical bullet; a thick-skinned,
even cameleon-like bullet, so much had it changed to suit the
countless fits of rage and hatred of all warmongers through
the ages. Moreover, the name of Sarajevo, having plunged
Europe into mourning at the beginning of the last century,
again ravaged and humiliated it towards the end. The fault of
that catastrophic Gavrilo Princip once more? From the depths
of Limbo, Antonin would surely cry: 'Yes!'

The days had a monotonous regularity. We got up and went
to bed early. I did the housework and my homework accord-
ing to a fixed routine. I did not play – who could I have played
with? My only companion had been taken away from me, and
the village children eyed me askance, or made fun of my
snowy-owl appearance. Their parents scolded them, because
no one was quite sure where I came from, whose daughter I
was, what obscure destiny was mine, and besides I had found a
home with Léontine and I was the pupil of Antonin, people
they respected – up to a point. But anyway, no one invited me
to their house, the adults were content to treat me with cau-
tious indifference. This suited me fine. What stories would I
have had to invent to evade their inevitably indiscreet, embar-
rassing questions? My parents were neither heroes nor martyrs
of the recent war, not even ordinary people who had been
killed in a bombing raid. Just two renegades who for sole
heritage had bequeathed me the anguish of their anonymity,
and the permanent whiteness of a sack of flour as a bonus.

★

The years passed. One, two, three. Every now and then,
Léontine would receive news of the children she had looked
after, but very little, and above all very remote from the austere
reality of my life. They were learning to live in freedom again,
openly, under their own names, with their parents finally
restored to them, or the few close relatives who had come
back, or else, in the absence of any survivor, in the midst of a

community that took the place of a family. They did not forget the old woman who had given them shelter in the days when murderers were abroad, but she had no place in their present life where everything had to be rebuilt. She already belonged to a past to which none of them wanted to look back. The name of Léontine, of Antonin, and mine too, were destined to lie dormant in a recess of their memory, for a long time. Would Léontine's name at some point then ring with sustained softness in their mind? Would it finally win pride of place in their consciousness, once their consciousness had become capable of inward pilgrimage, of lingering on the threshold of their bygone childhood? Gratitude is so slow to mature, to blossom out of the mists and undergrowth in which our half-straining, half-flighty thoughts flounder. Resentment comes to us so much more easily, and our bitterness is so much more enduring.

Gratitude was very late in coming to me, all wrapped up as I was in own misfortune. And even now, am I quite sure I express all the gratitude they deserve to those who have stretched out their hand to me whenever I was teetering on the edge of the abyss? I doubt it. And it's high time I did something about it, nearly all the people I'd like to acknowledge have passed away. Gratitude, like friendship, is above all a matter of love, of love clad in modesty, discretion, patience. Léontine had a considerable lead on me in this respect, she knew full well that more often than not we are out of synch with our lives, we do not understand until afterwards the meaning of the obscure stirrings that lurk deep in our flesh and quietly overwhelm our hearts. We are all like Cleopas and his companion seated at table with the risen Christ at that inn at Emmaus, who, after their master is gone, marvel at the disquiet they had unknowingly felt. 'Was not our heart burning within us, as he spoke to us on the way. . .' they say to each other with astonishment. But these experiences cannot be taught, you have to live through them yourself, be grazed by them. It is not just prophets who speak in the wilderness, the same is true of witnesses, especially when they report an

extraordinary event, whether it be terrible or marvellous. Witnesses to life: in other words, all of us. Everyone speaks in the wilderness. Léontine spoke little, she always acted, responded to the emergency.

One lunchtime, while we were eating, Léontine dropped the glass she was trying to carry to her lips in her big deformed hand, like a grouse claw. The glass broke on the floor. She just said, 'Ah!. . .', then her head tilted towards one shoulder. Her mouth and eyes remained wide open. She seemed to be squinting at me, with a slightly quizzical air. I wanted to laugh, but the mouthful I had just swallowed got stuck in my throat, and I coughed, spluttered. I looked at Léontine again. She had not stirred. All of a sudden I did not find her at all funny any more, with her idiotic grimace, it was unnerving. I called her name a few times. She did not reply. Then I felt scared, so very scared, without even knowing why, that I leapt up from the table and ran away. Outside, the light dazzled me, and spurred me on. I raced off into the countryside, without a second's thought, seized with delight by the splendour of this autumn midday. I gorged myself with bilberries, my mouth and fingers were purple. That was not enough. I was ravenous for colours. So I rolled in the grass, in the mud. Then I climbed a tree and having reached a lofty branch sat on it. Settled astride it, among the orange-coloured leaves, I whipped on an imaginary, and therefore magnificent, horse. A vegetal horse with a coat of rust and citrus hues, quivering in the wind.

I rode above the earth and shouted till I was breathless random disconnected words, rude words mostly. I was a fairly coarse sorcerer's apprentice. High upon my mount, I chased the clouds, spurring into empty space, haranguing the birds, insects, squirrels. I galloped full pelt towards the sun. But with all that jiggling about, I lost my balance and fell like a pine cone. Nothing broken, but I was scratched all over, my clothes torn. The sun continued on its course; it was already low, dark red. So low that it dropped behind the mountains, drawing in its wake the light, the heat of the day, and all the colours. And my great euphoria along with them. Fear overcame me once

39

more like a whirlwind, I took to my heels again. I had only one thought: to throw myself in Léontine's arms.

She was still in the same place, in the same position, but her figure seemed more blurred, all in grey shadows in the semi-darkness of the kitchen. The water spilt on the floor tiles glistened faintly, formed a silvery trail that held my gaze for a long while. Flies buzzed around her head and the dirty plates. The big clock marked the seconds in its usual deep tone; seven o'clock struck, every stroke hammering in my chest as if my heart had become tremendously resonant. I dared not approach Léontine, that shapeless lump, turned to stone in her chair, so very close, so very far away. She seemed to be carved out of a block of solitude. The solitude of the dead when no one keeps vigil over them, when they are abandoned at the hour of their passing into the unknown. As I had just abandoned her. Did I then have any right to ask *Mane vobiscum, Domine, advesperascit*, I who had bolted, sick to my stomach with fear, deserting Léontine, with her eyes wide open and mouth gaping, in front of a dish of cabbage and potatoes with bacon, leaving her to the flies? Wavering on the threshold, I gazed searchingly into the gloomy room, at the statue half-collapsed in a heap at the end of the table, at the cloud of voracious flies, and a question nagged me: are the dead as vulnerable as newborn babies? Is it as much a failure of love to abandon the one as the other? For I had a strong sense that, however old and worn out she might be, Léontine was as pitiful as a babe-in-arms dumped on a pavement in a fruit-crate. But what do the dead need? What nourishment should they be given? Tenderness, nothing but tenderness, and thoughts as light as the breeze, freshened with silence. But I was capable of very little tenderness, and my thoughts were leaden with obtuseness.

I went over to Antonin's. When he saw me all scratched and ragged and stained with mud and grass and bilberries, he was shocked. But it was a much more violent shock I gave him when I wrote in chalk on the slate that served him as an ear:

'Léontine's dead, I think.' He read this sentence, then his astounded gaze oscillated for a while between my face and the slate. Suddenly he emitted a kind of groan and rushed out. I wanted to follow him, but he instructed me to wait for him there. For a long time I contemplated the phrase I had just written, until the words no longer made any sense. The expression used by the nuns came back to me: 'Go home to God'. Was that Léontine's destination, or had she gone to rejoin her Victor on the Field of Desolation? But maybe God too languished in desolation, among the outcasts and victims, waiting to have His name cleared? As Antonin did not come back, I lay down on a bench and went to sleep.

★

I saw Léontine again one last time, stiffly dressed in her coffin, with her grouse claws crossed on her chest. I did not hide anything among her clothes, no stowaway, no message. I felt a pauper to my very soul. Perhaps Antonin had slipped an unobtrusive talisman in a fold of his friend's dress?

I followed the funeral procession to the cemetery, at Antonin's side. When the box was lowered into the trench, I felt faint and sought a hand to cling to. But I was standing on the wrong side of the amputee and I grabbed the end of a sleeve flapping in the wind. Such was the way Destiny clasped my hand.

A few days later Antonin was fished out of the waters of a mountain torrent, with his pockets full of pebbles. Great store is always set by the grief of lovers, but the grief of friends can be just as devastating. Was the bullet shot in Sarajevo thirty-five years earlier, which had never ceased to whistle inside the deaf man's head, finally going to fall silent, to leave Antonin in peace in the coldness of the earth?

I returned to the cemetery, walking like a robot, reciting in silence a few multiplication tables and Latin declensions in between two prayers and some dry sobs. There was not even an empty sleeve for me to cling to any more. Nothing. I was just ten years old and orphaned again.

A family in the village took me in until a new refuge was found for me. At night the shattering of the glass that fell from Léontine's hands, the drone of the lugubrious flies and the rumble of the flowing torrent wakened me with a start. It was then that I began to feel resentful towards my parents. It was urgent that they should come and fetch me, take me in their arms. In their bird's wings; for I dreamed of my parents as birds, sovereigns of the skies, like royal eagles, whiter than circaetus. It was a matter of extreme urgency. They did not come. I was taken to another village, perched higher up the mountain, to some people very close to the land, wedded to the soil, with their feet firmly planted on the ground.

My childhood died the day I realized that my father and mother would never come. And I learned the taste of hatred, a strong and bitter taste. And I became passionately mean. Mean with words, smiles, trust.

Mean and thin. Hatred feeds you, but it gnaws away at you even more. I had a face like a ghost. People thought I was grieving for the twofold death of my guardian and my teacher. Not so. I was not thinking of them, at least not directly. I was stricken with another grief: grief for my parents, as if their invisible bodies had been exhumed from the graves where Léontine and Antonin now lay. My white eagles, my betrayers. It was for them that I mourned, and with them that I was at war to the death.

I thought of Baby Jesus buried under the late Mother Mary-Joseph of the Eucharist's habit. What state of decay had she reached? Had she found her way to God, and returned the Child to his Father? In my anger, I liked to imagine that he was mouldering in the dampness of the earth, between the dead woman's fleshless femurs, awaiting the unlikely hour of his deliverance, sharing my destiny. In the circumstances, I should have hidden myself in Léontine's coffin, to speed up the process, to have done with this endless waiting, and to make straight for the Almighty in order to demand a few explanations of him.

III

As dessicated as a thistle and as pale as a winter moon though I might be, I was strong. A good investment for the plantigrades who took me in: inexpensive to feed but hardworking. And meek, into the bargain. For obedient I certainly was: not by natural inclination but out of habit. When you spend your earliest years in a strictly calibrated mould, according to the rule of St Bernard in my case, then in the company of two housebound invalids, paring time in an attempt to overcome those sly predators of the soul, boredom and suffering, discipline comes to you naturally, and therefore painlessly. This carapace did not at all preclude the development of a smouldering core of rebellion, of rage, nestled in the pit of my stomach, right beneath the navel. Just where my whore of a mother had at the outset severed all link, confiscated all memory, obliterated love.

My new guardians were called Marrou. Auguste and Marcelle Marrou. They had their feet planted very firmly on the ground, those two, and sharp eyes. They ran an inn, under the sign of the Great Bear.

Nothing to do with the constellation, except by association. It was the animal that the name referred to, exclusively, reverentially. The Marrous were not stargazers. The inn was dedicated to the bear like a temple to a god, a church to a saint. It has to be said that Auguste Marrou owed everything to this animal. Everything: the roof over his head, his livelihood, his reputation, his pride. His reason for being. The ursine species was both literally and metaphorically his entire stock-in-trade.

He came from a dynasty of paupers who had bettered themselves in their own way by mastering the beast. His ancestors had for generations been hunters, animal trainers

and above all bear leaders. There were two heroes in the family pantheon, a great-grandfather who, armed with cold steel, had fought in close combat with an enormous she-bear, and a great-uncle who had criss-crossed Europe chained to his ursine street-entertainer that performed as a dancer, juggler and acrobat. But the stabbed female flattened her killer by falling on top of him, and the fur-coated artiste tore its impresario to shreds one ill-tempered evening while on tour in Munich. Thanks to a few savings accumulated over decades of hustling, wandering, bearish living, the descendant of the tribe had managed to buy himself an inn. He showed himself to be full of gratitude, this heir, and worshipped, with as much fervour as naivety, 'the Master of the Caves', 'the Lord of the Mountain', as he liked to describe the bear. Portraits of some of his ancestors posing in glory beside a monumental carcass or holding the upright animal, like a big mossy tree trunk, on a leash, knives, stakes and guns used in the hunt, and the stuffed heads of grimacing bears decorated the smoke-stained walls of the bar. A real shrine, this bar, a sacred den. But already by the time I arrived the faithful were less numerous than in the past. The human species, and therefore the category of chin-waggers and drinkers included, was becoming progressively more scarse locally, and even more so the ursine species, which was teetering on the verge of extinction, to the great dismay of Auguste Marrou.

As I was still very young, I was sent to school. This first confrontation with the world of children was a disaster. Right from the start, I was rejected, insulted and soon bullied. One day I returned to the classroom after break so knocked about that the schoolteacher finally took pity on me. Until then he had not paid any particular attention to me, convinced that I must be as intellectually etiolated as I was physically, and that there was nothing to be expected of a pupil such as me. Having asked me a few questions, he realized that in fact I already had a degree of knowledge and maturity a good deal superior to that of his nonetheless normally pigmented pupils. His astonishment became even greater when he discovered

that Latin was as familiar to me as the local dialect was to the village children. He happened to be very keen on Latin.

Despite their pedagogic eccentricities, my mothers, then Antonin, had actually done a pretty good job. The schoolteacher immediately took me under his wing. He called on the Marrous to discuss my case with them, and an arrangement was reached: I was excused from attending school, where I obviously did not belong, but the teacher would give me exercises to do at home, and I was to go and see him twice a week so that he could supervise my work. This arrangement suited everyone – the Marrous, for a start, who were never short of imagination in finding various domestic tasks for me to do. He had a splendid name, this zealous Latin scholar: Amédée Roquelouvan. And, full of confidence in me, he promised me a brilliant future as a schoolmistress if I persevered in my studies. And taking over from him – why not? – when he retired. But he was looking too far ahead, and above all not taking into account life's unpredictabilities.

At the inn it was my job to look after the poultry yard. My fine dreams of birds of the mountain peaks were woefully taken down a peg or two, to the cackling of chickens, geese and ducks. I waded through sludge, the droppings of clucking, quacking fowl incapable of flight or song: the castrati of the skies. And I too felt castrated – deprived, as though by amputation, of my mother and father, of space, of height. I nursed my hatred, like a brooding hen. But I was preparing my wings. Even imaginary wings need to be cared for, kept shiny, developed. Imaginary wings especially. Otherwise you end up like Antonin, with your pockets filled with pebbles, accumulated debris at the bottom of your heart, and plunk, you throw yourself into the mountain torrent.

★

Oddly, the more ursine of the couple was not the bear-worshipping innkeeper, but his wife. It was she who was the great bear. Lumpish, more of a growler than a talker, and fairly heavily moustached. Her husband was the bon vivant type, all

45

excitable, with a lot to say for himself. He spent more time sitting at drinkers' tables than behind the counter, endlessly going on about those mythical winters when bear and mountain-dweller lived as neighbours; as enemy brothers, admittedly, but magnificent enemies. He would give you a barnstorming version of Genesis, would Auguste Marrou, a reinterpretation of the drama of Cain and Abel, of Jacob's wrestling, casting the bear sometimes in the role of the frati-cide, sometimes that of the victim, and of course in that of the angel at the ford of Jabbok.

The dream of this biblical scholar with a taste for the wild was to encounter a bear and wrestle with it for a whole night, and emerge from the fight wounded but victorious, with gleaming scars on his warrior body as well as a blessing, like the golden glow of a low-burning candle, upon his brow. He had dreams, he claimed, fabulous dreams in which he turned into a brown bear, huge of course, and a powerful male, that goes without saying. And he imagined himself not copulating but making love with a she-bear who would then give birth to sturdy little Marrous with shiny coats. Basically he was a shaman without knowing it, this jolly and bawdy fantasist with his constant stream of jokes on the sexual prowess of his brown-coated demi-god, told to the sound of clinking glasses and uproarious laughter. Meanwhile, Marcelle slaved away, sullenly.

The shaman of the inn had more than one string to his ribald raconteur's bow. Another of his favourite subjects was the famous bear's-fart. According to one legend, during hiberna-tion the bear travels in spirit to the kingdom of the dead, snaffling huge numbers of wandering souls along the way and storing them in his maw. The captive souls then make his belly swell, like leaven. When he emerges from his long slumber and steps outside his cave, on the night of the first of February, this repository of souls inhales, sniffing the sky, the brilliance of the moon, and he releases a huge fart that expels the whole tribe of gaseous spirits he is holding prisoner, thereby decon-gesting his intestines. But these souls suddenly let loose being

not always well intentioned, the living have to protect themselves against them by making a thunderous din and lighting torches, safety flares supposed to keep the undesirables at a distance. This is the *festa candelarum*, in other words Candlemas, celebrated the night after the release of the flatulent spirits. The Church sanitized this somewhat vulgar ritual with the substitution of a distinctly more poetic ceremony, that which celebrates the Presentation of Christ in the Temple and the Purification of the Virgin.

On the evening of the second of February a cheery excitment reigned in the inn. In the kitchen there were no idle hands; in the bar, roistering and laughter aplenty. At the end of the evening, a farting competition was organized, each of the participants trying to equal the bear firing his salvo on return from the land of the dead. This farting spree was not at all a widespread tradition, just a brainwave of the innkeeper, the wilding shaman-in-the-making who presided over the event in a state of euphoria.

The first time I witnessed this spectacle, from the threshold of the bar where I positioned myself for a while, hidden behind a curtain, I was completely flabbergasted by it. Because I had quite different memories of this feast-day, going back to my early childhood in the convent. This was the day when my mothers would light candles which they carried in procession, singing an antiphon: *Lumen ad revelationem gentum, et gloria plebis tuae Israel*. . . A light to lighten the Gentiles and the glory of the people Israel. . . Next they intoned a canticle, then a psalm, and the celebrant read a passage from the Book of Malachi, and from the Gospel of Saint Luke, telling of the visit of Joseph and Mary to the Temple in Jerusalem to consecrate their first-born son and make an offering of a pair of turtle doves.

A pair of turtle doves or two young pigeons, the text said. This was the offering made by the poor, those who had not the means to pay for a lamb or a goat. I thought this was a fine thing, I have always liked birds. But I did not realize that the two birds were offered as a sacrifice and therefore destined to

be bled to death. I imagined them flying about and cooing in the Temple. I gazed at the flames of the candles my mothers held in their hands: their faces reduced to a white-ringed oval shimmering like golden water. I expected these flames to take flight, to scatter in plumules of translucid fire and to start dancing through the chapel. To whirl round until they came together to form incandescent doves. And what if the faces too were to detach themselves from the veils, the spotless collars, from beneath the dark cowls, and go flying up in their turn to the stained-glass windows? At that time I would have loved to turn into a dove. . . At that time the magical was for me part and parcel of life, I was still unaware that I was nothing but a daughter of shame and misfortune, bearing the stamp of disgrace. I did not dream of being a white eagle, and anger and bitterness were unknown to me.

So where were the turtle doves, and the crystalline voices of my pious mothers? '*Lumen, lumen et gloriam. . .*' Tipsy men made merry in the bar, climbing on the benches and tables, and with their butts in the air produced the rattle of gunfire. Then they drank to the health of the bear, to the repose of the dead whose vagrant souls they drove back to their eternal abode with resounding blasts of wind, and to the randiness of women it was such a pleasure to lie with. Was this a mass too? At heart, it may very well have been, a very crude mass, but so joyful, and demonstrating so much appreciation of life, the earth, the seasons, that there was nothing sacrilegious about it. Marrou and his mates paid homage in all innocence to the mystery of life, to the forces abroad in this world, to the unrecognized powers of the flesh. To their own incarnation. Confident that in the house of the Almighty, which comprises many dwelling-places, these men with their love of life, accepting with cheerful gusto their nonetheless extremely harsh and wretched destiny, would find their place.

But I was a long way from such considerations when I spied on them from behind the curtain. And I had terrible trouble reassessing my ideas, forming an opinion. Were they funny, these overgrown children with long moustaches, calloused

hands and their gloriously bared scrawny buttocks. Were they simply vulgar, were they being profane? I suspected that despite everything they surely found favour with God.

By my second Candlemas at the inn, I was used to it. Between one year's festivities and the next, Auguste could not refrain from inserting a few encores, so the surprise had lost its edge.

★

We have to assume that the surprise had worn so thin for Marcelle Marrou that it turned to exasperation, for in the spring following the third Candlemas I spent at their den, she put a stop to her fart-obsessed husband's capers.

I was in the poultry yard, cleaning the hutches. The innkeeper's wife called me and asked me to go and fetch the Old Man's knife, the prize piece of the collection. The Old Man was Auguste's famous great-grandfather, and the knife whose blade measured about thirty centimetres was the one he had planted in the colossal bear's heart. I climbed on a stool and took down the broad-blade knife with care and with a thrill of excitement, for my head was stuffed full of the heroic legends recounted by the man who had inherited it. Marcelle gazed at it for a while, then began energetically to polish it. As I stood with my arms dangling, watching her rub the blade, she accused me of idling and told me to get back to work. She also asked me to tell her husband that she wanted to see him. I conveyed the message to Auguste who was pottering about in the barn and I resumed my task in the yard.

When I came back, less than an hour later, carrying a basket of eggs, I could not believe my eyes. I dropped the basket, the eggs smashed on the ground. Marcelle Marrou did not bat an eyelid. She sat enthroned on her chair, her hands resting on her knees, palms turned upwards, gazing at her husband with a haggard look on her face. He was lying at her feet, stretched out on his back, with his arms spread, the knife stuck in his throat. A pool of brick-red liquid surrounded his head like a halo, and soon the yolk of the broken eggs delicately marbled the pool's circumference with threads of gold. The two of

them formed an unusual and grotesque Pietà. The massive Dolorosa with her eyes transfixed stared at the recumbent figure aureoled with blood, big tears running down her cheeks in silence and dripping one by one into her scarlet-red palms. She was as motionless and drained of colour as Auguste, who, with his gaping mouth, looked nonplussed at having been all of a sudden cast in the role of a dead body.

Violence is contagious. I suddenly felt a stabbing pain in my belly and my back, then something flowing out of my body, and I saw red drops fall from under my skirt, spotting my ankles. So there was I, crying as well, from the centre of my body, tears the colour of wine, of fire. Had someone inflicted an invisible stab wound on me, was I in turn going to be drained of blood? I was so scared I screamed. The Pietà did not turn a hair, she continued to let fall her silent tears, looking stupefied. I fled, my legs stained with blood, and a queasiness in my stomach. It was not until much later that I realized I had just had my first period. For a long time afterwards, at every recurrence of my periods, I was seized with panic, as if, by magic, the blood of Auguste Marrou, and beyond that the blood of the legendary she-bear, ritually flowed through my entrails, claiming a right to life at my expense. I felt as though my womb was the occult stage on which the criminal scene was reenacted, in all its crudeness.

Marcelle Marrou never the explained the motives for her deed. And no wonder: from that day forth, she never uttered another word, only emitted grunts and groans. It turned out to be a double murder, with a sole stab of the knife she dealt a death blow both to husband and to her own reason. Her nickname, the 'great bear', changed from metaphor to reality, her anamorphosis was complete. So, instead of sending her to jail, they locked her up in a lunatic asylum.

And once again I found myself out on the street, a mongrel without a collar afflicted moreover with a secret wound in the pit of my abdomen. All in all, the crime committed by the great bear was a triple one: the little that remained of my

childhood, already so badly damaged, was destroyed, laid waste for good. My own body was betraying me, it was growing up, weeping blood, changing shape. Only the colour of my skin, my hair, did not change, and my anger, ever more concentrated on my absconding parents, hardened.

The thought of the Baby Jesus I had kidnapped from his manger came back to me again, but in a more acidic light. The light that steals into our gaze upon the world, on entering adolescence. The naivety of my past deed suddenly seemed to me pathetic, and faith a childish nonsense. Yes, my faith dropped away from me like that impure blood that my body expelled, with persistency, with violence. And the pale faces of my mothers singing, '*Lumen, lumen et gloriam. . .*' scattered like a cloud of butterflies with pearly, friable wings, leaving me with a terrifyingly empty, orphaned heart. I no longer beseeched, '*Mane vobiscum, Domine, advesperascit*', seeing that evening kept on falling, darkening, and the Lord never came.

<p style="text-align:center">★</p>

The murder of the innkeeper by his wife sowed great agitation in the village and in the vicinity. But the fact that Marcelle Marrou lost the power of speech after having cut her husband's throat with the stout-hearted ancestor's knife magnified the crime. A crime that inspired both horror and admiration. It is not every day that the bear's spirit takes total and brutal possession of a human being. But what dire animal had taken up residence inside me, the kid with no pedigree, buffeted by the dramas that occurred in the homes of my hosts? What animal was it that impregnated my body with its suspect whiteness? No one was willing to take me in, I undoubtedly brought bad luck. As for Amédée Roquelouvan, the only person who had shown any concern for me, he had left the village a few months earlier, having been posted to another town. As a farewell gift, he presented me with a Latin grammar and a small anthology of poems by Latin authors.

However, I did have some good luck in my misfortune. In fact, this has always been the case in my zigzag life; year on year, good fortune has alternated with bad, someone has

always turned up *in extremis* to get me on my feet again whenever I was down, and help me through to the next stage, even if this help sometimes came at a price. On this occasion, providence intervened in the guise of a character in a religious farce.

So I fled from the inn and went rushing off into the mountains. It did not occur to me to go and alert the neighbours. When death struck under any roof where I had been given shelter, I instinctively ran towards the trees, the birds, far away from humans. I came to a halt, out of breath, by a mountain stream. At that time of year, when the snows were melting, the water cascaded, fast-flowing and icy. I took off my shoes, my socks, I dipped my feet into the water to wash up to my thighs. The cold bit into me, as though an army of red ants was attacking me. I rubbed my skin with a pebble, but the blood kept flowing, maddening me. Suddenly I heard a noise. I looked up and saw a woman emerging from a cave. I gave a faint cry of surprise and fear. The apparition burst out laughing, then exclaimed, 'Now, don't panic, silly, I'm not the Immaculate Conception!' Well, she did not need to spell that out, there was no danger of my mistaking for the Virgin Mary this old trout, muffled up in a crudely knitted cardigan, who spoke in a gravelly voice. As for me, I was more like the negative of little Bernadette Soubirous, who was a pretty black-eyed brunette. All the same, I remained rooted to the spot, my frozen feet in the stream, my skirt hitched up over my hips.

'Have you hurt yourself?' asked the woman, looking at my bloodstained legs.

I immediately lowered my skirt and leapt on to the grass, shaking my head in denial. I had no desire to speak, but the woman would not leave me alone.

'You're not the girl from the Marrous' inn?'

I nodded, with a scowl.

'Have you lost your tongue?' she said in a mocking tone of voice.

And without thinking, I retorted, 'Not my tongue. Words.'

It was true, I could no find no words to relate what I had seen, to express what was going on inside me. A revolution, in my daily routine as well as in body and mind. Everything was bleeding, life, the sky, my womb, language.

'Bah! Words, you can live without!' the woman commented in her rasping voice, and she started to walk away.

She had not gone ten paces when I cried out, overcome with panic once more, 'I'm scared!'

She turned round, observed me for a moment, then said, 'Follow me.'

I had nowhere else to go, so I followed her.

We went through a wood with paths slanting across it, and came to an isolated shepherd's cottage. We could not have been very far as the crow flies from the village I had fled, but being a mere bird from the poultry yard, with clipped wings, I had never ventured this far. The landscape was magnificent, both vast and spare.

There was just one room in her house, furnished with the bare minimum. The woman, called Adrienne, did not ask me any more questions; she simply took care of me. She served me with a bowl of soup and a piece of bread. I was not hungry, but she insisted. 'Eat up!'

I swallowed a spoonful of soup and a mouthful of bread, and I felt hungry. Could she see inside my stomach, this massive, brusquely-mannered woman, or even dictate her rule over it? In any case I obeyed her without having to force myself. My body responded to her harsh yet gentle voice. She inspired trust in me. She told me to rest. I was not tired but, as with the food, I had only to do as she said and, as soon as I lay down on the bed, made of planks of wood covered with a feather quilt, I felt an unexpected sense of well-being, and I fell asleep.

When I woke up, I saw an enormous reddish-brown cat perched on a shelf above the bed. It was staring at me through half-closed eyes. I would not have been surprised if it had begun to talk in my hostess's deep voice. She had disappeared. I got up, opened the door and sat on the threshold. It was

broad daylight. How many hours had I slept, then? I had lost any notion of time. The drama of the previous day already seemed distant, unreal. For the first time since leaving the convent, I felt at home, safe. But a home without walls, under the open sky, in total freedom. Indeed, could this be called a home – so much space, light, wind? It was a great deal more. It was the enjoyment of a sovereign right of abode upon the Earth, in the Mountains, generous hosts but nonetheless jealous of their secrets.

The sun, of a diaphanous yellow, floated among the budding foliage of a grove over to the east. In this grove, wild cherry, elm and ash grew side by side. But the wild cherry trees, already in flower, stood out among the other trees whose buds were only just preparing to bloom. They stood there in the morning light like tall jets of stilled froth, scarcely quivering, shimmering white. And I greeted this frothy whiteness with emotion. Did we belong to the same family, they and I? But their floral albinism was ephemeral, and so graceful, whereas mine was permanent, and problematic. All the same, the sight of them consoled me. And I felt at peace in this landscape, close to the earth, the trees.

<center>★</center>

I must have gazed at the wild cherry trees in blossom too long, too intensely, for I had a vision. At least, a kind of bedazzlement rather, like a prelude to the few visions that came to me later, at different ages during my life, always out of the blue.

The wild cherries detached themselves from the group of trees and their silhouettes advanced, swaying, their bearing no less ethereal than sensual, like models on the catwalk, then they took up position on the edge of the grove. They twirled round a few times with a slow rustling. Their beauty combined the utmost elegance with an air of lively impudence. Their twirling gradually quickened until it became a mad whirl, and the cherry tree-women turned into torches of incandescent snow. Flower-sparks flew from the boughs and

fell in flakes round the branches, but these, far from being laid bare, blossomed even more profusely.

Was my mother among these dishevelled women, half vegetal, and half white lightning? Had she come to wave to me on the threshold of my adolescence? The cherry tree-women must have heard my questions and a voice rang out, at once cajoling and mocking, resonant as a burst of laughter.

'Silly! None of us is your mother, we are effulgences of the earth, lightning-brides of the moment, paramours of the seasons, glimmerings of a memory to come.'

Then I cried, 'So you are my mother!'

Their sole response was to issue a high-pitched, strident laughter, like the commotion in an aviary. And suddenly they atomized into a cloud of white birds flying swiftly away. This ripped at my heart, rousing it from its torpor.

No matter how much I blinked, the spectacle was over. Everything had returned to normal, the sun continued its ascent, the grove recomposed itself. The vision had lasted only a few seconds. But the laughter of those impudent beauties resounded within me long afterwards.

It was still echoing when Adrienne came back, around mid-day. I dared not speak to her about my vision. What could I have told her? That I had seen some mountain fairies? She would have regarded my story as rubbish and she too would have told me I was silly.

She had heard about the crime committed at the inn, the whole village was in a state of shock about it. They were looking for me. Could the big bear have killed me as well, and – why not? – devoured me? Or was I her accomplice? Adrienne had tried to calm them, said that she had found me, safe and sound but very frightened, and promised to bring me back to the village so that I could make a statement to the police.

'Have you recovered those words you lost?' she asked me as we headed back to the village.

I said I had. I felt stronger than ever before. The laughter of the trees babbled inside me.

IV

I stayed with Adrienne for a few weeks. One day she announced that she had found me a place as a domestic servant, not at an inn but at a country house. She had a cousin, Marthe Jacquaire, who worked as housekeeper at Fontelauze Manor; they needed a housemaid there. The said cousin offered to introduce me to the mistress of the estate, Baroness Elvire Fontelauze d'Engrâce. This name was not unfamiliar to me, I had often heard it crop up in conversations among patrons of the inn, but I could not really remember the gossip that sprang up every time it was mentioned.

Marthe Jacquaire and her husband Toine were the caretakers of the estate. They lived in a small lodge contiguous with the stone wall surrounding the estate, near the main gate. When the baroness made my acquaintance, she examined me from head to toe in a silence that I found chilling. Then she declared, 'This white blackbird is quite tall for her age. That's excellent.' And with this comment that was no less succinct than enigmatic, she was gone. It's true that I had suddenly shot up, like a bamboo cane. I was the same height as the baroness and just as thin. But she, then over seventy years of age, had an impressive head of dark hair – not one of which had turned white – dressed in a chignon. Old age may have spared her hair, but had wrought intense damage to the skin on her face and her hands. It was as though a zealous and meticulous spider had woven a very complicated web over her countenance, so dense and intricately ramified was the network of lines and wrinkles with which it was covered. Her eyes were the colour of the waters of the mountain torrent flowing into the valley: a linden green, intense, opaque, and cold.

I was assigned a room on the top floor of the manor house.

There were three exactly the same, adjacent to one another. Formerly, these three rooms were occupied, in the days when there was a large number of servants and the baroness entertained. My window looked out over the park, at the far end of which, surrounded by rose trees, was the family graveyard – an ancient concession granted to Protestant families at a time when their dead were not entitled to burial in Catholic cemeteries.

My days began early. I would join Marthe in the kitchen, and help her with most of the household tasks. At about nine, she would take the baroness her breakfast, in her suite upstairs. She would then accompany the baroness to her son's bedroom, the baroness's son being paralysed as a result of a hunting accident. I had been told that while handling his rifle, he had accidentally fired a bullet straight into his face. Such ineptness left me puzzled. Death's job was only half done, depriving the careless hunter of the power of speech and the use of his legs, and of his sight in one eye.

Aged about fifty at the time of my arrival at the manor, Philippe Fontelauze d'Engrâce was nothing more than a big broken body whose mutilated face emitted plaintive burblings and what sounded like the croakings of a mouse caught in a trap. The baroness had had an elevator installed alongside the splendid indoor staircase, but what she called 'Philippe's lift' was closer to a goods conveyance, a kind of wooden crate that slowly descended, jolting and grinding, from upstairs to the ground floor.

Every day, whatever the weather, the baroness would take her son out for a walk in the park after lunch, and I would go with them. The half-dead invalid would come down, seated in a wheelchair, with a rug over his knees. I would wait below, ready to take delivery of the relic of this soul in purgatory, lodged in its wooden shrine. I would see his feet first of all, then the ample folds of the draped rug, then his hands lying limply on knees closed together, his hunched shoulders, and finally that half-disfigured face. To me, his bronze-green eye, its dull glint made gloomier still by dark rings round it, was like a nocturnal butterfly dozing under a

57

net; beneath its mangled eyelid, the other eye was an already dead butterfly.

I pushed the wheelchair along the paths, Elvire Fontelauze d'Engrâce walked ahead, at a slow, regular pace. The destination of our walk was the little cemetery screened by rose bushes. There, we would come to a prolonged halt before a tomb inscribed with two names: that of the baron, who died in March 1918, and that of a young woman. Her double-barrelled given name, half-feminine, half-masculine, and above all her dates of birth and death greatly intrigued me the first time I read them: Agnès-Déodat Fontelauze d'Engrâce – 11 November 1918–6 June 1944. A life that from beginning to end, more or less, came under the sign of victory, and you sensed immediately some bitter irony must have attended this all too brief trajectory. But the baroness saw no need for any introductions. I learnt from Marthe this was the posthumous daughter of the baron, who was killed at the front. Her mother had bestowed on this late-born child her deceased husband's forename.

On rainy days, we would wrap up the relic in a hooded great coat and the baroness would equip herself with a large black umbrella that formed a bobbing dome above her shoulders. I contented myself with stuffing my mane of white hair under a beret, like a cauliflower in a braising pot. We constituted a tragi-comic trio, the figure of the baroness like that of a hydrocephalus wader, the hooded paralytic, and I, bent over the unwieldy wheelchair, walking in slow procession, one behind the other, beneath the rain, or through the fog.

Not a word was uttered during these walks. The slightest sound acquired a peculiar resonance: the rain drumming on the fabric of the umbrella; our own footsteps and the wheels of the chair squeaking on the wet gravel; fragments of bird-song, the distant barking of dogs and bleating of lambs; and above all the sibilant respiration of the shattered man. Just listening to it, I ended up short of breath myself, with a constricted heart.

On returning from our walk, I had a few hours' freedom. I would take the opportunity to go wandering in the woods on the estate, alone at last, or to read a book borrowed from the baroness's library. While keeping me at a distance – the appropriate distance between a woman of her age, of noble descent, and a young servant of unknown parentage – Elvire Fontelauze d'Engrâce treated me with respect and trust. I was a white blackbird, submissive and discreet, never workshy, and not too foolish.

The library was austere, most of the books not very enticing to a young girl of very summary education such as I still was then. More often than not, I would bury myself in a dictionary and fasten on a word that I would explore in all its aspects: etymology, composition, definition, its various derivatives, expressions and turns of phrase in which it was used. I loved words, like choice confectionery wrapped in shiny paper of shimmering colours or clear glassine that rustles in your fingers when you unwrap it. I let them melt in my mouth, releasing their flavour. My favourite were the words you had to crunch, like nougatine or toasted caramelized nuts, and those that had a bitter or tart after-taste. Some words enchanted me, because of the disturbing softness of their suffix that brought to their meaning incompleteness and a latent impulse of desire: flavescence, efflorescence, opalescence, rubescence, arborescence, luminescence, dehiscence. . . They described a process taking place, very inwardly, secretly. . . and I had created a word based on this model: 'amorescence'. In the hope that by the magic of this new word a little love would arise in my mother's absconded heart, and in mine, all caked with tears and anger.

But I did not have the opportunity to use all the words I picked out, or invented, having no one with whom I could converse freely. So I fashioned them into bizarre chapelets that I would run through my mind while doing the housework or pushing Philippe's wheelchair along the paths in the park. Sometimes I would hum them under my breath, in bed at night, like a lullaby.

★

Visitors were rare. No one came to the manor but Doctor Larracq, three or four times a week, to check up on the physical wreck; pastor Simon Erkal, on an irregular basis though for long visits; and a nephew of the baroness, Fulbert Fontelauze d'Engrâce, twice a month. Whereas the lady of the house would always accompany the doctor and the pastor to the steps leading from the house at the end of their visits, she never paid her nephew this compliment. Younger than her son, a fine figure of a man, and self-assured, this Fulbert in the eyes of his aunt was nothing but a stinking clod of mud hidden in a golden casket. She sensed that he was a little vulture with his eye on the manor house, the park and the woods. He knew that he was extremely well placed in the running for the inheritance: Agnès had died without issue, and Philippe, who had never married, was no more than a zombie, who, even if he were to outlive his mother, would be incapable of asserting his claim. You could sense that the dashing Fulbert would be quite prepared to propel the elderly future orphan's wheelchair straight into a home for the handicapped.

Another task was entrusted to me: the monitoring and maintenance of the time-pieces and pendulum clocks with which the residence was crammed. I counted some thirty, most of them upstairs in the baroness's apartments. The ritual took place once a week, on Sunday morning. I would make the round of this herd of clock-hands forever trotting in an endless circuit in every room. I would dust and polish the cases, make sure the glass clock-faces were impeccably clean, and wind up the mechanisms. I acted as time's sheepdog.

Elvire Fontelauze d'Engrâce would then inspect her chronometric flock, a peculiar smile, devoid of any joy, fixing on her lips when all the instruments struck midday simultaneously. She insisted on this temporal ceremony taking place on the Lord's Day; it was her own personal mass, of which she was both officiant and congregation, and I the verger. The twelve chimes would emanate from all directions

in a curious cacophony, some mechanisms emitting harsh, brief sounds; others, long drawn out and resonant; sharp, melodious, limpid, deadened. . . The voice of time was a choir singing in unison, at every pitch.

Was the old lady, in mourning for her entire family, trying to vanquish time, or at least to give herself the illusion of doing so? On several occasions I overheard snatches of conversation on this subject between the baroness and the pastor, who strove in vain with invariable patience and consideration to soothe this parishioner of his, of a rebellious and somewhat frenzied spirit. One day I heard her say to the pastor, 'There's no other god but time, and this god is a Moloch who tirelessly and ruthlessly puts his children, every one of them, through fire. Some burst into flame at once, like my husband, others are consumed by slow burning, to increase their suffering. Such was the case for my daughter, as it is for my son. And also for me, terribly so.' No matter how the pastor tried to argue with her, summoning to his rescue the prophets Isaiah, Jeremiah and Hosea, who had all battled against this false god, nothing was of any use.

'I don't worship him in the least,' replied the baroness, 'in fact the hatred I have of him is as adamant as that of the Judges and prophets, but unlike the latter I do not turn to some other god who is supposed to be the one true god. I merely state the facts: the false god Time, Moloch or Baal – call him what you will – gives ample proof of his power and evil-doing, while the one you regard as the only God offers me none at all of his benevolence.'

And when Simon Erkal, having run out of arguments, urged her to pray and humbly beg for mercy, she retorted, 'But who's to say that the battle I fight against this almighty tormentor, time, is not a form of prayer?'

All of a sudden I who had never given any thought to time – there were many other issues that tormented me – now began to worry about it. So what was this flux without beginning or end, as immaterial as light, more corrosive than acid, that right from the very start infiltrated our flesh, mingling with our

blood, insidiously grinding down our hearts, imposing its deadly law over us, without so much as a word? Who was this stranger, no less invisible than omnipresent, this savage nothingness that toyed with us?

Occasionally I would stand in front of a mirror and examine myself as if I too were a clock, my body being the case; my face, the clock-face; and my eyes, the hands. And in concert with some thirty tickers, I would start delivering staccato tick-tocks, tick-tocks, and striking the hours by singing ding-dongs in a voice that ranged from high to low depending on my mood. Whenever I had my periods, I would just bellow out furious 'no, no, nos' by way of a chime. In short, I was infected with the baroness's craziness, but in my case it remained play-acting.

<div align="center">★</div>

When you live in a house for a long time, you end up learning to read in it the history of its proprietors. A kaleidoscopic reading at first: here and there, you glean clues, traces, though fragmentary and confused. The furniture, the ancestors' portraits hanging on the corridor and drawing-room walls, the photographs standing on the dressers, the knick-knacks – all indicate trails to grope your way along towards the recent past of the family that owns the premises. But it was mostly thanks to my indiscreet investigations of the library, half out of curiosity, half for want of anything better to do during my free time, that I managed to lift the veil a little on the dark chapters of the Fontelauze d'Engrâces' history. You see, a distracted reader sometimes forgets a card or letter inserted in a book as a bookmark. Or, better still, on a shelf close to the ceiling, colonized by spiders and dust, you come across a bound file containing newspaper cuttings, or private diaries carefully wrapped in brown paper and firmly tied up with string. You can tell that the person who put them away right up there, made to look as if they were unimportant, had secret reasons for doing so. That is how I was able to read back over a number of pages concerning Philippe and Agnès-Déodat.

For a long time the son had remained an only child. He was all the more coddled and cosseted for being gifted with a wonderful voice. A voice as pure as that attributed to angels, and one that enchanted everyone who heard him sing. And he also had the diaphanous beauty of angels, their fairness, their gracefulness. For it is generally in this charming guise that human beings in their foolishness think of angels, sparing themselves from further enquiry as to what these mysterious creatures really are and taking very good care not to pay close attention to the perhaps terrifying sound of their otherworldly voice.

Little Philippe reigned as prince, both within his family and over the sacred territory of his angelic voice, and he thought he was immortal. Until the day when he sensed rebellion, latent at first, then gaining ground, in the heart of his voice kingdom. It rose from the depths of his body, whose prettiness began to melt away like snow in the sun; a hairy down sprouted on his face and limbs, grew tangled in his armpits and in his groin; something that he could not control grew heavy, hardened at the base of his stomach; a smell at once sourish and musty emanated from his skin; pimples swelled on his face and neck. But there was much worse: at the same time, his voice failed, lost its beauty. It would suddenly desert him, behave like a bouncing ball, sometimes mimicking a goat, sometimes a toad, or else be completely strangulated. No matter how much anyone tried to reassure him about the normality of this phenomenon, and advise him to rest his throat while his voice was breaking, after which he would regain his command over it in a new register, he just would not listen. The little prince would not accept this dispossession, this deprivation. He felt betrayed, by his own body, by the adults who had not protected him against this inward rebellion, by nature, by the angels of whom he had considered himself an equal, and, close on their heels, by God whose glory he had so magnificently sung, through the medium of Bach, Pergolesi, Allegri, Handel, Tallis or Vivaldi. In his distress and fury, the poor pubescent boy was ready to blame anyone.

Puberty is a brutal, painful and humiliating exile. Little girls are expelled from childhood to the rhythm of the flux of their blood and the stabbling pains in their abdomen and back, little boys to their rhythm of their changing voice and its growing huskiness. And suddenly nothing in the world around them can be taken for granted any more, everything becomes subject to caution, to wariness. But at least little boys then attain the status of free men, whereas girls, once they become nubile, are placed under strict surveillance, objects of covetousness as much as mistrust, and accused of impurity every time they menstruate.

The youth rebelled against the changes he was undergoing, refused to cross the threshold that opened before him. However, he was rushed towards it, with redoubled violence. The first signs of his disgrace became evident at the very beginning of the year 1918, while his father was at the front. When the father returned on leave to his family, Philippe was evasive, and sullen, so ashamed was he to appear before his father in his new plumage and new voice, both equally ugly. Far from taking pity on him, Déodat Fontelauze d'Engrâce duly noted his son's metamorphosis and concluded that it would be advisable to send him to boarding school soon, to continue his studies and prepare for the harsh calling of manhood. Yes, manhood, for men were falling like spring showers at that time, and their replacement needed to be assured.

The father was right to worry about passing on the torch, because as soon as he returned to the fray he was reduced to mincemeat. He was killed one day in March, during the Montdidier offensive in the Somme. A few months later, his widow, then in her mid forties, discovered, with a mixture of amazement and fear, that what she had taken to be a first sign of the menopause was in fact that of a late pregnancy. Her deceased husband had proved as manful during his leave as on the battlefield.

From the outset, Elvire Fontelauze d'Engrâce's feelings towards the coming child were ambiguous. She was too grieved by the death of her husband to be able to rejoice in

this new life that she would have to bring up by herself, and besides she considered herself old enough to be a grandmother rather than the mother of a newborn baby. Like her son, she was ashamed of the surprise her body had sprung on her.

When Philippe realized what was developing in the increasingly rounded belly of his mother who was all dressed in black, his feelings were completely unambiguous: a concentration of resentment and jealousy. The little fallen prince suspected this embryo of wanting to steal his place, and of forcing him to take the place left vacant by his father. And he preemptively declared war on this usurper.

The other war, the one that had claimed his father, ended on the very day of the posthumous child's birth. Agnès-Déodat was born to the sound of victory bells and the return of peace. A fine entry into this world, contrary to mine. But all the same, the little semi-orphan was not greeted with joy. She was only a girl; her mother had been hoping for a second son. As for Philippe, girl or boy, the intruder remained no less his enemy. Yet he kept up appearances when he was introduced to his little sister on his return to the manor for the Christmas holiday. He had been boarding at a school in Bordeaux since September and he only came home at the end of term.

Though he did save face, he lost his voice for ever. For, galled by the coming of this rival, he tried to reconquer his realm. One afternoon he retired to the woods and, without anyone's knowledge, he endeavoured to sing. Damn the advice that had been heaped on him to be patient and not strain his voice! He had no more time to waste, he was going to show them all, his mother first and foremost, of what he was still capable, he was going to reassert his preeminence. He would raise his song, such to make the cherubim turn pale, till it reached the home of the dead where his hero father now dwelt. He would burst the eardrums of his abhorred little sister with the sole flaming dart of his voice. And he went at the Thomas Tallis motet, *Spem in alium*, in which he had excelled a few months earlier:

'*Spem in alium nunquam habui praeter in te, Deus Israel, qui irasceris et propitius eris . . .*'

'I have never put my hope in any other but in you, God of Israel, who will be angry and yet become again gracious . . .'

God proved extremely angry and not at all gracious. After several disastrous attempts the rebellious youth in a fit of frenzied rage forced his voice, and it was then that it broke. Into a thousand pieces, beyond repair.

'*Domine Deus, creator coeli et terrae, respice humilitatem nostram.*'

It was on these words that he ruined his voice. The Creator did indeed take the measure of his wretched creature's humility and found it extremely underdeveloped. The creature inflated with vanity was therefore punished forthwith, and for want of humility was dealt a lasting humiliation. In the woods, only the crows were witness to his undoing, but they hailed him with their cawings, perhaps mistaking him for one of their own, showing off with his discordant shrill screechings.

And Philippe was soon nicknamed the Falsetto. He made a pact with himself: he would make her whom he held responsible pay most dearly for this unremitting disgrace and affliction. He waited a quarter of a century, but his moment came.

★

From the photograph albums I leafed through, lingering over some of the pictures with a magnifying glass, it seemed that Agnès-Déodat, nicknamed Agdé, was a puny-looking child, a little girl of rather colourless appearance, as if the gloominess of her gestation inside a body swathed in black had imbued her with grey shadow. But as she quitted adolescence, she emerged from her chrysalis. In contrast with her brother, she acquired her good looks on coming of age. And far from ruining her voice in the process, she allowed it to develop, to come gloriously into its own. On this voice, with its deep, rich contralto modulations, she worked patiently, subjecting it to a rigorous discipline.

It was then that the Falsetto intervened. Seeing that his sister wanted to dedicate herself to a career as a singer, he hastened to thwart her plans. As he had already turned thirty,

and had a position in the banking business, he suddenly took on the role of proxy father, anxious for the young girl's future. He began by dissuading his mother from allowing Agdé to go and pursue her singing studies in some big city, and convinced her it was better instead to think about getting her daughter married. He even undertook to find her the ideal son-in-law.

The fine catch that he maliciously foisted on his sister was called Geoffroy Maisombreuse. He was thirty-four years old, and not without charm or assets. The girl tried in vain to express reservations. She was seventeen and regarded as incapable of deciding her own destiny. The engagement, then the wedding were celebrated in quick succession. The Falsetto was satisfied, he had succeeded in introducing a serpent into his sister's nest.

Geoffroy Maisombreuse did not profess any immorality, he was by nature, quite simply and ludically, amoral. Life for him was a game, in every respect. Gamesters need to have a great many cards or pawns in hand. He must have thought that marriage might turn out to be an excellent card, to feign respectability, for example. But he quickly tired of this pretty queen of hearts and he soon neglected her, then offended her. And in the end he destroyed her. This process, I deciphered from the diary Agdé kept from 1935, the year of her engagement, to February 1944, the date of her first death.

For she died twice over. Many people die like this, lingering on for months, years, even decades amid the ruins of love, of hope, into which misfortune has dashed them. Such was Orpheus's torment, losing his Eurydice twice, twice foundering in grief, before being torn to pieces by the Meanads in their fury. Such is the torment of all those men and women whom nothing can console for the loss of their loved ones. And not even the saints, male or female, are unfamiliar with this sense of abandonment, to the very point of incandescence, when the Lord forsakes their soul and plunges them into the darkness of nothingness.

The young bride often wrote of her husband at the beginning

of her diary. She even believed herself to be vaguely in love with him, but this illusion was quickly dispelled. Then the war came, consummating the couple's disunion. Geoffroy opted for collaboration, as a person might play a lucky number on the roulette wheel. To win the chance of very soon wielding power, with such a wide margin of freedom in exercising this power that it would even include impunity for any crimes. Agdé refocused her attention and energy on singing. The less she mentioned Geoffroy in her diary, the more she developed her thoughts on music. Handel, Purcell, Schubert, Brahms and Mendelssohn, and especially Bach, Gluck and Mahler occupied her thoughts.

Gluck. Agdé threw herself body and soul into his opera *Orfeo ed Euridice*. Her contralto voice, ever more rich and shimmering with gleams of purple, slate blue and silver grey, destined her to take the role of Orpheus. She dreamed of being able to sing the threefold cry to Eurydice at the very beginning of the first act in such a way as to move trees and rocks to pity. To silence the war. In actual fact, under the cover of talking about music, of analysing her score, Agdé was thinking of only one thing: the great love affair she was living through.

How, on what day, in what place she met the man whom, for prudence's sake, she called her Eurydice, I did not succeed in discovering. But these details are of no importance. From the moment you are in love, your beloved seems to have been there for all eternity, time begins with him, the earth is reborn with him. On the other hand, the reverse holds true: from the moment you no longer love, the other seems never to have existed.

'My Eurydice!' This exclamation appeared more and more frequently in Agdé-Orpheus's journal after her amorous bedazzlement, sometimes in the middle of a page, just like that, without any apparent connection with the preceding and following lines. Or else, in a lively hand, she would write these words: 'I love'. With no specification, no object. The verb and its object were kept apart, as if both were too brimming with

passion to risk coming into contact with each other, for fear of causing an explosion. Numerous pages were strewn here and there at random with these fragmentary phrases, 'My Eurydice!' and 'I love!' These interjections reminded me of those mauve blue crocuses and yellow anemones that when the snow melts flower abundantly in the short grass of upland meadows, on the edge of mountain streams.

Far too preoccupied with his important duties, which he contrived to shroud in mystery, Geoffroy, had not noticed the change in his wife. They lived separated under the same roof. A semi-deserted roof, in fact, as Geoffroy was away most of the time on business. But the Falsetto remained on the look-out, and nothing escaped him. Especially not the tones of his sister's voice.

One day when he visited her, he came upon her rehearsing the role of Orpheus. Standing behind the drawing room door, he listened to her at length. He was obliged to admit that her disastrous marriage had no harmful effect on the contralto's voice, quite the contrary. He pressed his forehead to the wood of the door, bewitched by the wonderful singing. And he guessed it was not from sorrow that Agdé had drawn these storm-tinged inflections, this strength and trueness of expression, but from a stolen, clandestine happiness. For, completely excluded though he might be from singing as well as love, the Falsetto was no less aware of the power of both. He had a keen ear and a flayed heart's sensitivity.

Towards the end of the year of 1943, Agdé several times referred to her brother in her journal, expressing surprise at the change in his behaviour towards her, of the interest he was beginning to show in her. Naively, she was pleased. He came to see her regularly, accompanied her on the piano. Did she eventually confide in him, or unknowingly give him some inkling? Like the sharp-eyed hunter that he was, he was able to make the most of every hint gleaned, he detected a scent, waited, then followed the trail and ran his prey to earth. A perfect prey – the man concealed behind the name of

Eurydice was a Spanish Republican who had been interned in the camp of Gurs, from which he had escaped and joined the ranks of the Resistance.

Once he had unmasked 'Eurydice', the Falsetto denounced him to his brother-in-law, who took over pursuit of the quarry. The Falsetto having undertaken the task of flushing him out, the brother-in-law saved for himself the pleasure of the sounding the horn for the kill. It was a magnificently executed kill. Geoffroy Maisombreuse was an aesthete.

<p align="center">*</p>

The name of Gurs was not unfamiliar to me, I had heard of it at Léontine's house. A name of onomatopeic suggestion, harsh and knotted like a swallowed sob, it had intrigued me then, especially as Léontine and Antonin never mentioned it without a mixture of anger and shame. For this camp, located in the valley of the Oloron torrent, on the outskirts of peaceful villages surrounded by hills, was built as early as the spring of 1939 to receive, or rather to concentrate and contain hordes of Spanish combatants, then the International Brigades fleeing from Franco's troops. As a reception centre for an exhausted, persecuted population in exodus, it left something to be desired: an uncultivated scrub-covered wasteland, water-logged by the frequent rains brought by the west winds, with wooden shacks of hasty construction, because originally intended to serve as temporary shelters, and all around a hostility fraught with mistrust and scorn.

Far from being demolished when the majority of these first inmates were able to leave for sometimes even more dubious or downright hazardous destinations, these temporary shacks were immediately brought into service again. In the autumn of 1940, new arrivals turned up en masse, labelled with an eloquent designation: 'undesirables'. Civilians, mainly Jews driven out of Germany, foreigners deprived of their citizenship and cast adrift in the wilderness of the word 'stateless', political prisoners. And almost at once they were joined by swarming masses of voracious house-guests impossible to dislodge: lice, fleas, vermin, rats. And

then hunger, illness, anguish. Death too settled in among them.

Throughout the years of war there was a great of deal of coming and going among the camp's population at Gurs. These movements were the result of either transfers to other camps or assignments to work units or dispatches to emigration centres, whether for enforced 'voluntary repatriation' or deportation to a destination coyly said to be unknown – Drancy, then Auschwitz. There were also cases of inmates escaping. Perhaps the one thousand who died inside the camp should be included in the number of escapees?

Loulou, the Baby Owl, was smuggled out of Gurs. His family left on a train that took them to a final camp, via Drancy.

After the Liberation, the camp continued to operate, but on a lesser scale. No more overcrowding of the kind there had been during the war, conditions of detention that were much less distressing, and above all death no longer prowled there. The purveyors of misery, terror and anguish that the collaborators, militia, informers and traffickers had been did not suffer the same fate as they had inflicted on their victims. They all came out alive, and free.

From start to finish, the camp at Gurs was supplied with prisoners, administered, and superintended by French officials. Once emptied of all its occupants, it was dismantled; the local people salvaged the planks and timber framework and used them to erect hen-houses, lean-tos, and haylofts. The place was abandoned to brambles and trees. With the recovery and redeployment of the building materials, followed by the burial of any remaining traces under vegetation, the camp sank into oblivion. Thus, many internment camps, in France and in Europe, that for millions of detainees were the antichambers of death, for long afterwards lay forgotten, like some ugly Sleeping Beauty.

One of Geoffroy Maisombreuse's accomplices in the ghastly mascarade that Agnès-Déodat was to witness one February evening of 1944 spent some time at Gurs after the war. He

related how events unfolded that evening. His statement was contained in a few pages that I found, folded in an envelope hidden in a corner of the library. Elvire Fontelauze d'Engrâce, to whom this document was handed over, could not bring herself to destroy it, and had kept it secret, as one might hide a wound, a trace of infamy. Did her loss of faith and her insane battle against Moloch date from the day she became aware of these facts, of the cruelty of her son-in-law and the baseness of her own son?

It was thanks to these yellowing pages, and to a few other scraps of information derived from here and there, that I was able to reconstruct the scene of Eurydice's execution.

★

Since Geoffroy Maisombreuse knew his wife wanted a divorce, he suggested they should break the bitter silence that had prevailed between them for some months, so they could discuss arrangements for this divorce. They should settle matters, go their separate ways with head held high, and an evening spent together was to seal their agreement to end their marriage. An evening worthy of the great singer that Agnès would not fail to become after this friendly parting. This proposition, for all its unexpectedness, inevitably won over the young woman, and she accepted.

When she entered the drawing room, she saw a fire burning in the hearth, illumination by candlelight, and on a small round table a champagne bucket gleaming between two crystal glasses. This scene of false intimacy must have seemed grotesque to her, and even repugnant. Geoffroy uncorked the bottle. Just as the cork popped, the far door opened and a trio, who had only been awaiting this festive signal, came in, soon followed by a music-playing duo.

The first three characters were swathed in long black capes, each one of them wearing an equally black, broad-brimmed hat, their face covered with a mask in the style of the classical theatre. Two of these individuals were disguised as twins, their masks wrought in a tragic grimace. They stood either side of the third figure, whose step was faltering, and whose mask

displayed an hilarious smile. They positioned themselves in front of the fireplace. The two minstrels wore just a velvet mask of gold and a motley cape. One played the violin, the other the flute.

The tune they were playing, very laboriously, was none other than that from the first act of *Orfeo ed Euridice*. Geoffroy offered a glass of champagne to his wife, and raising his own he exclaimed, 'Let's drink to your dear Gluck, Orpheus, and above all to your beloved Eurydice!'

Agdé froze, like a statue.

But he continued in a jocular voice, 'I've convened this gathering of maskers to offer you the opportunity to demonstrate in public the exquisite qualities of your voice. Better still, to put to the test the magical virtues of your singing. The musicians are pitiful, I know, but you must excuse them, they're not professionals.'

Having made this introduction, he sat in an armchair and served himself a second glass. 'Let the festivities begin!'

And the amateur musicians resumed their playing of the piece of music. Agdé remained turned to stone, glass in hand, not yet understanding what trap she had walked into.

'Well, Orpheus, you're not singing? Perhaps you're upset because you're not sure about the casting?'

And he clicked his fingers. The two tragic maskers immediately tore off the comic character's cape. He was naked, with his arms tied behind his back.

'Is this not your Eurydice, lovesick Orpheus? You do not greet her?'

Still Agdé did not stir. She stared at her lover's body stripped bare, trembling in the flickering glow of candlelight and of the flames in the hearth. The musicians kept tirelessly repeating that tune from the first act of the opera. Outside a chill wind blew. The two tragic maskers began humming to the tune played over and over again, 'pom, pom, pom'.

'Is the choir of nymphs is so moving, then, that it's made you suddenly turn so pale and weep, Orpheus? Yet you know full well I don't like sentimentality. Enough crying! Let your

voice take over from your tears at last, and let it do so power-fully, magnificently, without restraint! If you want to touch the heart of Hades whose coldness is without measure, you must surpass yourself, sing like a flow of lava. This is the challenge I issue, Orpheus: sing with telluric feeling, a heart of thunder, the jaws of a she-wolf! Amaze me, and I shall restore your Eurydice to you. On my word as master of the Underworld!'

It is likely that he would have kept his word if Agdé had risen to the challenge, for he was, first and foremost, a gamester; a gamester capable of bowing to an adversary he recognized as even more bold and shameless than he, who, in the course of a game meticulously orchestrated by himself, managed to produce an unexpected wild card worth a high-ranking ace. It had been many years now that he had been waiting to meet this superior rival, but every one of the victims caught his net had floundered with the pitiful ineptitude of fear, or else had arrogantly stood up to him in the name of values that were totally alien to him. Since it is rare that anguish is conducive to playfulness, or that dread of torture inspires brilliant repartee, he had still not found his master, and this left him feeling vexed. And, even more, bored. No one had been able to offer him the response he hoped for, a response that was not included in the normal repertory of human reactions in distressful circumstances. It was his impression that he had exhausted this repertory, which his duties in the Militia allowed him to study at very close quarters and in high doses. When all was said and done, war had less piquancy than he had thought.

Was Agdé finally going to surprise him, to overcome her terror and, gulping back her sobs, belt out in a raucous voice, inflamed with fury and sensuality, a song of fighting passion. He would have so much appreciated seeing her transfigured into imperial female, half beast, half goddess, venturing to push to the limit the inversion of roles and exalting the masca-rade into a blazing little apocalypse, trampling underfoot all modesty and fear.

But Agdé did none of this. Astoundment nailed her to the spot. Stupefied, she beheld her lover's mocked body, his naked genitals. A headless body; for this mask that overlay the prisoner's face with a hideous and silent laugh was no head. And this bared body, these genitals exposed to the feasting gaze of eyes bright with cruelty had a face's vulnerability.

They were a face. That of her Eurydice, at once so familiar, beloved and alarming that all visible surroundings were eclipsed by it. They were the face of Eurydice and Orpheus entwined, dislocated one inside the other, and teatering on the threshold of Hell. A fallen star that had dropped out of a gaping abyss in the flanks of humanity, presaging the end of time – their time, for both of them, these captured, doomed lovers. A calamitous face – a heart wrested live from the bosom of love itself.

The two tragic characters modulated their 'pom, pom, poms' in booming voices.

'The choir of nymphs is growing impatient, Orpheus. It's up to you! I'm going to count to ten, after which, if you don't sing, your Eurydice will cross the Styx with a one-way ticket.'

And Geoffroy began the countdown: 'One, two, three, four . . .'

Agdé made a movement, but the ground was spinning beneath her feet.

'. . . five, six, seven . . .'

She could only moan.

'. . . eight, nine . . .'

She squeezed the champagne glass she was holding in her hand so tightly that it shattered. A piece of glass cut her palm.

'Ten!'

Having pronounced this last figure, Geoffroy once again clicked his fingers. Then the two tragic characters fell silent, flicked off Eurydice's hat, then removed his mask, completing the striptease act. And Agdé screamed. The dual nudity of face and of body that had itself become a face was unbearable, and the contrast between the two was even more shocking than with the mask on.

Besides, was the face still a face? A gag stained red with blood crushed the mouth, the eyebrows and cheekbones were split, the nose broken, the eyelids swollen. Agdé suddenly leapt towards the disfigured man, but Geoffroy held her back.

'Too late. You failed to seize your chance, you weren't up to the part. Too bad. Now, this has to be brought to a conclusion. Every opera, even an unsuccessful one, has a finale. Gentlemen, on with the show, if you please!'

And the two tragic players bundled Eurydice up in his cloak again, adjusted his mask and dragged him out of the room. Agdé tried to intervene, in vain.

'It's all your fault,' Geoffroy told her. 'If you had sung in time, the nymphs would not have turned into Furies.'

The spectacle ended outside. The master of ceremonies asked the two musicians to extinguish all the candles and to light the lamp on the stone steps. A harsh glare illuminated the icy courtyard. The trio reappeared on the other side of the drawing room's bay window. Hades' two flunkies stripped Eurydice, then went to fetch buckets. With no more than a jerk of his head, Geoffroy signalled to the musicians to tackle the final tune. They played the music of the cold song in Purcell's 'King Arthur' as laboriously as they had played the previous piece. The two tragic players threw the water in their buckets over Eurydice, and his body leapt violently as if an electric charge had just travelled down his spine. He died on the spot, stricken by the cold. The water froze on his skin instantly; a shroud of ice on his body-face. And he remained upright in death, soldered to the ground aglitter with snow, obstinately grinning that white laquered, papier-mâché smile.

On the other side of the window, Agdé collapsed.

Curtain. Not even Geoffroy applauded.

★

From the time of these events, Agdé's mind wandered. She no longer spoke, inaudibly murmuring disconnected words. She no longer sang, she would very quietly hum, stop abruptly, shake her head wearily as if constantly searching for a melody growling inside her just at the brink of oblivion. She wandered

through the rooms of her house, stumbling against walls and furniture. Everything had become unfamiliar to her, unmanageable, even space. Those who saw her then, said she put them in mind of a swallow that, having found its way into a room by mistake and incapable of locating the window, panics, flies round and round in circles, hitting obstacles all over the place, and finally dies of exhaustion.

In a medical file attached to her death certificate, I came across another unusual detail. The cut, albeit not a serious one, that she inflicted on herself in the hollow of the palm of her right hand when she broke the champagne glass, never healed. Blood seeped from it, drop by drop, continuously, like water from a water clock. She wore a glove on that hand, and she looked on this gloved hand as an alien appendage, a limb grafted on to her. She held it away from her body, whispered unseemly words to it. Every day a brown circular stain would appear on the glove. No treatment was successful in clearing up this cut. I later learned that Geoffroy Maisombreuse, erotically inspired by this wondrous seeping, would take these gloves adorned with a petal of dried blood to prostitutes, asking them to caress him with their right hand thus gloved, until they brought him to orgasm. On each occasion, he would take away with him the doubly stained glove. This was an extremely chaste way of making love with his wife, who had become as transparent as a ghost. Dozens of these gloves were said to have been found in the drawer of a dresser in his bedroom.

Towards the end of winter, Agdé took to going off on her own. She would escape into the countryside, lie on the ground where a little snow still lingered, put her ear against the soil to try and detect some sound, a cry, or a sigh. She was seeking her Eurydice's body. Now, where had his murderers buried it? But the only sounds to be heard, of the very, very faintest, were of the snow melting and of buds in the obscure process of germination. One day in April, she found in the hollow of a tree trunk a titmouse's cup-shaped nest, made of twigs and mud, well lined with feathers, down, and bits of fur.

She examined this nest and recognized some of her lover's hair in the silky lining. She called out to the titmouse, begging it to reveal to her the place where it had found these hairs, but the terrified bird's only response were sibilant cries of alarm. Agdé finally stole the nest in which there were eleven eggs about to hatch. The desperate little titmouse followed after her, twittering to no avail. Agdé kept the nest; the chicks broke out of their shells, demanding to be fed immediately. They all died, except one, of which she took great care, feeding it with insects and little worms for which she scrabbled in the earth. She established a chirruping dialogue with the young titmouse. The bird eventually flew away.

After the titmouse's departure, Agdé fell into a state of prostration; she remained curled up, clutching the now empty nest to her breast. Elvire Fontaine D'Engrâce, who did not know the origin of the ailment that was consuming her daughter and did not realize how serious it was, nevertheless insisted Agdé should be taken to hospital to be cared for there. But it was too late, the young woman was drained of strength, the blood that seeped from her palm now only formed pale pink stains. Her stay in hospital lasted about two weeks.

As her blood seeped away from her, Agdé's madness too cleared, and her memory, thought to have been lost for ever, returned, intact. One morning in June, she summoned Pastor Simon Erkal. He came to her bedside; their meeting lasted quite a long time, Agdé spoke in a whisper. Her adoptive titmouse fluttered outside, around the window, proffering silvery trills. Had it come to tell her it had at last found the body from which came the hairs interwoven with the feathers and twigs of her nest. Agdé died at dawn the day after her conversation with the pastor, while on the other side of the country the Allied landings were beginning.

The wind turned for Geoffroy Maisombreuse, carrying the smell of burning. Without warning, his shadow of an ossified wife had regained her wits and unexpectedly turned into a damning witness – for what on earth could she have told

Simon Erkal? He felt cheated. His wife's madness, so peculiar and titillating at first, was suddenly reversed. Like the war. Really and truly, nothing could be relied upon. And this landing on the Normandy coast was an earnest of ruin. Evidently, the countdown to his own defeat had just begun, his life as an unmitigated bastard would not be worth much before long.

What does a gambler who has put up a huge stake do when he loses? If he is a good loser, he admits defeat and faces the consequences. If he is a crook, he makes his escape as quickly as possible, leaving no trace. Geoffroy chose to flee, incognito, without waiting for the end of the war. He vanished in the century's turmoil.

I have sometimes wondered: in his flight did he take with him as a talisman a glove marked with a double-ringed stain?

The Falsetto was a hopeless player, he never had any luck, particularly when he thought he was winning. Although implicated in his sister's drama, he did not bear the greatest share of responsibility for it. He was unaware of the vileness of the famous surprise devised by Geoffroy and he had not taken part in its implementation. His whole world was turned upside down when he learned what had happened. Despite the depth of resentment felt by this hurt overgrown child, he still had enough of a conscience to appreciate all of a sudden the extent of his wrongdoing, the excess of his vengeance. Certainly, he had wanted – and with such belligerence – to stand in the way of his younger sister's happiness, having himself been robbed of all joy, and, having himself lost his own voice, to prevent her at all costs from succeeding in a career as a singer, but he had not wished for her death after a long and painful agony, nor for that of the man she loved. He had only wished for her an unhappiness equal to his own, wrought of frustration, boredom and bitter solitude.

Seized with remorse as belated as it was ineffectual, a few months after Agdé died he tried to commit suicide. But for all that he was an excellent shot, yet again he was unlucky, and failed. It is surely easier to shoot a hare, a dove, a boar or a roe deer, or even your fellow man, than to fire a bullet into your

own skull. At the very last nanosecond, some signal emanating from the depths of your brain must produce the cry of an animal desperately clinging to life, violently averse to dying, and cause a slight trembling of the hand, enough to deflect the trajectory of the bullet by a few millimetres. So the Falsetto only succeeded in shattering part of his jaw, and in losing an eye and the use of his legs. Just managing to survive, confined to a chair, and, even more so, to the hell of heightened remorse. With one eye fixed on the human tragi-comedy, the other on the void.

Storms are frequent in this area, and impressive. One summer's afternoon, five years after I came to the manor, a tremendous storm broke. I was serving tea in the drawing room where the baroness was receiving her nephew, the man impatient to inherit. They had nothing to say to each other, as usual, and each inconsequential remark was followed by a long oppressive silence. The porcelain teacups set down on the saucers at regular intervals punctuated the silence with their refined clinking. This was like an additional pedulum clock, with an erratic mechanism, sounding the emptiness with elegance and discretion.

But the rumblings of the storm gathered force and the clinking of teacups began to sound absurd against such resounding background noise. I noticed that Fulbert was becoming increasingly nervous, the electricity in the air finding a conductor in him. The baroness remained supremely calm, an almost imperceptible smile lit up her face and the green of her eyes acquired glints of bronze. She listened, with the attentiveness of a music-lover at a concert, to the howlings of the wind and the deep rolls of thunder in the distance. She seemed to have totally forgotten the presence of her visitor. All of a sudden Fulbert's hypertense nerves snapped, and turning towards me, he yelled at me to close the windows. The three drawing room windows were indeed open, the wind blew in, in warm gusts, carrying a feverish heat and an earthy smell at once heavy and pungent. Without taking the trouble to look at her nephew, Elvire Fontelauze d'Engrâce said, 'May

I remind you, Fulbert, that this is my home. You are not in any position to be giving orders here. If the storm bothers you, you may remove yourself.'

The nephew turned red and was left momentarily speechless. Then he rose, tight-lipped, about to deliver some incensed tirade before making a man of the world's dignified exit. But the storm silenced him, stealing the show. A streak of lightning in the form of a giant trident flashed across the sky, harpooning the edge of the park. There was the sound of trees cracking, then came the clap of thunder. The teacups rattled in their saucers and Fulbert, from crimson having turned deathly pale, was seized with trembling.

But he had even more of a fright to come. A fiery ball of sulphur yellow, ringed with lavender blue, burst in through one of the windows like a cyclone, hung in the air, as though hesitating, then, falling to the ground, spun round the room at frenetic speed. It was the size of a grapefruit. Round it whirled, sputtering, releasing a strong smell of ozone and soon of burning, then as if by magic it disappeared. The baroness remained motionless, did not even bat an eyelid throughout this no less brief than dazzling scene; she observed it with a radiant expression. The fringes of her shawl were burned, a black circle on the light-wood parquet marked where the fiery intruder had danced round. Fulbert collapsed into his chair, with sweat on his brow, still ghastly pale and with trembling jaw.

'How lucky we are!' exclaimed the old lady in a voice of admiration. 'Such phenomena are very rare. What a wonderful spectacle!'

'But this. . . this is madness!' stammered Fulbert, wiping his brow.

'Of course it is,' said his aunt, 'there is always madness in beauty. There must be if it is to coruscate. What would our lives be without these moments of brilliance?'

'No, it's you who are insane. . . out of your mind!' Anger had abruptly replaced Fulbert's terror.

'I won't see you to the door, Fulbert, you know the way out perfectly well. All I ask is that you forget the way here

from now on, for I don't wish to receive any further visits from you. You're tiresome,' his hostess contented herself with replying.

'You prefer being visited by these balls of fire, even if it means letting the manor go up in smoke!'

'Precisely, it would then be in better hands than yours.' And she added, 'You'll never have any understanding of beauty.'

Had I dared, I would have applauded. But the spectacle was not over yet: trees were burning on the far side of the park. The downpour of torrential rain did not extinguish those immense torches that with harsh death-rattles writhed against the azure-streaked charcoal-grey sky. We remained in the drawing room for a long while, the baroness and I, watching the trees blaze and the rain fall, without uttering a word. When calm returned, to sky and earth, and the trees were no more than smoking firebrands in the falling dusk, the baroness turned to me, and laying a hand on my arm, she said, 'I greatly appreciate your company, Laudes, you know how to watch, listen, learn, and you are demanding. . . of yourself. It's the only demand worth making. Alas, I realized this only too late . . .'

Then she stood once again in front of the open window and casting a final glance over the park and the blasted trees, in a soft voice she recited these words, which I found disquieting:

'I dearly love beauty, yet I do not recognize it as beautiful unless I behold it amid thorns.'

She closed the window, and added, 'Those words are by Johannes Scheffler, who went by the name of Angelus Silesius, a great seventeenth-century mystic. A renegade, I should say, for he left the Lutheran church to convert to Catholicism at the age of about thirty. But what does that matter when one is capable, as he was, of great insights, and of declaring that "abandonment is the only means by which to apprehend God, but forsaking God Himself is another abandonment of which few can conceive. . ." Yes, forsaking God Himself, the idea of God, walking the tightrope over the void . . .'

From that day, our relationship changed; there was an unspoken intimacy between us.

★

Fulbert did not reappear until two years later, on the occasion of his cousin's funeral. Philippe died during a walk in the park, one misty day in September. His heart suddenly stopped beating, that was all. That same evening Elvire Fontelauze d'Engrâce did the round of her collection of clocks for the last time. I escorted her, armed with pincers and pliers of various dimensions. She asked me to rip the needles from all the clock faces. Moloch had overstepped the mark, it was time that time finally stopped.

Voluntarily exiled in a timeless universe, the baroness could no longer sleep, lost her appetite. She did not even go to bed any more, remaining seated in an armchair all night long, dozing in fitful snatches. Apart from a few glasses of sugared water, she no longer put anything to her lips. One morning when I was offering her glass to her, she seized my hand and squeezed it very hard. And she said to me, 'Look, Laudes, over there, on the wall.'

I examined the wall to which she was pointing, but could see nothing out of the ordinary about it.

'But yes,' she insisted, 'there's a letter on it. A letter in the process of being written. Help me to read it, my eyesight's so bad . . .'

The wall was pale blue, a little yellowed in places; no sign of any writing. As I made no reaction, she began to decipher the invisible letter by herself.

'My dear daughter, dear Agnès. . .' She stopped, then resumed: 'Dearest Agnès, my dear child. . .' After another pause, she began again, 'My little Agdé, my darling daughter . . .'

This tentative reading-writing took quite a while, and occurred on several occasions. The second time it happened, I played along, realizing what the old woman's intention was; bereft of both her children, she was anxious to reconcile brother and sister in death before going to join them. At first

she hesitated over every word, wavering between discretion and tenderness, the fear of saying too much or not saying enough, of offending her daughter. But gradually the words came to her, the phrases marshalled themselves, all her love and regret were expressed in a clear and simple confession. Constantly recommenced, reread, intoned, this letter of hers covered the walls of the room, lining them with ghosts of smiles and tears imploring forgiveness.

Elvire Fontelauze d'Engrâce died one November morning, her voice failed in the middle of a sentence so often repeated that it had acquired the silky gleam of a pebble polished by the tides: 'for rest assured, Agdé, that although I showed you so little understanding, helped and defended you so poorly, it was not for want of love, but for want of intelligence in love, and. . .' A prolonged sigh completed her sentence. She was gone, pursuing it in the invisible world, where her husband and children had preceded her; in the abandonment of God, who speaks only where everything falls silent.

I went over to her, knelt down and gently took her hands in mine; I joined her in the recitation of her letter which I knew by heart. I read out the letter several times over, whispering it, like a litany. Then I rested my forehead on her knees, and for the first time in years I wept. And the words that I had rejected, thought I had forgotten for ever, stirred within me: '*Mane nobiscum, Domine, advesperascit.*'

When I got to my feet again, it was gone midday. That meant nothing, time was suspended, the clocks had been mutilated. The faded blue of the walls seemed luminescent, showing through the wallpaper there appeared to be undulating letters. I opened the window so that all these words could escape, go whirling round in the wind, settle in the trees. Come springtime, perhaps birds would glean them to line their nests, like the titmouse with Eurydice's hair.

I thought I saw a pearly diaphanous globe, like the ball of fire that had come bursting into the drawing room two years before; it was the size of a rounded breast, full of milk. It circled the room in silence, then flew out of the window to

vanish among the russet and ochre-coloured leaves fluttering about in the drizzle.

Then Fulbert made his reappearance. Barely two months had passed between the death of his cousin and that of his aunt. He wasted no time in taking over the premises. While inspecting his newly acquired property, he expressed amazement at the state of the clocks. I too feigned amazement, and said I knew nothing about it. All the hands torn from the clock faces, I had buried in the woods.

He had not been there a month before he summoned us, the Jaquaires and myself, to tell us that he intended to dispense with our services. He regarded the Jacquaires as too old, and me as undesirable. My physical appearance vexed him, and above all I was guilty of having witnessed the scene when his aunt had magnificently dismissed him. He was avenging himself for that affront. As I had already reached the age of majority, he had no problem, either of conscience or of legal consequence, in sacking me.

But before leaving, I gathered some spoils: Agdé's diary and all the documents relating to her, which I burned by the side of the mountain torrent; the crystal glass engraved with roses from which Elvire would sip her sugared water, I have to this day; and finally the score of *Orfeo ed Euridice* annotated by Agnès-Déodat, which I took from the drawer in the baroness's bedside table when I had to empty her room. Before Fulbert came to inspect all of his inheritance and lay claim to every object, I stole it, And that too I have kept.

<p style="text-align:center">★</p>

The last night I spent at the manor I scarcely slept at all. The memories accumulated over the eight years I had lived in that house jostled chaotically in my mind. I thought of the baroness, and even more of her daughter Agdé, though I had never met her. But there are meetings that occur in a different time zone, in a dimension parallel with the heart. Agdé was my friend, the closest and most secret friend I had ever been granted.

I heard the patter of rain on the roof, gurgling as it ran down the gutters. Pale moonlight filtered through the slats in the shutters. I got up and opened the window to push back the shutters. I stood there, despite the cold, contemplating the park shrouded in milky darkness. And for the second time I had a vision.

I saw a rugged landscape emerge from the mist. A kind of grey heath strewn with misshapen rocks of dark purple speckled with mauve or faded gold. These rocks came from a shower of meteorites. A woman came forward, her back bowed. She was a gleaner. A gleaner of celestial stones. She examined the ground, picked up certain stones, weighing and feeling them. She rejected a great many; those she selected, she put in a basket over her arm.

When her basket was full, the gleaner crouched down and emptied the contents at her feet. She made another selection, carefully, arranging the aerolites in several piles around her. She considered them for a while, then drew a small hammer from the pocket of her dress. She next took a stone from one of the piles, put it on the ground and struck it with her hammer. The blows reverberated against my temples.

The stone broke, spliting open like a nut. The gleaner removed the kernel from the mineral shell. It was a word. She raised it to her mouth, licked it a little to try the taste of it, then ate it. She proceeded in this manner at length, picking a stone now from one pile, now from another, and each time swallowing the word she extracted from it. I realized that each of these piles corresponded to a word category: verbs, nouns, adjectives and adverbs, conjunctions and articles, pronouns and phrases . . .

The gleaner gleaned, hammered and ate diligently. She concocted her sentences. When the heaps of stones were exhausted, she stood up. She was big, like a woman about to give birth. She took a few steps, stopped, and with the support of her hands at the base of her spine, her head thrown back, she shouted. The inaudible cry escaped from her in the shape

of a swarm of not only bees but also butterflies, dragonflies, cockchafers, flies and multiple beetles. A cloud of insect-words buzzed round in the air. Then groups formed, ranged themselves, the buzzing grew more subtle and rhythmic. It became a great whispering. Punctuation marks hovered for a while round the groups of insect-words, then fastened on them here and there, vibrating almost imperceptibly.

Sitting cross-legged beneath this cloud of murmuring movement, the woman shook out and smoothed down her dress. The motions of her hands sculpted a body in the dust and noise in the air. A still body, long and stiff like that of a recumbent figure on a tomb, soon took shape, lying across the thighs of the woman delivered of her child. I could not distinguish whether it was the body of a man or a woman. And was it a lullaby or a *Miserere* that floated above this strange couple?

With one hand, the woman unbuttoned the top of her dress, while holding in the hollow of the other the head of the person of indeterminate sex. She freed her left breast and squeezed the tip of it. Drops of milk spurted out, falling over the recumbent figure. When the lactation was over, the woman lent over the body, now all white, and caressed it, unless perhaps she was wiping it. Was this a suckling, an annointing or a funerary ablution?

My questions remained unanswered. The cloud of insect-words slowly descended and covered the two bodies amid a sound of crumpled paper and cloth. Then it dispersed and the two bodies reappeared. A cocoon of very pale silvery grey enveloped the woman and her strange progeny. But had she produced it, or was it not just a mirage created by the wind from the dust of the smashed stones, from the mizzle of masticated words, the still-live embers of an aching love? Again, my question remained in abeyance.

A twofold greyish statue lay on the heath. Nothing but the woman's breast emerged from the chrysalis, heavy and silky-smooth, and resonant. An opaline bell that sounded a thudding heartbeat.

The vision faded, but the sound of the bell continued for a moment. Sound travels more slowly than light; so it is during storms. Dawn was breaking. I could just make out, on the far side of the park, the wall of the Fontelauze d'Engrâce cemetery, with its frieze of bare rose-trees. I wished I could see those December bushes in bloom, blazed with white flowers. But visions obey laws as secret as they are imperative, over which our will has no bearing.

I closed the window. And then I realized that I was soaked. But underlying my anxieties and grief, I also felt a deep sense of peace welling inside me.

Thus did I take my leave of the manor.

V

The pastor Simon Erkal and his wife invited me to stay with them until I found a new job. The death of Philippe and of Elvire Fontelauze d'Engrâce seemed to have greatly affected the pastor. One day, without looking at me, without even appearing to be speaking to anyone in particular, coming out with it just like that, he said how much it tormented him that the baroness had not been reconciled with God before departing this world. And without reflecting on the impropriety of intruding on his soliloquy, I replied, 'She reconciled her two children just before joining them in the mystery of death. That's just as important. It may even come to the same in the end, making your peace with God or with those close to you.'

The pastor started, turned to me and, in a voice thick with emotion or – who knows? – amazement, asked, 'What do you mean?'

I could only reiterate, 'I'm telling you what I saw.'

'And what exactly did you see?'

But there, I drew the line. After all, did he tell me what Agnès-Déodat had confided to him as she lay dying? No. So I kept my secret. I retained the last piece of the jigsaw puzzle (or was it the one before last?) of the baroness's blighted life. It is right that people retain some element of mystery, otherwise we might believe we knew everything about them. As it was, the pastor did not insist. He was not the kind of man who wanted to catch souls in a net; he appreciated the unpredictability of the human soul all too well to play the hunter or detective.

Towards the end of winter I left my hosts. The pastor gave me a small bible in a yellow ochre sheep-skin binding to which his wife had added some bookmarkers: purple ribbons for the Old Testament, and pale yellow ribbons for the New.

I went to bid farewell to Adrienne up in the hills. I had been back to see her several times during my years at the manor: I loved her shepherd's cottage, her quiet strength forged in solitude. I had not forgotten the day she plucked me with a steady hand from the mountain stream where I stood bare-legged, treading down my fright and fury and washing off in panic the blood of madness. With a few words, a bowl of soup and a night's sleep she replanted my feet on the ground, on solid rock. She left me on my own in the morning brightness with the wild cherry trees in blossom; light airy blooms, as invigorating as hearty mocking laughter. And she introduced me to the manor, my heart set to rights again, ringing with floral laughter. This touch of quiet impudence instilled in my heart enabled me to survive in that house of mourning and regret.

The day I came to say to goodbye, the trees were still bare, the grass short, but the earth was covered all over with explosions of big roaring red flowers with a strong smell. They were fires lit to clear the undergrowth.

Then I headed for a town down in the valley. I moved to new surroundings, a hotel with the gentle of name of the Wood Pigeons, where I was taken on as a char. I assumed my duties the day a man flew into space for the very first time, orbiting the Earth in a craft called Vostok.

'Now then,' I said to myself as I tied on my apron, 'there's a fellow flying around three hundred kilometres up there, while down here I've landed in a pigeon's nest.' At the time, I really envied that Gagarin!

When all was said and done, my job was to deal with waste, and I became expert in all kinds of everyday dirtiness. This gave me a new perspective on my fellowmen, I had a low-angle view of them, from the floors and carpets that I had to clean every day, the bathroom tiling and lavatories that had to be scoured, the dustbins emptied, and the soiled crumpled sheets changed. This ground-level work caused me great consternation for a while; whereas at the beginning of my stay at the manor I was disturbed by the insidious undermining process effected by Moloch Time, during my first weeks at the

hotel I was bowled over by the enigma of the human body, this curious mechanism for producing waste, filth, all kinds of sordidness. And the stains and mustiness of love I also encountered, before experiencing its pleasures, though I had an intuition they were all part of the same thing.

The guests included some travelling salesmen, some holiday-makers and a few regulars. Some of the regulars behaved as if they were members of the family, and the owners and employees, who constituted this supposed family, entered good-heartedly into this rather foolish pretence. I had never had a family or clan mentality, not merely because I was a monad that had appeared from nowhere, a white cuckoo migrating from one nest to another, but out of personal preference.

These regulars were entitled to be addressed in a special way, as Monsieur, Madame or Mademoiselle followed by their first name. I remember Madame Solange, a widow of about fifty, driven from her home by a horror of being alone, and Monsieur Robert, a representative for a firm that made toys and novelties. Madame Solange had sold her house and taken board and lodging at the Wood Pigeons. This name delighted her, her late husband having shot wood pigeons galore throughout his hunting career. As for Monsieur Robert, he stayed once or twice a month, when he came to sell his frippery in the area. As he was always jovial and bantering, showing off his latest articles every time he appeared, and handing out some amusing novelty or other, he was the darling of the household. Among other tat, he gave me a pen of zero carat gold that scratched and sputtered out viscous ink the moment the nib touched paper, a set of fluorescent plastic vampire-teeth, a box of chilli sweets, and a shiny card-board Marilyn Monroe mask with half-closed eyes and a pouting mouth. Not having the nerve to throw away these props of a journeyman comedian, I stored them in my suitcase under my bed.

This indefatiguably cheerful chappie was basically just a

peddler of pranks, he lacked that mixture of spirit and candour that old Marrou had in abundance. His real passion lay elsewhere: this we learned from the press. One morning Madame Solange came bursting into the kitchen where I was preparing breakfast with my employer. She was brandishing her newspaper like a torch.

'Monsieur Robert! Monsieur Robert!' she yelped. 'He's got his photo in the newspaper, on the front page!'

Excited by this wonderful news, my employer asked: 'My, what on earth can our hero have been up to, to get himself on the front page?'

Madame Solange tossed her the local rag, and flopped onto a chair, out of breath. The hotel proprietress's smile froze, her face took on a greenish tinge, and she uttered a grunt of amazement as she read the article devoted to her cherished client. Then she in turn slumped on a chair.

Monsieur Robert had always traded in a small way in bad taste, but this was in a different league altogether. The police had finally arrested a serial killer who had been making the headlines for several months, and this killer was none other than our itinerant clown. He had been connected with three crimes, but was suspected of having committed others. Crimes with no apparent motive but the pleasure of strangling victims with delicate necks, two very young girls and an old woman. I was shocked by the news, but not for long. Although I was young, nevertheless I had already been substantially disillusioned, thanks to old Madame Marrou, the Falsetto, and Geoffrey Maisombreuse, among others. A good hardworking wife, a highly educated young baron of very refined musical sensitivity, and a handsome man somewhat spoiled by fate could harbour within them a bloodstained fury, a coward made even more depraved by his deceitfulness, and a distinguished torturer. In fact, I was not surprised by anything that anybody might do, myself included. The capacity for maniacal frenzy and harmfulness, the streak of cruelty latent in every human being seemed to me so enormous that I scarely batted an eyelid when any man or woman acted on them. And oddly, I always tended to identify more with the

criminal than the victims, or at least to fall into the throes of self-examination with regard to the amount of nastiness lurking within me, at a far remove from my consciousness. I was less fearful of encountering a murderer than of being suddenly overcome by a tidal wave of barbarism rising from some obscure corner of my being.

I told myself that Monsieur Robert had played around with masks too much, that by dint of wearing them he must have lost sight of anyone's face, he did not know who he was any more, what a human being was. Or perhaps he had grown weary of the guffaws he prompted with so little effort, and wanted to hear a different kind of laughter. An extreme laughter, fraught with terror and earnestness; that of death seizing the living. A laughter which this dissatisfied Punch simultaneously provoked and stifled by squeezing slender necks in his strong grip. Or maybe it was quite simply his way of leaving refuse in his wake. Like most murderers, Monsieur Robert was a large mammal at an early stage of development that marked out its territory with its excrement – excrement in the form of corpses. But I did not share my thoughts with my two companions. Madame Solange, sprawled on her chair, kept feeling her throat, looking distraught, while the hotel-keeper succumbed to a fit of hysteria. Yet considering the folds that cushioned her chin and the fat that larded her throat, Madame Solange had nothing to fear. On the other hand, I could very well imagine her plunging the knife with which she used to carve the Sunday joint into the jugular of her late mother-in-law whom she still so much enjoyed bad-mouthing.

That evening, in my room, I pulled out my suitcase from under my bed and opened it. At last I was able to get rid of Monsieur Robert's jokey presents without fear of offending him. For the first time I tried the fluorescent vampire teeth on my own gums and looked at myself in the mirror. I remained dubious, and removed them. Then I put on the langorous Marilyn mask, and that unnerved me. There was something at once voracious and pathetic, voluptuous and unhealthy about

this brightly painted doll-like cardboard face. Dolls have always given me this impression, perhaps because I have never owned one and so have never got used to them. All the same, I put the mask back in my case, unable to bring myself to throw it away.

A few days later another story hit the front page of all the newspapers, eclipsing the headlines about the strangler: the lovely Marilyn Monroe, overwhelmed with loneliness in her superficial love affairs, afflicted with desolation in her celebrated glory, had just put an end to her oppressive existence. I got the mask out of its hiding place and laid it on my pillow. I stroked its brow with my fingertips. And suddenly I felt an obscure pity for this girl about whom I knew almost nothing, except that she had lived the life of childlike femme-fatale in a universe light years away from mine. I wished I could help her, accompany her a little way into the unknown to which she had exiled herself. It was ridiculous, I was as ignorant as anyone else in the face of death and whatever journeys might lie ahead in the hereafter, and I no longer believed as I did in my childhood that you had only to die to go straight to God. All the same, ridiculous or not, I felt pity and concern. Through this shapely idol's sad demise, something much vaster rapped at my consciousness, like the darkness, with all its immensity concentrated in a twig or in the body of a butterfly, quietly tapping on a window in which a little light shines. It was the destiny of the newly deceased that tormented me: how do you take that first step in the next world, how do find your bearings in a boundless abyss, how do you proceed when you have been relieved of your body? Are you still subject to fear, to suffering? In truth it was my own destiny yet to come that worried me. But even then I thought, albeit vaguely, that the only compass you have to orientate yourself in the limitless expanse of death is the one you have created for yourself during your lifetime, day after day, hour after hour, without even being aware of it. An immaterial compass composed of your myriad thoughts, words, emotions, desires. Of what you have done. And failed to do.

'She had everything, absolutely everything, and she goes and kills herself! What a waste!' sighed Madame Solange in anguished tones on learning of Marilyn Monroe's suicide.

'What do you mean by everything?' I asked, bringing her a small carafe of house red.

'Well, youth, beauty, success, wealth, any amount of lovers, and no small fry either! Simply everything!'

I remained sceptical of this definition of the heart's desire: there was a worm in the too sweet flesh of this big fat apple, picked in a chimerical paradise, and the little Hollywood Eve, like so many others, was overwhelmed with nausea by chewing on this maggoty apple. And she spewed up her life.

My own life was so dull I was in no danger of getting tipsy or consequently hung over. I was doomed to sobriety. But you can turn frugality to advantage, and even make a opportunity of misfortune, as long as you accept your fate. Since my vision of the dancing wild-cherry trees, I had ceased to pine for my parents, and my anger towards my mother had dissolved in a whirl of white flowers. My roots, I had invented for myself, inspired by trees. The ones that grow in a shallow bed of rocky earth perched over a ravine; their roots partly dangle in space, the rootlets flutter freely. It suited me, this flexile anchorage where earth, rock and air meet. In this untrammelled state, it was, somewhat free-floating, that I came to the manor. I had shared my life with the last members of an old dynasty without any regret for not belonging to it. The shrub planted on the edge of a cliff does not envy the oak rooted in deep soil. Though lacking in majesty, the suspended shrub enjoys space on all sides, its aerial roots play, just as its branches do, with the wind and rain, with the birds, insects and clouds, and with the stars. These keep it company on its arid ledge.

★

One day I was seized with nostalgia, I had a desire to return to the hills, to see Adrienne again. I took a week's holiday. I arrived on a fine October's day. In this part of the world, the colours are mellow in autumn, as though infused

with mist. Ochre, deep purple, pale yellow and chalky mauve predominate on the mountainsides at this time.

The forests acquired a subdued powdery brilliance in the pure light that lacquered the sky. The flocks had just descended from the highland pastures where they had spent the summer, and an incessant sound prevailed over the hills – sheep bells and bleatings, occasionally punctuated by the bark of a dog or a shepherd's cry.

The house had grown dilapidated. The panes in one window were broken, the roof needed repairing. I approached the threshold and called out to Adrienne. No one answered. I looked towards the grove; the leaves of the wild cherry trees accentuated the surrounding lustrelessness with their large patches of bright red. I called out again, several times, with still no reply. I walked round the empty house. I saw a man lying in the grass. He was taking a nap in the midday sun, bare-chested under his jacket despite the coolness of the air. With his arms folded under his neck, his legs slightly spread, he dozed with enjoyment. There was something voluptuous about his body's abandon. A sheet of glass stood in front of him, fitted in a wooden frame.

I found him handsome, this stranger lying on the ground behind a windowpane, half-naked under his work clothes, offered up to the sun shining directly above him. I crouched down beside the windowpane and tapped on it with one fingernail. 'Is anyone there?' I asked. He turned his head, no more than a fraction, and rested a nonchalant gaze on me. I remained seated on my heels, observing him. He was not all that handsome, but to me he was desirable, this man taking pleasure in the open space, the light, his solitude, and the silence so quietly intruded on by the sound of sheep; taking sensual pleasure in the moment. With one hand I stroked the glass, tracing the outline of his body. 'Is anyone there?' I repeated in a low voice.

He gazed at me placidly, without a word or a smile, but his eyes gleamed brighter and brighter. He removed his right hand from behind his head, brought his arm towards his torso, then slowly ran his hand over his skin, rested it on his

trousers and opened his flies. He suspended his gesture for a moment as though to test my reaction. I could have pulled myself together, stood up and run away. I wanted to watch, I stayed put. His penis stiffened, skewed a little sideways, casting a slender shadow on his belly, like the style of a sundial. I smiled, amused. This sudden discovery of the male anatomy, which had until then remained unknown to me, far from being shocking or disturbing, entertained me.

I walked round the windowpane and approached the man. I stroked the ray of shadow that fell across his belly; the shadow quivered. Finally I tentatively reached towards that funny stump that stood up in the air, feeling it with my finger-tips, then I enclosed it in my hand. The skin was soft, very warm. I held his testicles in my palm, as you might weigh fruit. Two very ripe little quinces, with a sharp sweetish smell. The man let me inspect his body, toy with his genitals, all the while in silence. But his eyes were burning.

Everything was burning – the grass, the fabrics on my skin and my flesh under my skin, the sun in the sky and another radiant sun in my abdomen. A sudden fever rose from the earth, ran in the wind, in my blood, my heart was racing and my thoughts were in a whirl. To tell the truth, I was no longer thinking, I was in the grip of a paradoxical state in which fascination was mingled with lucidity, seriousness with jubilation, self-forgetfulness with the strongest sensual self-awareness I had ever experienced. Time had stopped, concentrated in a playful and solemn moment that expanded and vibrated in its frozen stillness.

Suddenly the man raised his torso, tearing off his jacket, he lent towards me and seized me by the shoulders. I toppled backwards, onto the ground. He rummaged under my skirt, bundled it up and in a flash removed my knickers. He fell on me, panting. Two sensations, both equally new and violent, travelled through me like a earthquake – the crushing weight of the man on top of me and a lightning rent in the middle of my body. I did not cry out, they took my breath away. The discomfort and pain were strangely accompanied by an

increasing excitement and were soon displaced by a radiant rush immediately followed by an obscure exhilaration of my entire body. The small sun that started to shine inside me when I began to play had now exploded. And that is when I cried out. The man gave a long harsh groan, then collapsed, his sweaty brow nestling against my neck After a while he got to his feet and, pulling up his trousers, said reproachfully I should have told him I was a virgin. The idea had never crossed my mind; besides, we had not even introduced ourselves.

His name was Martin, he lived in a village lower down, where he had a wife and children. He was Adrienne's godson. He told me, with no particular emotion, that she had died the year before. She was buried in the village cemetery. She had left her house and the few animals she owned to Martin.

'What about the ginger cat?' I asked.

He did not know what had happened to the cat and did not care. He was fixing up the cottage, in order to let it. He did not intend to sell it. From the way he said this, I sensed that his affection for Adrienne ran deeper than he had cared to reveal.

I went to wash in a stream. Was it the same mountain stream where Adrienne had found me twelve years earlier? Once again, blood stained my thighs, but I was not in the grip of any fear and the fieriness I felt in my lower abdomen did not cause me any pain. I looked around; no apparition in sight, neither of the Virgin, nor the late Adrienne, nor the ginger cat. I nevertheless addressed a prayer to the Virgin, that she might warmly welcome Adrienne, who had passed on to the hereafter without drums or trumpets. As for the early loss of my virginity, I saw no harm in it, rather a postumous gift from Adrienne for which I was grateful, as for the soup, bread, rest and trust she had offered me in the past. Thanks to her amateur glazier godson, I had just tasted the extraordinary pleasures of the body, had touched, from within, the shifting and reddening darkness of the flesh. I walked for a while in the ice-cold water, wobbling slightly on the pebbles, still dazed by that blaze of desire stirred by a windowpane standing between

heaven and earth, in bright sunlight, like a crystal gong striking midday, loud and clear. And the hour chimed explosively in my body that had suddenly turned incandescent.

As I came out of the stream, I stumbled on a pebble-stone. A white diamond-shaped stone. I picked it up and stuffed it in my pocket.

Martin invited me to stay in his windblown house for the duration of my holiday. I had all the time in the world to contemplate the wild cherry trees, to listen to the water burbling in the mountain stream and the rustling leaves of all the trees around, to the soaring cries of eagles, griffon vultures, falcons and black kites gliding midway between clouds and peaks. Martin came back several times, supposedly to continue his repair works. We took the opportunity mostly to complete my education in love, although this was not really the right word. Neither he nor I ever spoke of love, knowing that love was not involved. It was more of a very physical friendship, an uninhibited closeness. I left early one morning, without saying goodbye. After all, we had stripped naked and embraced before saying hello, when we first met. So ended my first relationship. Desire left me the way it had come, with no warning of its arrival and no explanation on its departure. A sudden squall. With desire, it's the same as with visions, there's no warning of its coming and going. I blackened the new windowpane with soot and wrote a few words on this glass slate by way of farewell.

<center>★</center>

I returned to work at the Wood Pigeons Hotel. But the gloominess of the place oppressed me more and more and boredom prompted me to look for another job. I found one in another town, a few kilometres away, but this slight relocation satisfied my need for change. I gathered together all my possessions: the Latin grammar and the anthology of poems given to me by Amédée Roquelouvan; Elvire Fontelauze d'Engrâce's engraved glass, carefully wrapped in an old faded black cotton scarf, dotted with little violets, that I had come across in Adrienne's house; the score of Gluck's opera; Pastor

Erkal's bible; the Marilyn Monroe mask whose surface was beginning to crack; the pebble I had found in the stream; my clothes. I buckled my suitcase and said my goodbyes to everyone, with joy in my heart.

There was a touch of the ludicrous about the name of the hotel where I ended up, a pretension to stylishness: the Mimosa Hostelry. The building was modern, but the archaism of the word 'hostelry' conferred on it an illusory antiqueness. The furnishing of the bedrooms was rather kitsch, with gold-veined rose-pink wallpaper, heart-shaped cushions, reproductions of Impressionist paintings hanging on the walls, bedside lamps with pastel-coloured shades trimmed with salmon-pink bobbles. The sight of these chocolate-box decors maddened me, and I got through the cleaning with surgical precision and the speed of a juggler, which earned me a reputation as a chambermaid without equal. Renown, even at the level of carpet cleaning, is often based on misapprehension. Every evening I felt a sense of relief on returning to my bare-walled garret, up on the top floor, with its narrow bed covered with a cream counterpane. Only the word 'mimosa' was justified. There were three of these trees in the forecourt, like elegant doormen welcoming clients, and a fourth in the backyard that my window faced on to. I looked down on its lacy foliage. It was this tree that kept me going as I waited for it to blossom, which it did, in the middle of winter.

But another germination was taking place, in my womb. And this one I was not expecting at all. I noticed that my period, invariably on time, was late, as if I might have washed too energetically in the stream the month before, or my blood have frozen. At first I tried to put my mind at rest, to delude myself, but come December I had to recognize the fact: I was pregnant. Having no one to confide in, I held a conference with myself. I set up a tribunal behind closed doors, playing every role myself. It was short and decisive. I first called on the prosecution: the charges were heavy. Martin would refuse to be implicated in this unwanted paternity; storm-trooper

chambermaid or not, I would be quietly sacked and it would be a long time before I was able to find another job; apart from bastardy, I was also likely to pass on my physical defect. Finally, I felt no welling up inside me of any maternal impulse. The problematic child, doomed to a lean future, was developing alone in its nebula, far from my heart. The best thing would be to seek the services of an angel-maker as quickly as possible.

Against all these fairly damning charges, the defence had little to counter. Except that by nipping the unwanted child in the bud, I would be guilty of even more hard-heartedness than my mother had shown towards me. And besides, I was loathe to tangle illicitly with death inside my own body. Sexual pleasure had revealed to me some of this body's obscure depths, allowed me to make fleeting contact with an elusive mystery immanent in the substance of the flesh, and this mystery endlessly amazed me: I did not want to break the already very tenuous link I had with it. The price to pay, if I kept the child, promised to be very high, bitter, but I suspected that the bitterness and heartache would certainly be much higher if I did not pay that price. And finally, while lacking the maternal instinct, I felt a confused excitement at the idea of having to perform actions, when the child was born, of which I had been deprived at birth, and which had left me – how I can put it? – with a cracked heart. A retrospective consolation, perhaps.

And that is how I opted in favour of the child's life, however disastrous the intruder's arrival was likely to be. It is not up to us to create angels fraudulently, they develop naturally, if angels indeed exist, in which case it is they that fashion us. I strapped a broad band of cloth round my stomach, under my dress, to hide the interloper from the critical eyes of others.

But the child decided otherwise. After inviting itself by surprise, it changed its mind, and of its own accord opted for limbo. One evening towards the end of the month of January, in a rush of blood it was gone. I could not have been sufficiently convincing, sufficiently welcoming. And in the fever

and pain that then overcame me, I asked forgiveness of this unformed child, as it departed from me, still so minute that I never knew whether it was a girl or a boy. In fact, I made no attempt to discover this.

I did not wash or throw away the sheets in which it was still-born. I carefully folded them round the tiny, almost translucid body, wrapped in a clean cloth, and I slipped in the white pebble from the mountain stream. In memory of the origins of its conception.

Before inserting the pebble between the folds of the swaddling-shroud, I held it in my hands for a long time. And as I caressed this fragment of rock, as old as the mountains, the words that St John in his Revelations addressed to the Angel of the church in Pergamos glistened in my memory: 'To him that overcometh will I give to eat of the hidden manna, and will give him a white stone, and in the stone a new name written, which no man knoweth saving he that receiveth it.' I polished and warmed this stone in my palms, but I left it blank: it did not fall to me to write on it any word. I committed it just as it was to the child clothed only in its mother's blood, to present to the naming Angel in its own right. Then I put the bundle of cloth in a bag and, as soon I had recovered, went out into the countryside and buried it on the edge of a wood.

I lingered for a while before the mound of earth – no more rounded than my belly had been – rising from the ground at the foot of a birch tree, which served as a headstone. Even more than sad, I felt undecided: that I should remain ignorant of the name reserved for my embryonic child beyond the grave was one thing, but that this fragile meteor should remain nameless for me, in this life, was quite another. I wanted to be able to think of the child by name, whenever it might come to mind. For I suspected that it would occasionally visit my thoughts, without notice, just as it had entered my body, and then evacuated it. So I chose a name for it, for me, just for me and the child. I called it Pergamon, after the ancient town of Asia Minor apostrophized by St John. Thus, without violating or betraying it, I remained closest to the secret with which my ephemeral child was nimbused. And

besides, Pergamon is a pretty name, just as suitable for a boy or a girl. And then, with peace of mind restored, I headed back to town in the freezing drizzle.

<center>★</center>

My drama had passed completely unnoticed, no one at the hotel had the least inkling of it. Some minor illness, accompanied by a high fever, had kept me in bed for a few days, that was all. As for the doctor I later went to consult, he struck me a blow that was much less innocuous than my supposed illness; he told me that I would never bear a child, the one I had been unable to carry to term had sealed my barrenness. The effect this news had on me was like a slow-working venomous snake-bite, at the time I experienced only a brief shock, but afterwards it caused me persistent pain, for a long time.

It would seem that trees have more delicacy than people. The day after I buried my volatized child, I smelt a delicious perfume, as discreet as that of the powder with which the baroness used to cover her face and neck as though with an ivory mist. The mimosa in the backyard had come into blossom, defying the still keen cold of February. Night was fading, but a blue-black darkness lingered within the confined space of the courtyard. I leaned out over this shadow pit and discerned the tree, all fleecy, quivering at my window ledge. Reaching out my arms, I skimmed its crest. I had the impression of caressing a big cloud steeped in sunshine that had accidentally fallen down a well and floated lazily in its inky waters.

In the daylight the mimosa looked dazzling: it bore a multitude of voluminous clusters of little furry pompons of brilliant yellow that made the air powdery with tactile light, with softness and gladness. As long as the blossom lasted, I felt happy, carefree. Every evening, coming back to my room was a joy, for it was when I re-encountered the mimosa that perfumed the yard. I slept with the window open, despite the still-persistent coldness of the night. Tucked under a eiderdown, with a nightcap on my head, I would inhale the air without a thought in my head, like an animal whose attention

<center>103</center>

is entirely claimed by a scent, and I would fall asleep in this delightful fragrant void.

But in the spring it rained a great deal, the clusters of mimosa lost their freshness, and before long their fragrance. The delicate pompons shrivelled, and crumbled. Finally the mimosa faded away, bereft of its sunlike beauty, its fragrance reduced to silence. For, indeed, its fragrance spoke to me, I detected in it a whispering, a humming silence on the verge of laughter, so full of melody. Other trees blossomed, and the birds magnificently picked up where the vegetal chorus left off. But I missed the hum of silence that emanated from the mimosa like a breath of magic. And something in me too crumbled.

The maternal instinct, which had scarcely affected me during the three and a half months an embryo had chosen to dwell inside me, suddenly perturbed me. And this perturbation only increased, reaching a peak at the height of summer. A sultry summer that made my garret airless. One night in July, I woke with a start, my face bathed in sweat, the blood throbbing violently at my temples. I cried out. But this cry astounded me – it was not mine, even though it was emitted by me. I regained control over myself, and listened. I thought I could hear that strange cry ricocheting in the dark, like a pebble made to skim across the surface of water. Then I remembered the white pebble placed among the bloodstained sheets, buried in the earth on the edge of a wood, and I realized the child should have been born that night.

No pain in my abdomen or back – the child had well and truly forsaken my womb – but a splitting headache. I got up, reeling, and leaned out of the window. The foliage of the mimosa swished about almost imperceptibly in the darkness, the air was soft, clammy in its warmth. In an undertone, I called out, 'Pergamon!' My call in turn ricocheted in the dark in little sonorous bounds. In response came the distant hooting of an owl, then barking. And close by I noticed a slight rustling, as of crumpled satin; bats zigzagged swiftly among the branches. The night birds were busy with their own concerns.

At the time of that birth which did not occur here on earth, was Pergamon receiving the secret name in the invisible world beyond? But that 'beyond' had struck at my temples, the child-meteor had travelled back through the convulsed space of my body to cast aslant my memory a long shrill ray, and I had felt the pulse of the invisible upon my brow. That night more than ever, the mystery of all life on earth overwhelmed me, banished me to uncertainty. And I wondered then if it was not I rather who had just been reborn, summoned out of myself, invited to the boundaries of the world, of time, for an everlasting exploration of the unknown.

By morning my fever had dropped; the unborn-newborn's cry never again rang in my temples. But Pergamon took up residence on the fringes of my mind and has never left. Every day, he releases his cry in silence far ahead of me, and without even being aware of it I grope my way in that albeit unlocatable direction. I do not know where I am going, but I am going there, secretly spurred by wonderment.

★

When autumn came, I was entitled to take a holiday. This time I turned my back on the mountains, to protect myself from their exceedingly strong attraction. Austere and grandiose, their enormous body had always borne mine, and fashioned me from within. They were my family, my beginnings, my base. And the rocks, streams, caves, forests, birds of prey and wood pigeons, crows and sparrows were my fellows, though I lived lower down, wandering the hills and valleys. But the mountains surrounded me, always standing on the edge of my vision like an ample gesture of the earth reaching skywards, and raising everything with them in their powerful upthrust, in their yearning for the heights – so intense and so patient – in their love of the open. The cosmic open, in which clouds, light and wind were resplendently transparent and vibrated with silence, where storms wrote in a fulminating script vast and fiery impromptu poems that intimated to us how the world began, and how it would end. And in which darkness opened up purple inlets that grew into

yawning abysses, inviting us to slip our moorings, of both heart and mind, like stars travelling in a different temporal dimension.

But I was tired, breathless as if all of a sudden I had been hoisted a little too high above myself, with no secure footing and no recognizable landmarks; or else plunged into some inner trench. Above and below kept switching round, inside and outside blending into each other; I had difficulty orientating myself.

I headed for the ocean, that great unknown. I took board and lodging in a little hotel, almost deserted during this season. For two weeks, in a reversal of roles, I played the guest. But I reduced this role to a walk-on part; I rose early, went out and did not return until evening. I spent my days looking out to sea, whatever the weather. This viscous, ever-booming expanse, sometimes of a leaden dull grey, sometimes a shimmering lime or slate, at first inspired me with dread. I sensed the menace contained in the dark mass of water, unflagging in its onslaught on the land, crashing on it in breakers that foamed with anger at its inability to conqueror, to swallow up and reduce the land in its icy entrails. Whereas in the mountains I took the measure of my own smallness, but with a sense of serenity, at the ocean's edge I took the measure of my vanity, of how little substance I was, with a vague anguish. I was just a particle of flesh that had strayed onto the sand, and of no more account than the algae, bits of wood, fragments of shells and other debris cast up by the sea. I was repelled by it in advance, consigned to its shores. I could not swim, but even if I could, I would not have been able to get any closer to it than I did then, so high and rough were its waves. Huge smacks that struck the air and shore with violence, followed by a perilous backwash.

Nevertheless I came back every morning, forcing myself to watch the sea, to endure its angry roar and spitting foam. I wanted to quell the fear it instilled in me, to learn to listen to it, to see it differently, the untouchable, challenging sea.

The problem with behaving too discreetly, as I did at the Dunes Hotel where I dined in the evenings, is that you arouse other people's curiosity. And then of course, a young woman on her own, as white as a cuttlebone, must be even more intriguing. The owner and the maid pestered me with seemingly casual questions. Perhaps they guessed I was in the trade; since reaching the age of reason I had worked constantly in service and after twenty years the job must have clung to my skin. But I remained evasive.

One afternoon I saw Mado, the maid, strolling along the beach. She came towards me and greeted me, feigning surprise. I suspected her of having watched and followed me, but I said nothing. It was her day off, she explained, sitting down beside me. She was a little younger than I, plump and red-headed, lovely-looking. She had a slight lisp, and with a pang in my heart I thought of Loulou.

She was a nice girl, Mado, at once naive and cunning, with an eager desire for life, but also a little scared of it. She told me how she came to be there, a commonplace story, pathetic and moving. We became friends. And this new-found friendship influenced my fate. Mado told me that the Dunes Hotel was soon closing, and she had already been investigating the possibilities elsewhere. She had found a place in another, much more sophisticated establishment, the Revellers' Inn, located in the area. She suggested I applied there, they were taking on staff. And, half seriously, half in jest, she added that the two of us would make a hell of a couple, the chubby redhead and the pure-white beanpole. The name Revellers appealed to me, and I responded, 'Why not?'

I applied to the Inn, and was taken on. As soon as I returned to the Mimosa Hostelry I announced my imminent departure. Before leaving the valley, I returned to the edge of the wood where I had buried Pergamon. I planted a white rose bush at the foot of the birch tree that guarded the child's tiny grave. Pergamon, my phantom child, my first and last born, conceived in unthinking joy, suddenly lost, and delivered in some part of the world one's summer's night, at a distance,

unseen. Pergamon, my mimosa-coloured secret, hard and smooth as a pebble-stone.

As always happened when I was getting ready to leave a place where I had lived, I slept badly the last night. I heartily welcomed the change, but all the same, when it was time to go, these small migrations threw me into a panic. The sleep that eluded me during the night overcame me on the train taking me to the coast. I made two journeys in one, going in opposite directions, the dream I had transporting me backwards.

I was in my room at the Mimosa. The walls were palpitating, at first gently, then this movement became magnified. They might have been the flanks of pale-coated giant bulls, swelling and quivering with anger and exhaustion. A draught blew across the floor, icy and dry and howling. I stood on a carpet of wind in the middle of the room.

The furniture noiselessly shifted. The bed, chair, bedside table drifted away, the walls having suddenly dissolved. The small space of what had been my bedroom opened up into an expanse of blurred confines, reminiscent of undergrowth on a misty evening. The cupboard revolved in slow motion, and as it did so became crackled and covered with moss and lichen.

The cupboard turned into a hide – the kind of shelter that hunters of wood pigeon construct on top of pylons, or in the tops of oaks or beeches, supported on a solid base of forked branches, to serve as an observer post from which to shoot.

The ceiling too had disappeared, for the cupboard-hide was perched at a height of some thirty metres. It was draped with ivy and russet creepers. The door was open, and banging in the void. There was a ladder leading up to it, but the wood looked rotten and a great many rungs were missing.

Yet I saw myself climbing with ease up this ramshackle ladder. As I was immersed in a paradoxical state of lucidity and hallucination, each as intense as the other, I who was dreaming, and aware of the danger, cried out to my double to come down as quickly as possible, but the dream persona was more intrepid than her dreamer and I continued my ascent.

When I got to the top of the ladder, I entered the hut. Its

see-through floor – so far apart were the planks laid – was strewn with dead leaves, cartridge cases, feathers and hairs. Still a dual entity, I wondered if the young woman kneeling on the rickety floor of the hide, busy searching through this rubbish, was actually myself or Agnès-Déodat. 'What does it matter?' I heard myself say.

The leaves crackled between my fingers, fell in yellow, brown, reddish dust. As for the cartridge cases, they were of neither cardboard nor brass, but ice. Ice that did not melt, even when held in the hollow of your hand. What storm had brought these fossil hailstones whose coldness and dampness remained intact? I raised one to my lips and licked it, ever so slightly. It had a salty taste. They were frozen tears. Were they the tears shed by all the departed, whose mingled hairs covered the ground, or those of the birds shot down, whose feathers were also lying around. But birds do not weep, I thought immediately, they suffer and die without any outward sign of distress, unlike humans who have the gift of tears – which, it must be said, leave murderers totally unmoved.

When I tried to climb down, I discovered the ladder was no longer there. It was lying on the ground below, broken into several pieces. The vertigo that overcame me was so extreme, I threw myself into the void. And I woke with a start, my forehead pressed against the window of the train, with a lump in my throat.

And so I left my mountain motherland. For a short while, I believed at the time. But fate had some surprises in store for me, and my separation from the mountains was to last much longer than anticipated.

Fate? No, rather an arid wind that rose from the desert wastes of my heart and blew surreptiously deep inside me, driving me without respite from one place to another. I had an obscure feeling there was nowhere that I belonged, nowhere that anyone cared about me. Loved me. Or ever would. I was just a white-powdered passer-by, hugging the walls, skirting the days, so insignificant in people's eyes that sometimes I had the impression I did not even cast a shadow.

VI

The term 'Revellers' was a polite understatement. The place should have been called the Rakes' Inn, or more accurately the Fornicators' Retreat. It was a country brothel, cradled by the maritime breeze. Very elegant it was too, this bawdy-house disguised as a country manor in the midst of magnificent rhododendron bushes, camelias and acacias. The owners were two sisters. Brune and Dora Bellezéheux. Pseudonyms to match the spirit of the place. We were also given new names: Mado was dubbed Maya, and I, Lola. They had a better ring, apparently, and preserved our anonymity. For when it came to clandestine operations they knew what they were about, these fifty-year-old siblings, they were pastmasters in the art of assumed names. They supervised every tiny detail of the little erotic field of action they had expertly prepared.

Did Mado-Maya know what she had got us pair of ninnies into? In any case, we played the game, with the discretion and style required of us. Each in a long-sleeved black dress with a high-necked collar, trimmed with an impeccably white lace apron, we padded around the corridors, the staircases, the bar and dining room, keeping the place clean and tidy, and attending to the comfort of the guests. For the most part, the latter rose late in the morning, their nights being very lively.

We were only gradually initiated into the ritual of the night-time ceremonies, while Brune and Dora reassured themselves that their new recruits would not go running off to denounce a scandal. So for the first few weeks we were only on duty during the day, when nothing spectacular happened. But with all the little telltale signs, the innuendos, and the covert whiff of lust that hung in the air some evenings, we were not fooled. Well, not entirely.

So, it was with a great deal of prudence and tactfulness that the Bellezéheux sisters finally invited us to find out what went

on behind the scenes at this theatre of theirs where, mostly at the weekends and always with admission by invitation only, an extremely dissolute play was performed. Our role was confined to waiting on the actors taking part in the impromptu performance – amateur actors, in every sense of the word, but bursting with energy. The rules were strict: we were not at any time to exceed our duties as servants, and similarly the actor-clients were forbidden to include us in their game. In the chilly distinctiveness of our housemaid primness, we would have nothing to fear. These guarantees proved reliable, I was never importuned during the evening events I attended in my capacity as a servant.

The discarding of clothes generally began in a leisurely fashion round about the middle of dinner. The rhythm varied according to the mood of the guests. While chattering with those seated next to them and picking at their food, the women would nonchalantly unfasten their blouses, bras, stockings, assisted by nimble-fingered gallants. Some women wore undergarments embroidered like pieces of wrought gold, others wore nothing. Little by little, garments fell to the ground, creating the impression of a forest of bodies gaily shedding their leaves in an untimely autumn breeze. As the wind of desire gathered, conversations continued, punctuated with laughter and the clinking of glasses and plates. Gradually they broke up into incoherent fragments interspersed with sighs. A slow surge would then begin, as the naked guests migrated to the adjacent salon furnished with large sofas, pedestal tables on which to rest their glasses, and plants that imparted a hothouse atmosphere. This salon was called Evohoe, the Bacchants' cry in honour of Dionysus.

The walls and ceilings were covered with mirrors, which rendered the space unsettled and unstable. Slowly, couples, trios or small groups formed, made their way towards the sofas, and occupied them. For slowness and a certain languidness were an exquisite salt with which these people, to start with at least, liked to season their bodies offered to each other

as delicacies. Furtively, they stroked, nibbled, kissed or sniffed each other. But once outstretched, or simply seated, crouched, or kneeling, they swapped the salt of languorous deferral for more fiery spices, and their bodies grew excited, uniting in all kinds of positions, at times forming strange shapes when they came together in a heap. There were some acrobatic poses, others grotesque, some not devoid of imaginativeness, even gracefulness, in their obscenity.

These bodies were no more than machines, their mechanisms racing, puffing, grunting, clucking, panting in a monotonous cacophony. They licked and fondled and penetrated each other avidly, all their orifices becoming insatiable mouths; mouths dilated with hunger, with refusal of emptiness. The most famished appeased their want by combining fellatio or cunnilingus with sodomy and coition. This required the litheness of a contortionist and a great expertise in sexual gratification.

The mirrors that covered the walls and ceiling made these conjoined bodies proliferate; the room seethed with hybrid creatures in constant metamorphosis among the green plants, suggestive of an aquarium full of molluscs without shells, more wriggly than gudgeons. Or a vivarium rather. And as the hours passed a disgusting smell grew more oppressive – a mixture of perfumes, sweat, semen, stale tobacco, lukewarm wine and champagne.

A slight bewilderment would overcome me, so great was the claim on your gaze from every side, and so deceptive. I sometimes confused bodies with their countless reflections, and would approach a mirror with a tray, about to set it down on some phantom table. And basically that is just what all this was: this oasis of boundless sexual pleasure was but a mirage. Embrace, sniff, taste, lay hold of each other as all these human reptiles might, though they wallowed in flesh and licked the fluids it secreted, though they explored each other's inner-most parts with febrile shamelessness, there was no meeting between them. Did they even see each other? I doubt it. They were blinded by their mania, consumed with an obsessive

delirium that dulled their eyes and their thinking, transfixed them.

No matter how active or audacious they were, these intrepid sexual adventurers remained paralysed on the threshold of the mystery they were desperate to penetrate. For these apparently frivolous libertines revelling in total freedom were in quest of a mystery: the mystery of the flesh. As I had been, that already distant October day when the body of a sleeping man had stirred my senses and thrown my mind into disarray. But I had not then observed myself in a mirror, been caught in the toils of my own reflection, nor had I exposed myself to the eyes of indiscreet observers. The window beside us was transparent, resplendent only with the sun, and the sky above us was open to infinity. We were not enclosed like conspirators in a reflecting prison, like reptiles in a barrel.

As I wound my way among these Stakhanovites of copulation, I wondered whether it was enough to multiply your experiences and take pleasure in repeatedly dying in a small way, to succeed in withdrawing from yourself, launching yourself into the darkness of the flesh. Perhaps it was because they were for ever kept on the brink of this darkness that they persisted, in the vague hope that next time they would not emerge from their voluptuous disporting unsatisfied, that this sensual pleasure would not take on a rancid and bitter after-taste as soon as it had been consummated. That they would finally wrest from the flesh its secret. Their own secret, that of their presence as living creatures exhausted by desire, mortals haunted by their future demise. In a word, the secret of their origin.

★

This notion preoccupied me for a long time. These libertines who strove to break every taboo were, in my eyes, engaged in a much more serious and pathetic enterprise than appeared. They reminded me of those salmon that undertake exhausting migrations, swimming against the current, to return to the upriver breeding grounds where they were born, in order to

reproduce in their turn, or die in the attempt. These people too were migrating towards their source, but zigzagging across various currents, without any compass or internal clock; that is why they were not getting anywhere, and, failing to attain their goal, were frenetically going round in circles, in murky waters.

I dared not discuss this with anyone. Mado would have laughed at me if I had shared my theories with her. As far as she was concerned, all these wealthy clients who came at regular intervals to rut with unbridled freedom, in mirrored splendour, were nothing but rich filth whose only interest lay in the tips they lavishly distributed after their orgies. She was not entirely wrong, and besides I too pocketed the tips without compunction. But this incidental manna that derived from the debauchery in no way assuaged my need to understand what was going on, what the lechery signified.

Allowing my thoughts to roam in this manner round the haunting mystery of these bodies eventually led to some strange connections in my mind. All this transgressive manipulation and exploration of bodies, the most extreme ways in which they were exploited, made me wonder about a number of issues: these ranged from ordinary tattooing, scarification and piercing, to torture, mutilation, dismemberment, the taking of scalps and snatching of skulls regarded as trophies, and, the ultimate extreme, cannibalism. From the outer skin to the entrails and bones, from the bark to the pith.

My wondering was extensive in scope, prompted as much by the violence and outrages inflicted on the living as by those committed on cadavers. So it was that I was reminded of the posthumous tribulations of young Bernadette Soubirous. She died of asphyxiation from asthma and tuberculosis, less than a century ago. For three days her body lay in state so that her sisters and the public could pay their respects. Then her body was enclosed in a double coffin, one of lead, the other of oak, which was sealed and placed in the crypt of a chapel within the convent walls. But this poor body that had caused Berna-dette so much suffering during her lifetime, and from which

death had delivered her, continued to intrigue those who had come to believe in her saintliness. Thirty years later, the double coffin was therefore exhumed, the wooden one unscrewed, the leaden one unsealed, and the frail cadaver was removed for examination.

Bernadette was intact, and odourless. No heavenly scent of roses, admittedly, but no stink of putrefaction. The young woman, dressed in the habit of her order, was still in the position in which she had been laid to rest: her head and upper body had just slightly tilted to the left. She still held in her hands, crossed over her chest, the rosary whose beads she must have frequently counted off during the long hours of her illness, and a crucifix. Her hands and nails were perfectly preserved, while the rosary was rusted and the crucifix coated with verdigris.

Transferred to a table covered with a white cloth, Bernadette was stripped of her damp robe and veil. Her skin had the stiffness and texture of parchment, her belly the sound of a cardboard drum. To examination by auscultation her body responded with a dull resonance, her abdomen rang hollow. Such was the dialogue, in the presence of an ecclesastical Areopagite, between the doctors and the deceased summoned from her tomb: the living tapped on the mummy's skin, perhaps hoping to prompt some prodigious ventriloquy, but all they heard, by way of reply, was the drumming of their fingers echoing in the darkness of her entrails.

The body was cleaned and replaced in a new zinc-lined coffin that was made fast and sealed with seven seals, before being returned to its crypt. This time the saint's repose lasted barely ten years. Once again she was removed from her tomb, the seven seals were broken, and the mystery of her odourless body that continued to survive the humidity and the attrition of time was re-examined. The corpse revealed nothing more than on first inspection, other than a little mildewing and a fine dusting of calcium salts, caused by the previous exhumation.

The replay of the unspoken dialogue conducted by means of percussion no doubt left the investigators feeling frustrated, for six years on the tomb was reopened. But in the course of

this third exhumation, not content with studying the body with a view to a final legal and canonical identification, they rummaged round inside it and did a bit of foraging in the process. Fragments of muscles, ribs, diaphragm and liver – the latter was singularly well preserved – were removed to serve as relics; her two kneecaps were also taken. Her heart was narrowly spared.

Having been devoutly pillaged, the corpse was wrapped in binding cloth, with the exception of the face and hands that were then covered with masks of wax skilfully created from castes and photographs. Thus masked and painted, prettily restored, redressed in new clothes, Bernadette was laid in a casket and transferred to the chapel of her convent, where the faithful may still come and contemplate her, in her eternal youthful rosiness. The saint living in Heaven, asleep on earth.

All these details I heard related by Madame Solange, who had made the pilgrimage to Nevers and meditated before the casket in the convent of St Gildas. She had also made several visits to the grotto at Lourdes, where the Lady of Massabielle appeared to Bernadette. During her first apparitions, everything had passed in silence, and the little shepherdess, no less cautious than inspired, declared that she had seen 'something white', then had specified only that 'that something had the shape of a young lady'. She used a neutral term to designate the vision – that something, 'aquerò' in her dialect. A very vague demonstrative pronoun, of confounding simplicity, to qualify precisely that which could not be simple, which eluded all definition, which exceeded the capacity of thought. 'Aquerò' had appeared eighteen times, on some occasions content merely to smile, on others uttering a few words, including those informing Bernadette that she would experience happiness not in this world but the next. This promise left Madame Solange sceptical. For despite her religiosity, she had her feet planted firmly on the ground, and among the litany of proverbs she was fond of reciting, she often quoted, with a wily expression: 'A bird in the hand is worth two in the bush.' Happiness she wanted here and now, tangible and enjoyable,

good homegrown happiness for immediate consumption, because there was no telling what the substance or savour of that of the next world would be, and what would be your share of it.

The promise made by '*Aquerò*' seemed to me, on the contrary, of great wisdom, and to demonstrate a profound realism, for I did not take it to refer to two separate categories of happiness, one terrestrial, which was denied to Bernadette, and the other celestial, which was reserved for her after her death, like some kind of reward or recompense, but a single happiness, all of a piece, both terrestrial and celestial, at once temporal and eternal: the happiness of being of this world, in this world, of inhabiting it fully, and loving it, while recognizing it as incomplete, beset with strange turbulences, marred by deficiencies and unfulfilled expectations, battered and ravaged by the incessant flow of tears, sweat, and blood, but also steeped in inexhaustible energy, shaped from within by a breath of dawnlike freshness and clarity – caressed by a song, a smile. The happiness imparted to Bernadette, as to all men and women of her kind, consisted of having received the gift of clear-sightedness, of clear-hearing, that allowed her to perceive the invisible immanent in the visible, the light breathing even in the densest of shadows, a radiant smile appearing at the far edge of the void, even on the very face of the icy waters of nothingness. The gift of a different kind of sensibility, rare intelligence, and boundless unguarded patience. The gift of a luminous humility – a tiny key made of glass, of wind, opening on the unknown, the unsuspected, on infinite wonder.

On the other hand, what shocked me was the way in which the bodies of saints were tampered with, like those of heroes and kings of the past. But in the case of saints the intrusion seemed to me even worse, for these are people who, during their lifetime, display a preference for obscurity – the better to contemplate the light that dwells within them – a preference for silence – the better to commune with an invisible interlocuter. These are people constantly striving, ever higher, ever deeper and more amply, to attain self-forgetfulness. Had not

the young Bernadette, fleeing the unwanted celebrity arising from her meetings with '*Aquerò*', come to seek refuge in a convent at Nevers, far from her native country and the site of the apparitions, in order to hide, as she herself said? She wanted to remove herself from the eyes of the curious, from the prying and suspicious questions with which she had been overwhelmed, as well as from the renown that she considered unwarranted. And yet after her death she is stripped, probed, minutely examined, then cut open, a bit of flesh sliced away here and there, the odd bone removed, and finally she is put on show, after being restored, like some damaged artwork, so as not to scare any visitors of a sensitive disposition with her complexion like old brown cardboard, her sunken eyes and excessively emaciated nose.

Moses died in the desert, he disintegrated into the sand and stones; Elijah left the earth in a chariot of fire; Christ escaped from his tomb and walked away with so light a tread that he flew off like a feather in the breeze. They removed their bodies from the adoration, mingled with indiscreet curiosity and superstition, of the living, who are ever wavering between fascination and doubt, hope and fear, the need for miracles and the need for proof. Distraught in the face of death, mortals are endlessly drawn to the supernatural, delving into the visible every which way, investigating matter right down to the atom, and their own flesh, composed of cosmic dust, even to its most infinitesimal cells.

For some people the bodies of those men and women who during their lifetime have come into contact with the divine are a potential deposit of signs that need to be pinned down, rooted out, deciphered and translated. Signs – but of what? Of what happens after death, evidence proving the existence of God? Ultimately, the remains of saints can be compared with meteorites, which are keenly analysed with painstaking thoroughness, with passion; for, being as old as the planet and the entire solar system, and of more or less the same composition, these fragments fallen from the sky are supposed to

be able to inform us about the Earth's kernel locked inside a colossal rocky shell preventing us direct access to it. So saints' bodies and celestial bodies are messengers of inaccessible hearts – that of God, that of the universe.

There is a body language attributed to saints, as if the parchment skin of their corpses were a palimpsest in which was concealed a text inscribed by the breath of the Spirit, a fabulous poem lying dormant in their dessicated derma. Their relics, then, would be so many verses wrested from this secret poem, snatches of a revelation on the verge of expression. A bone, a tendon, a lock of hair, a tooth, a nail, or even a single eyelash taken from these venerable corpses would therefore be regarded as precious as magic words making it possible to reconstruct the divine poem written into the very fabric of the body, little 'open-sesames' capable of unlocking the door to the mysterious happiness of the next world that was promised to Bernadette, and of which she must, in the midst of her anguish and suffering, have had a foretaste in this world.

Happiness – that is what everyone was looking for. For some, the ultimate happiness lay in celestial bliss, for others, more attached to the earth and to their carnal present, it lay in physical pleasure brought to a peak, from moment to moment. While pursuing goals that were at once similar and diametrically opposed, both followed obscure paths all of which passed via the body, sometimes dead, sometimes alive. But the horizon they were all endeavouring to reach with equal fervour, whether in a heavenly or earthly direction, kept receding as they groped their way towards it. And I, circling between these two extremes, questioning those on both sides, tired myself out yet more, without even experiencing the hope of those on the one hand, or the excitement of those on the other.

And just what did I know about happiness? Not a lot, so rarely had I encountered it, even fleetingly, either celestial or terrestrial.

★

I had kept up the habit of going to the seaside on my days off.

I would take a bus, get off near the beach and walk bare-legged across the sand. I would venture into the water up to my knees. I was still a bit scared, but this fear had grown familiar, it was nuanced with new sensations. And besides I loved the all-pervasive smell, and the discordant cries of the sea birds, as wild and erratic as mountain birds, and yet so different. The sea birds' harsh cries travelled horizontally, skimming the waves, rending their roar, the mountain birds let their cries fall, almost from the clouds, intensifying the silence of the peaks. The open sea for the former; for the latter, the heights.

I gathered in the hollow of my palms the surf of the waves breaking at my knees. I juggled, empty-handed, with the spray, the wind, the sand. With the piercing cries of the sea-gulls. An oceanic 'Evohoe'!

One afternoon as I sat on the beach, daydreaming, looking out to sea, I saw a raft floating on the waves. The water gleamed like molten metal. Victims of a shipwreck writhed on the raft, their twisted limbs intertwined like brambles. All of them had their eyes trained on me. There was something feverish, crazed, pleading about their fixed gaze. Were they dead, or drawing their last breath?

Though closed, or gaping with marine-blue darkness, from their mouths rose a voice. A single voice, as if the heap of bodies slimed with algae formed one enormous mouth.

'Why do you torment us?' this wailing voice repeated several times.

I did not understand, I felt rather it was they, those shattered bodies, that were harassing me.

The raft bobbed sluggishly on the metallic waters, like some funeral cradle. And suddenly a huge wave gathered, curled over the skiff, and engulfed it. It pounded the vessel within its toils.

When the billowing wave came tumbling into shore, it spat out a kind of giant mummy, the colour of mud and rusted iron, that landed at my feet. Then the water receded.

The mummy was bulky and measured several metres in

length. Was it a statue reduced to the state of jetsam? I lent over it with a mixture of fear, repugnance and curiosity. Intense cold emanated from it. I shivered. Its face was eaten away by the salt, and its features barely distinguishable.

The body was no more readily identifiable, the salt had also eaten away its torso and genitals, and it was entwined from head to foot with algae, like weals of flagellation.

'I'm cold,' said the jetsam. The voice rose from its chest, as from an empty drum, and it diffracted in cavernous echoes throughout its entire body.

'I'm cold. . . I'm cold. . . I'm cold. . .' droned the recumbent figure, as long and hollow as a dead treetrunk. This created a disturbing and monotonous polyphonic effect.

Placing my hands on it, despite my aversion, I rubbed the chilled effigy to warm it. In vain. I sensed the echoes of its deep voice leaping within, rebounding off each other, and thumping against my palms. A vocal pulse, beating wildly. Far from conveying the least warmth to this frozen mummy, I provoked it to great distraction. 'You don't love me, you can't communicate anything to us, neither breath, nor warmth, nor life. . . I'm cold. . . your heart is miserly, you can't offer me anything. . . I'm cold, so cold. . .' The voice switched from plural to singular as if 'we' and 'I' were one and the same person, and it kept repeating itself, locked into a loop.

I straddled the derelict and lay down on its torso.

'Your heart is miserly, it beats slowly, not strongly enough to reverberate in ours and restore it to life. . . I'm cold. . . your thoughts are too feeble to reach us . . .'

No matter what I did, I was at fault. I drew back, annoyed, squatting on my heels.

'And all you can do is complain!' I cried. 'Who are you anyway?'

By way of reply, with painful exertion the recumbent figure slowly turned its head toward the ocean. It set its eroded face seawards; its body released a long-drawn out moan. I saw a small crab scurry across its brow. I tried to catch it, but as I was balanced precariously on the algae-enslimed torso, I toppled over.

When I got up again, the derelict was gone. The mark of its body was left in the sand – a shallow dip between the sea and me. Out on the ebbing waters, a pitching raft laden with indistinct bodies floated away. And my vision faded.

Still sitting on the beach, I shivered. And yet it was sunny. But I felt chilled to the bone. I chased away a little crab that zigzagged across my foot. It scuttled off towards the fringe of foam glistening a few paces away from me. I left the beach with a feeling of intense weariness, and the sense of having missed an encounter with the unforeseen. We are not always equal to the visions visited upon us.

On the bus that took me back to the Revellers' Inn, I decided to hand in my notice at the earliest opportunity. This few months' interlude with the Bellezéheux sisters and their Sardanapalian guests had gone on long enough. While it may have turned me into a voyeur, this stay among these devotees of orgies had also made me myopic as a visionary. I was no more than visually impaired, liable to attacks of being deceived by own eyes. I needed to get away, to try and recover my eyesight elsewhere. I had no idea of the location of this elsewhere, but accustomed since birth to finding places of refuge in extremis, I trusted to my lucky star, no matter how capriciously it had always treated me.

*

I did not know exactly what I was going to tell the Bellezéheux sisters to justify my decision, but I had to get this over with as soon as possible. It was suddenly a matter of urgency to me. Dora being away, it was Brune who saw me in their office. She asked me what lay behind my sudden desire to leave, suggesting several possible reasons, none of which was correct. Disheartened, she explained, 'If I insist, it's because I really like to understand the why and the wherefore of things, events, people. For reasons of mental salubrity.' I caught the ball in the air, Brune having just provided me with the components of my answer.

'Precisely,' I replied, 'that's why I want to retire from the

game – because I too need to understand, but here, in the Evohoe salon, I come up against a mystery. Debauchery seems to me an artifice disguising an impasse. . . a distracting illusion. . . a kind of treasure hunt in which all those taking part are being conned, while happily colluding in the con . . .'

My diatribe was somewhat muddled, and Brune eventually interrupted me.

'What of it?' she said. 'If everyone's happy, what's the problem? Of course it's a treasure hunt – pleasure is precious, and enjoyment inestimable. Here they are to be had in plenty. So where do you see any con?'

I shook my head, a sceptic still firmly holding my ground. Brune rose, walked towards a door at the back of the office and, opening it, invited me to follow her.

She led me into a small room immersed in darkness. Brune switched on a lamp. A golden light dimly illuminated this boudoir furnished with several armchairs, a low table, a cabinet with some glasses and bottles gleaming inside it. It was a blind room, without any windows. Brune went over to a crimson red curtain and pulled the cord. The curtain drew back, revealing an expanse of apparently grey-laquered wall. Our figures were vaguely reflected in it. Brune turned to the lamp and switched it off, plunging us back into darkness. Then she pressed a button and the wall became transparent, luminous. It was a large unsilvered mirror that did not reflect anything but served as a windowpane. Or rather a giant peephole. This one-way window looked down from a slightly higher level on to the Evohoe salon, at this time of day deserted. Brune played around with some other buttons and the lighting in the salon changed accordingly, now muted, now harsh, diffused in certain places, concentrated in others.

'This is our watchtower, from which we control the lighting. From here, we can see everything, and no one can see us. Better still: we hear every sound, even the least sigh. This booth is very well wired, every corner of the salon is fitted with microphones. We might as well enjoy the spectacle with sound and lighting, mightn't we? It's more than ten years now that Dora and I have been running this establishment, and we

still watch the show with as keen a pleasure as ever. And we've never had any trouble – the orgiasts are extremely well behaved. Their vocabulary is very crude, but they utter their rude words without raising their voices; they're what you might call ritual conventions, it's all part of the game. And besides, however lewd in word and deed our clients might be, they are unfailingly courteous towards each other. Everyone fornicates as he or she pleases, selects their own partners, rests when tired. Freedom reigns here in peace and joy.'

It was true, I had seen it for myself, the orgiasts demonstrated enormous tolerance, for in general they were totally indifferent towards each other. They went from one body to another, to the most available, the most inviting, without wasting time on the frame of mind of the timorous, without pouncing on the neophytes. They appreciated only ripe fruit, leaving the still green and the overripe time to accord.

'Sometimes,' Brune went on, while continuing to play around with the electricity, 'some clients, wanting only to watch, come and join us. They prefer to take their enjoyment by proxy, in short to experience visual orgasms. I call them the ascetic gluttons. Their hunger for bodies is insatiable and yet they constantly keep their food at a distance. They only consume flesh in the form of a spectacle.'

That too I had noticed. During the course of these evenings some voyeurs would always turn up whose presence did not at all bother the fornicators applying themselves zealously to their task. Sometimes a man would arrive with his companion, take care to undress her himself, then lead her to wherever the fancy took him, unless she herself identified some group that suited her. He would then hand her over to the others to do as they pleased with her, and watch her being fondled, licked, and mounted in various ways by strangers taking it in turns to do the job.

On one occasion there was a couple that caught my attention – despite the many claims on it and, in a place where licentiousness was indulged at a pace at once frantic and repetitive, for all that it was jaded. The young woman was ravishing, a

brunette with long hair, a triangular face, a slim body. She had eyes the colour of slate, with a melancholy expression, and a complexion of matt white, of glazed maiolica-like smoothness. A circle immediately gathered round her, lured by her attractiveness, and also, perhaps, by that trace of sadness in her smoky blue eyes. The men admired her for a while without daring to touch her, then one bold fellow made his assault and others in turn closed in on her. As the candidates succeeded one another between her thighs, she kept her gaze, like that of small frightened animal, fixed on her companion's. Having taken up a position a few paces away from the divan on which he had placed her, like some idol temporarily surrendered to the avidity of worshippers, he held her gaze in silence, without betraying the least disquiet. He stared at her in a solemn manner, his arms hanging loosely at his sides, or lighting a cigarette which he stubbed out almost immediately. He remained fully clothed, very reserved, distant even, then, when the fornication session seemed to have lasted long enough for him, he advanced towards his companion, and without any concern for the latest pretender, who, stark naked, was about to take possession of the pretty nymph with a veil of unfathomable sorrow in her eyes, he extended his hand towards her to help her up. Like a meek child, she obeyed and followed after him. They departed from the salon hand in hand, under the admiring and, for some, frustrated gaze of those present. But in the Evohoe salon there were substitutes galore, and those left disappointed resorted to other divans well stocked with flesh no less available than rapacious. Brune, who could see everything from up in her observation booth, must surely have noticed this couple with the look of sleep-walkers who had come not so much to amuse themselves as to put their love to the test, on the rack. Obviously it was the man who must have decided to impose this strange ordeal on both of them, in the absurd hope of forcing love to reveal its dark side, the body its secret, and gratification its final word – sublimating the elements of fire and water with trial by sex. Unless he simply wanted to kill off a morbid jealousy?

Had he attained satisfaction that evening, had he by this

diverted route penetrated more deeply the carnal obscurity of his lover? Had the twilight blue of the young woman's eyes as she submitted, distraught in her passivity, to repeated copulation and physical contact, proved more eloquent than when he joined with her in private. And what image of herself, of them as a couple, had she, the prostituted lover, thereby acquired?

I shared my speculative thoughts with Brune. She shrugged her shoulders and exclaimed: 'But you're getting needlessly complicated, my poor Lola, you're wasting your energy! Who says there's anything to understand?'

I reminded her of what she had said to me at the beginning of our conversation, that she liked to understand the why and the wherefore of things and of people's behaviour.

'Indeed, but there are limits,' she said. 'It's enough for me to know that my clients come of their own free will, to satisfy their sexual appetite, and that they go away satisfied. And all of them, the ascetic gluttons no less than the greedy ones, are completely obsessed – for this is what it's all about: enjoying an obsessive fascination to the utmost. And sex lends itself particularly well, doesn't it, to the consummation of such a fascination? At least the kind of sex to which no limits apply, no taboos – truly carnal encounters, bare-skinned, in the full glare of light. When you're committed to an obsession, you don't give a damn about the whys and wherefores, you experience a rapture beyond compare, at once dark and dazzling, delicate and violent, and you have a sense of repletion bordering on dizziness, of omnipotence and omnipossession that is all the more intense for being ephemeral. . .' She waxed lyrical. I realized that she spoke with great authority as an extremely dedicated votary herself. A blissfully happy glutton.

I observed the empty salon whose appearance varied continually in the changing light, like that of an ocean sky. I listened to Brune with only half an ear. I was bored. While Brune and her friends, both the active fornicators and those who fornicated by proxy, had pitched their tents with delight

on the south face of obsession with sexual games, I struggled up the north face, burdened with questions that were unanswerable because fundamentally absurd.

When she finally closed the crimson curtain and ceased her litanies, I felt relieved. The last act of a play that had grown tedious was over. I expelled a sigh by way of applause.

I gathered up all my bits and pieces, including my own name, Laudes, and took my leave of the two priestesses of the divine family of Dionysus, Aphrodite and their offspring Priapus. I was no more a member of that family than of any other.

Yuri Gagarin, who had marked the outset of my career as a hotel chambermaid with an historic flight, marked the end of it with a catastrophic one. The very day that I turned my back on the Revellers' Inn, the Mig 15 jet he was piloting, being unable to continue his fabulous voyages aboard a spaceship, crashed into the steppe just after his announcement from up in the cockpit: 'Mission accomplished. Returning to base.' This little phrase resonated strangely inside me for a while, as if, without knowing it, Gargarin had meant to say something else. But what? I've always had the annoying habit of taking nothing at face value.

<p style="text-align:center">★</p>

For want of anything better, I took a job as waitress at the station brasserie in a small town in the Landes. There is not much to say about that long year spent drying glasses and weaving among the chairs and suitcases, ferrying ham sandwiches and plates of local salad with chicken and chips. Except that the owner of the brasserie, who insisted on calling me Claude, was a fan of Edith Piaf. He drowned the hubbub in the brasserie from morning to evening with the huge voice of his adored Little Kid. Far from getting sick of this wash of sound, or rather vocal torrent, I was infected and developed a craze for it.

This vibrant voice, I adopted as my friend and ally. It

accompanied me during my hours on duty, rallied me when I felt depressed. It kept me warm, not so much like a fire as the body of a familiar animal. Untamed, yet familiar. The body of a stray dog carrying in its tangled coat the smell of the streets, courtyards and bistrots, and that of waste grounds, funfairs, open-air dances, mingled with the indefinable scent of stars fallen from the sky. The body of an undomesticated bitch, with strains in its throaty voice of a she-wolf gnawed by hunger, but bearing the wound of its hunger like a blazing solar burr in its mouth. The body of a cavorting bitch, crazed with love, impudence and intemperance, and exultant with desire. An intensely alive body lying beside me, panting at my neck, licking my heart with great bursts of song. A true friend, magnificently demented and generous. I had an uncanny knack of befriending the voices, smiles and tears of dead women. Which just goes to show that death is no obstacle. At least not entirely.

But for all that Piaf beyond the grave might sound the drumroll of her voice in that crowded room, she did not prevent people from talking. From one table to another, I would catch snatches of conversation, collect them up, along with the crumbs and the dirty plates that I stacked on my tray to carry to the kitchen; the whole lot sank into greasy water. And the same thing happened all over again, endlessly. It's amazing what people can produce in terms of waste, fag-ends, chatter, while anxiously listening out for the announcement of a train they're waiting for.

But there were also clients who were not waiting for any train, who came there just to kill time, installing themselves by preference at the counter. The time of their lives was unrelieved, still, entirely closed in on itself, like water in a goldfish bowl. But a goldfish bowl with no goldfish is a bit sad, so as a substitute for those brightly coloured small fry they would resort to gossip and blather, just to brighten up the tedium of their days a little. And then the restlessness of the travellers in transit, alternately eyeing their luggage and their watches, created little waves of excitement that could be felt by these lead-legged, lead-bottomed stay-at-homes.

Events occurred that spring that shook up people's ideas and gave them something to talk about. Students behaved like mutinously jubilant swallows, they turned the lovely month of May, the streets of the cities and by extension the whole of society upside down. Instead of building their nests in the tradition of their elders, they improvised barricades, and their springtime mating flourished in these makeshift shelters. I followed all this from a distance, from the depths of my station bolthole, humming the tunes of Piaf, especially the song '*Padam. . .Padam . . .*'

'*Padam. . .padam. . .padam, des je t'aime de quatorze juillet. . .* July fourteenth I love you's. . . *padam. . .padam. . .padam, des toujours qu'on achète au rabais. . .* forever's to be had on the cheap. . .*padam. . .padam. . .padam, des veux-tu en voilà par paquets. . .* loads and loads of would you's. . . *padam. . . padam. . . padam, écoutez le chahut qu'il me fait. . .* just listen to his hullaballoo . . .'

A hullaballoo there certainly was, that month of May, giving rise amid general confusion to no end of crazy panics among some people, heady dreams among others, and also some serious thinking. The regulars at the counter appointed themselves commentators, issuing bulletins on what was happening that would cause humorists to pale with envy, and the rioters, with disgust. Occasionally, in a flash of shrewdness, they would be spot on. But it was all just a verbal game that did not change by one iota the hermetically sealed goldfish bowls in which their lives continued in a peaceful doze.

It has to be said, these events created wripples that reached even my provincial brasserie: the proprietor bought a television set that he positioned high up so that the customers could watch it. This wretched television relegated Piaf to a sideshow; now she was just a support act, at off-peak times, in other words between the news, the football matches and the soaps. I found it bizarre at first, this visual and audio intrusion of the outside world, sometimes very distant, into my daily life. Though I might hum the refrain of the song '*Les amants d'un jour*', 'Lovers for one day' – '*Moi j'essuie les verres au fond*

du café, J'ai bien trop à faire pour pourvoir rêver. . .'I just dry the glasses at the back of the café, I've much too much to do, to dream the time away' – I nevertheless let my imagination wander, fuelled by images half-glimpsed on the television screen. And besides, I fell in love. For the first time, because with Martin I hadn't had time to fall in love. His name was Frédéric; he worked in one of the station offices. He came in every day to drink a glass of wine or a coffee at the counter. It was his sense of humour that captivated me. Our relationship was going so well, we moved in together. I was as happy as a kid riding a beautiful wooden horse on a merry-go-round, who catches the pompon dangling above the menagerie, entitling her to another free ride, indefinitely.

The following year, another event ignited the powder in people's minds. This was the televised transmission of the launch of the Saturn V/Apollo XI rocket to the moon. The room was packed with people, even travellers waiting to depart failed to keep eyeing the clock, everyone craned their necks towards the television. We saw miniaturized in black and white the huge multi-stage rocket blast out of its base with a tremendous roar, pouring a torrent of fire into the Florida sky. The spaceship soon became very tiny, with a trail of flames behind it five times longer than itself. But while this spectacle was more impressive than that envisaged by Jules Verne in *From the Earth to the Moon*, with his 'Columbiad' capsule propelled by a giant canon, the three astronauts bundled up in their heavy spacesuits lacked the elegance of the hero of Savinien de Cyrano de Bergerac's novel who, thanks to a belt of flasks filled with dew tied round his waist, rose slowly through the air as the dew turned into fuel under the effect of the heat of the sun.

But the highlight of the spectacle was reached a few days later, when the Eagle module, manned by Neil Armstrong and Edwin Aldrin, separated from the command module piloted by the third member of the crew, Michael Collins. After some difficulties, which caused the rate of Armstrong's heartbeat to accelerate violently, Eagle made its moon-landing in the Sea

of Tranquillity. The astronaut's pulse must have finally calmed down. That of the masters of the Kremlin, on the other hand, was surely set racing by the sight of their obsessive enemy's successful exploit. Holed up in a secret bunker, Brezhnev and his entourage were glued to their private television, just like several hundred million other earthlings, except those of the USSR, who were debarred from this politically offensive and ideologically pernicious spectacle. And the Chinese people, too, were autocratically spared this affront. For the age-old lunar dream had for long been contaminated by a fierce rivalry, each of the self-proclaimed superpowers of this planet wanting to beat the others in the conquest of space and to affirm its technological supremacy, as if the devastation they wreaked on the terrestrial globe were not sufficient. The moon was a soft touch; and for all these conquistadors it was no longer an object of poetic reverie but of frenetic covetousness. However, the majority of earthlings, who, like me, followed the event on the small screen, were not involved in these scheming considerations.

'*J'irais décrocher la lune si tu me le demandais. . .*' Piaf sang in the name of love. 'I'd go fetch the moon, if you were to ask me to. . .'. We insignificant folk hadn't got beyond that stage. . . We still haven't, as a matter of fact. That said, this moon landing nevertheless upset me. Were we going to defile and plunder that planet like our own, appropriate and colonize it? The moon I felt ready to go and fetch for the sake of Frédéric's lovely eyes could no longer be the same as that one.

The proprietor transformed the room into a campsite that evening. He invited his staff and friends who did not have a television to join him, to take advantage of his set, this astral messenger. And in the middle of the night, on the stroke of three thirty, he cheered loudly. Dozing on a chair, with my cheek on Frédéric's shoulder, I woke with a start just as Armstrong planted a ponderous left foot on the lunar surface. Afterwards photographs of the imprint of his booted foot in the moon's greyish dust were shown; it reminded me of an undercooked waffle. This was 'one small step for man, a giant

leap for mankind', declared the super-kangaroo treading on virgin soil.

Aldrin joined him, and they unveiled a commemorative plaque, then raised the American flag. That must have been hard for Brezhnev to swallow. On the plaque was engraved a gallant declaration: 'Here men from planet earth first set foot upon the moon. July 1969 AD. We came in peace for all mankind.' However, peace is not mankind's forte. It was just as well the moon turned out to be uninhabited, otherwise, once the polite greetings with their spacesuited visitors were over, its inhabitants would soon have been disillusioned: other earthlings would have returned to teach them, to their cost, the arts of war, crime and pillage.

They laid a second plaque to the memory of the five astronauts who had died in the battle to conquer space. The name of Gagarin appeared on it. In the lunar waste, the names of space rivals could coexist in peace – the peace proclaimed by mankind, far from his own territory.

And they left, laden with stones collected from nearby, and with the glory they had won on the earth far below. Hardly had they left the moon than a strange kind of meteor crashed into it: it was the Soviet probe Luna 15 that was also supposed to bring back small samples, but which had fallen victim to a technical fault at the very last moment. The rivals' probe had made an apposite choice of both time and place to explode, the site where it came down being called the Sea of Crises. Did Brezhnev and his entourage appreciate the joke?

And so the moon was deflowered. The earthlings' long-cherished dream was suddenly consummated. In future, it would no longer be possible to contemplate the moon on clear nights without forgetting that technological warts had grown on its face. But human beings are fickle and, with the exception of a few scientists, as soon as this feat was accomplished they lost interest in their conquest. The moon experienced the same fate as long-desired beautiful virgins that men forsake after one night of love, to go and pay court elsewhere. Attention turned to Mars, the orange-red planet

located even further away in the solar system, and therefore higher on the scale of desire. The idea was to turn the moon into a relay station between the earth and other surrounding planets, to establish a permanent base there, send in very sophisticated robots capable of exploring the terrain and if possible exploiting the various resources, instal vast astronomical equipment the better to study the universe, build laboratories and a factory capable of producing oxygen – all to the exclusive benefit of earthlings, of course. Finally, from up there, it would also be possible to set up powerful spy-satellites in order to keep watch on those lilliputian humans considered to be politically dangerous. Countless projects.

In short, the moon that was once deified, glorified, was reduced to the functions of a service station for cosmic juggernauts, a dormitory suburb of earth swarming with robots, a stepping-stone between our planet and its distant neighbours in the solar system, a vast industrial zone, an energy milch-cow, a superior surveillance device. Another extremely important role could also be assigned to it: as a dump for our excess rubbish, our nuclear waste, and – why not? – as a cemetery for undesirable peoples exterminated en masse, and also for herds of animals subjected to wholesale slaughter. But I'm jumping ahead, all these possibilities were not yet envisaged on that day of triumph when Armstrong and Aldrin walked on the powdery surface of the moon.

★

Human beings are fickle in all things, and I experienced the same fate as the moon. Having cherished, loved and desired me, Frédéric gradually tired of me. His eyes began wandering in the direction of other women and eventually he found himself a planet Mars to suit his own requirements, attractively plump and stylish. The more smitten he became with his new conquest, the greater his aversion towards me. One evening, on returning 'home', I found the apartment empty. Frédéric had not only removed himself, body and heart, but he had taken all the furniture and fittings with him. Betrayal by total clear-out. Not even a goodbye, nothing. Just a few

nails left in the bare walls, and my suitcase containing the handful of souvenirs that I carted round with me from one town to the next.

The emptiness of the apartment inwardly convulsed me, sweeping aside the thirty years that my life amounted to and reducing me to the state of a newborn baby treated from the outset like a meat scrap only fit for the dogs or the rubbish heap. I collapsed from the shock, and lay curled up on the floor. A taste of tart raspberries filled my mouth, I was deafened by the pounding of my own blood, and my brain was just a spongy mass steeped in idiocy. All my motor skills and mental faculties were obliterated. Taking advantage of this general breakdown, my lachrymal glands began to produce floods of tears. They came pouring out of me, like a heavy cloudburst. For it was not even I that was crying, since at the time I lay on the verge of nonexistence, without the slightest capacity for thought. The fugitive had also made off with my consciousness, my identity, my desire to live, and my will. A clean sweep.

And so I remained for a long while, lying in a puddle of tears. The time it took for the shock to abate, for me gradually to come to my senses. I rolled over on to my back, not moving, like a swimmer floating on water, and I stared at the ceiling. A yellowish stain here, a crack there, and there a blister about to burst, to crumble. I could see the smallest details. The electric wires of the ceiling light hung down like a bunch of rootlets.

'Well, well,' I calmly said to myself, 'he's even taken the lightbulb.' I tried to remember how many watts the lightbulb had been.

I did not even realize that night had fallen, my eyes adjusted to the gloom, and the street lighting bathed the room in an ashen brightness. I eventually fell asleep on the floor. I slept only a few hours. I found it very hard to open my eyes, my eyelids were swollen, painful. And still in my mouth, that taste of sour raspberries. I felt drained, I was aching all over, and my thinking too had seized up – why had the mattress got so hard, and how was it that my pillow, sheet and blanket had all

slipped off? I put my left hand out to touch Frédéric's arm or hip – he always slept on that side of the bed – but my fingers felt only the wooden floor. Then the events of the previous day came back to me, the way blood rushes back to a wound, reawakening the pain. I gritted my teeth so as not cry out, took very deep breaths so as not to start weeping again. And again I stared at the ceiling, at the place from which the electric light-globe had disappeared. This plaster sky was a mirror in which were reflected the whiteness of my skin, my heart's ghastly pallor, my life's penury; and the cadaverous hue of love. From the depths of my stupor, some words spoken by Elvire Fontelauze d'Engrâce detached themselves and resurfaced: 'Abandonment is the only means by which to apprehend God. . .' It was something she had said one stormy afternoon, quoting a poet whose name I had forgotten. I could not remember the rest of the quotation.

'Abandonment is the only means by which to apprehend God. . .' murmured the baroness's weary voice floating to the surface of my torpid memory. But was it enough, in order to succeed in capturing God, to be consigned to the dustbin oneself, reduced by knock-out to a state of total abandonment? It seemed not, for I captured nothing, neither God nor the devil. I was overwhelmed with intense grief, bewilderment and shame, there was no room for anything else. It was only when I finally got to my feet that the second part of the quotation emerged from oblivion: '. . .but forsaking God Himself is another form of abandonment of which few can conceive.'

Seeing that ever since my wretched birth God had neglected me, I had ended up doing likewise; for years I had fully returned his indifference. But I had the obscure impression this wasn't the same, and that in our neglect of each other there was almost a point of contact. I went to take a shower, leaving this surmise unresolved. Towels and soap had gone from the bathroom, just like the lightbulb from the sitting room, and all the rest. Fortunately, Frédéric had not been able to dismantle the plumbing as well.

The suddenness and above all the boorishness with which my companion had left me, in the end, by their very excessiveness, turned out to be effective. Instead of leaving me to mope indefinitely in disaffection, he made a clean break. Radical amputation is much better than incremental paring, it averts gangrene. Since only my old suitcase had been spared, I took this as an invitation to travel. Once again I was overcome with the desire, stronger than ever before, to get away. But this time I was not content to find another job nearby, I decided to venture beyond my regional boundaries. So I went prospecting, poring over the classified ads in all the newspapers I could lay hands on – and a station brasserie is a good place to find these.

One advertisement caught my attention. A seventy-year-old woman was looking for a young woman to do some light housework and read to her, in exchange for a modest salary and free board. I plucked up my courage and picked up the phone. I embellished my curriculum vitae, attributing the years I spent at the Fontelauze d'Engrâce manor house not to a kid taken on to help round house, push a wheelchair and set the clocks, but a young woman in attendance on the baroness. I slightly juggled the dates and passed over in silence my stay with the Marrous, and I sanitized my experience of working in hotels. If I had recounted in detail my progress from rejected bastard, to mountain peasant, to chambermaid at drab hotels down in the valley, then factotum in a high-class brothel, and finally waitress at some godforsaken station buffet near a pinewood forest, my application would probably have failed.

My chutzpah paid off. The woman suggested meeting the day after next. I dared not tell her I lived a few hundred kilometres away. I just had to come to some arrangement with my boss. There again, I was obliged to embroider the facts, and I invented a very sick aged aunt who had summoned me to her bedside. I bought a new suitcase and a fitted coat of dark-brown broadcloth, in order to appear before my prospective employer with some semblance of smartness. And I went and stood on the station platform where, from the other side of the brasserie windows, I had seen thousands of trains pass.

136

VII

Switch of perspective: through the window of the carriage where I had just taken my seat, I watched the brasserie slip past. Then, a few metres on, I saw the windows of the office where Frédéric worked. He had moved only a short step away, the rat, and was now living in another street in town, but he still had to come back to his place of work every morning. I had put on seven-league boots and was on my way to Paris.

To Paris, where I knew no one and nothing was familiar. And so far from the mountains, the ocean. I had no guarantee of being employed. Never mind, I said to myself, I could not have tumbled any lower than the depths into which Frédéric had cast me. The pain of abandonment was so acute that, to contain it, I found no other remedy but to flee. My inconstant lover had so deeply mortified me that he not only damaged my self-esteem, but also destroyed my vision of love, my trust in love. And I fled these ruins, so as not to fall apart among them. I felt the need to go and look elsewhere, and above all look at things differently.

Luckily, I landed the job. The woman had poor eyesight and did not listen very attentively. She thought I looked peaky, and that my name was Maud. 'Maud's fine,' I said to myself, after Lola and Claude I was not too particular. She herself had the name of a cartoon character, or a song bird: Philomène Tuttu. That endeared her to me.

She lived in a small apartment on the second floor of a block of flats in the Bastille area. I was accommodated in a maid's room under the eaves. In the morning, I would arrive at her door to do the housework and, some days, to accompany her to the local market. The trips to the market were an excuse for a walk, when we would toddle along, arm in arm, and treat ourselves to a rest in a bar on the stroke of midday.

We would sip a glass of white wine; she liked hers sweet, while I liked mine very dry. This small aperitif would perk her up, and put her in high spirits. So it was that she recounted her life to me in disordered fragments: one day, something that happened during the Occupation; another day, a childhood memory; yet another day, a story from her years of married life. She had buried three husbands. The first had died a few months after their wedding, carried off by meningitis. She was twenty at the time. The second was hit by a stray bullet during the liberation of Paris. The third had died of cancer two years ago. With her three husbands she completed the tally of all four evangelists: the youngest being Matthew, the next, Mark and the last John-Luke. I was the one who pointed this out to her, it had never occurred to her. She was amused.

'John-Luke doubled up,' she remarked, 'to prevent a fourth husband from following on. All I can do now is find a Jesus, but that's not so common.'

I suggested that a Peter or Paul might do.

'Not any more,' she said, crunching a toasted peanut, 'I'm too old to remarry, and besides, I'm tired of closing men's eyes.' And she repeated in a husky voice, under her breath: 'Men's eyes . . .'

Her triple widowhood posed a problem of conscience for her. The three deceased husbands each lay in a different cemetery: which one would she be buried alongside when it came to her turn to close her eyes? She was thinking of being cremated, and having her ashes scattered in the wind. That way no one would be offended.

In the afternoons I was off duty. I took the chance to supplement my income by doing a few hours of cleaning for other tenants in the building or in the neighbourhood. In the evening, I would have supper with Philomène and for dessert we would savour books. I would do the reading, since her eyesight was too poor.

This exercise of reading out loud, together, revived the taste for books that Elvire Fontelauze d'Engrâce's library had awakened in me but that I had rather neglected since. Indeed,

so much was my taste restored that the one hour originally intended for this occupation became extended as time went on.

Philomène was a disconcerting reading audience, because she was as wilful as she was whimsical. She liked only novels and short stories, exclusively in the French language, because she was wary of translations, and dating from the nineteenth century, towards the end of which she was born and which she referred to as her cradle. But in this roomy cradle, she just would not settle: after two or three chapters of a novel by Balzac or Stendhal, she would ask me to return to this novel or that by Georges Sand, Flaubert or Barbey d'Aurevilly, which we had begun the day before or the previous week and had to break off reading. I was continually having to jump from one world to another, and without transition switch from Zola to Nerval, from Chateaubriand to Eugène Sue, or from Victor Hugo to Villiers de l'Isle-Adam. This disorientated me, and above all exasperated me. Whether sexual or literary, swopping about was decidedly not for me. I nevertheless managed to save Maupassant from these fitful readings, thanks in part to the brevity of his stories.

Every week I would visit the municipal library to renew our supply. At first I scrupulously followed Philomène's guidelines, then I grew bolder and explored among all the shelves, borrowing books not mentioned on my fellow reader's list. I took care to select writers that still came within the geographic and temporal ambit laid down by Philomène, but within these confines I pursued new trails. My forays into drama and poetry nearly all failed, my audience scorning these literary genres. One evening I had a memorable flop with an author I had chosen because of his name and the title of the work, about which I knew absolutely nothing. It was *Les Chants de Maldoror* by Comte de Lautréamont. I just liked the sound of it. As I turned the pages, Philomène stiffened in her armchair. Obviously, she was not at all receptive to the lofty counsel of Lautréamont, inviting his readers to become 'temporarily fierce like the text they are reading, [in order to

find] without losing their bearings, the precipitous and untrodden path through the desolate marshes of these dark and poison-filled pages', or 'like a shark', exposing its belly reddened with hunger and streaming with voluptuous cruelty 'to the air's lovely darkness'. I only had time to read through a few pages of the 'First Song', Philomène refusing to take any more of this miscellany of horrors. I closed the book, but I finished reading it that same evening in my bedroom, alone and under my breath, as if I were plotting with dark spirits.

Frédéric had brought to a pitch of incandescence the rage and sorrow roused in me as a child by the twofold deaths of Léontine and Antonin, but which had been smouldering inside me from the start.

And although in Philomène's company I was relearning gentleness and affection, I nonetheless retained this anger buried deep in my entrails. *Les Chants de Maldoror* resonated powerfully within me, their voice seemed familiar. After trees, this was a new family I was discovering: books. But did not the latter take their shape in the substance of the former? Were they not just as much filled with rustling, whispering leaves? Both drew their strength and energy from the earth, the humus and mud of the days, and they thrived in the open air, with space around them. Sap, ink – one same dark blood flowing slowly, reaching towards the light, and sighing with the world's distant murmur.

I did however manage to get Philomène to enjoy two writers very far removed from each other, both in terms of their position in her century of choice and their particular universe and style. Joseph Joubert and Georges Rodenbach. The subtlety of the former's meditations and maxims so captivated Philomène that without realizing it she strayed beyond the confines of novel-writing; as for the latter, he enchanted her. At the end of *Bruges-la-Morte*, she told me that she felt completely imbued with mist and milky shadows, and she began dreaming of a trip to Bruges. 'The two of us,' she said, looking radiant.

These reading sessions, into which I introduced more and more of my own contributions, drew Philomène and me closer to each other. I stayed on far beyond my official working hours; in the end she would listen to a continuous reading of the books I brought. As she got older, little by little she lost that impatience that still dissipated her attention when we first met, and she gradually forsook novels for other works. So it was that, for her, the author of the Memoirs eclipsed Chateaubriand the novelist, and she took a growing interest in the journals and letters of writers. For myself, I learned to give rhythm to my reading voice, and more supple modulations, to allow the words to breathe more freely, to acquire volume and resonance.

The difference in age between us, and in our social status, in the end faded completely into the background; we were two accomplices of disparate ages, ever roaming the literary landscape by the light of a lamp. We were two friends, exploring the boundless wonders of the imagination.

★

My Parisian life was easier than all the years I had spent in the countryside and in small provincial towns. I enjoyed a freedom I had never known before, anonymity kindly reigning in the streets, cafés and all public places. The great white blackbird that I was melted into the crowd, where in fact your path might cross that of countless birds of every feather and every colour. Young citizens revelled to their heart's content in fanciful dress and hairstyles, some showing no reluctance to display cheerful bad taste. Nothing seemed to them too short, too big or too tight, too garish, or too dishevelled. Outrageousness was acceptable, mockery asserted its credentials, and rebellion its rights.

But outrageousness is not always playful, it can appear ferocious, with no other justification than for the sheer hell of it. My carefree happiness was suddenly shattered, even more violently than when Frédéric left me taking everything with him.

I arrived at Philomène's apartment late one afternoon to

find her door ajar. I nevertheless rang the bell as I was in the habit of doing to announce my arrival – three short rings at regular intervals – and I pushed open the door. The sitting room was devastated, all the drawers overturned, objects and clothes scattered on the ground. Philomène – but was it really her? – was slumped in an armchair, her dress rucked up, her legs outspread with a canary-yellow feather duster stuck between them. Her head was bowed over her chest, encased in a plastic bag. A trash-can head.

I remained paralysed in the doorway staring at this senseless image. Paralysed not only on the threshold of the apartment, but even more so on the threshold of my gaze: no connection was made between my eyes and my brain, the gap was truly too great.

'The imagination has made more discoveries than the eye,' wrote Joseph Joubert. Not true: at that moment the macabre and obscene discovery that my eyes inflicted on me far exceeded the worst that my imagination could have invented.

My will too was split apart, separated from my body. I wanted to rush to Philomène to untie that blue plastic cowl tied round her neck, but an overriding force restrained me. I backed out on to the landing. And there, out of view, I screamed. Apparently my cry re-echoed throughout the building, and even into street. The screaming issued from me, impersonally, just like the weeping a few years earlier, upon the invasion of grief. But this was so much more virulent, above all so much uglier than grief; it was hideous. And this hideousness overwhelmed me. I fell into a black hole.

I was taken to a hospital where I stayed quite a long time. I had lost my wits. I was stuffed full of tranquillizers to unlock my jaw; it had snapped shut on my cry, and become locked fast. My tongue bled. My eyelids too were sealed. My body had closed in on a wall of darkness, my mouth fed on emptiness. But in the depths of my dark night, my memory let loose its ghosts.

When at last I resurfaced, the name I uttered was not that of Philomène – the horror had driven it from my mind – but Eurydice.

And Eurydice was a hydra with countless faces of great dissimilarity: the sallow and distorted face of Mother Marie-Joseph of the Eucharist; the dark profile of Esther howling before the mountains; Loulou-Elie's sweet little face and the spectral visage of his father, framed one inside the other; Léontine's bewildered face gaping among the flies, and Antonin's with its haunted expression; Marcelle Marrou's moonface dripping tears on her Auguste's stricken countenance; the deformed mask of Philippe Fontelauze d'Engrâce and his mother's beautiful frozen features. And superimposed on them, Agnès-Déodat and her disfigured lover.

As if that were not enough, I saw appearing in the midst of this carousel flashes of the carton mask of Marilyn Monroe, all cracked up, and furtively raised to reveal a glimpse of Frédéric's face – at its best, when he smiled at me, when he laughed, while he was sleeping, and his most hidden face, which he revealed when we made love.

Finally the forever unknown face of Pergamon appeared as an empty hollow.

Eurydice was all this. And Philomène melted into this funereal maelstrom. But my voice refused to name her, to assign her a place among the dead.

My voice did not escape undamaged from the cry I had released. It suddenly became deeper, mingling huskiness with smothered growls. With every word I uttered, I surprised myself, thinking I was hearing a stranger. My throat had acquired a fog-horn pitch. This intrigued the doctors, and a delegation of specialists gathered at my bedside: a laryngologist, a speech therapist, and finally a psychologist. But my voice-box was resistant to all this attention, and I continued to sound my fog-horn. The police inspector who came to my room as soon as he was allowed to, had to put up with my vocal rebellion. He asked me a host of questions in the hope of gleaning some information for his investigation, which was getting nowhere. But I had very little to tell. He on the other hand saw fit to give me details of the crime. The aggressors –

for it was thought there were two of them, perhaps more – had beaten up their victim, forced her to swallow a litre of bleach and, to stifle her screams, stuffed a rag in her mouth, then amused themselves by raping her with a feather duster, and finally they had put a plastic bag over her head. Torturers making facetious use of household products and implements. They had gone off with jewellery, money, and other small items of value.

<p style="text-align:center">*</p>

Eurydice, Eurydice. Too many dead already had rallied under that name. For how much longer, to what extent, would the ranks continue to swell? Eurydice: she was not a wood nymph any more, but a proliferating dragon. I felt the breath from its multiple mouths travel across my skin, scald my flesh. Their breath smelled of cellars, grimy snow, gun powder and face powder, dried blood, endless tears mingled with sweat, and of bleach. It made me nauseous, I vomited any food forced down me. An acute fever poisoned my blood, I almost died. Eurydice was urging me to descend into the Underworld.

I did not die. A vision intervened between death and me.

I saw a little girl on a swing. She abruptly thrust her body backwards and forwards, extended and folded her legs in sudden jerks, to give momentum to the small wooden plank on which she was seated. But the plank hardly moved. On the other hand, at the little girl's every effort, the ropes and struts of the swing grew longer. In the end the child was suspended very high up. So high that she disappeared into the clouds.

I saw her again before long, crouched in the hollow of one of these clouds that had the colour and weightiness of lead; she held a ridiculous pair of oars – a small, red plastic spade for building sand castles in one hand, and a pendulum in the other. She was rowing hard, in her cloud, at ground level.

This was not the earth's surface, but the lunar surface, of dull silver. The rower jumped out of her sailing craft on to this ashy ground, in the middle of a crater. She immediately knelt down

and began to dig, now with the spade, or the pendulum, now with her bare hands. The toes of a foot started to poke through. The little girl pulled out the foot buried in the lunar dust and threw it aside. Wasting no time, she stuck to her task. A metal lid emerged. The little girl dug deep and extracted the vessel to which this lid belonged. It was a slightly battered rubbish bin made of tin. It was tall. The child had to stand on tiptoe and use the pendulum to knock the lid off. A host of sounds escaped from the bin. They were kisses. Kisses of every kind, gentle and caressing, sensual, teasing, biting, shy, soft, laughing, rough, distracted. . . The kisses of transient lovers, fickle-hearted lovers. Betrayed kisses, repudiated kisses.

The little girl lay down on the grey ground, exhausted, her arms crossed over her chest, clutching the spade and the pendulum. A procession of dustbins filled with kisses extended behind her as far as the eye could see. They stood gaping. The kisses were strewn across the crater, like shavings of the sun, or the stars, cold and lustreless. The foot that the little girl had dug up first of all, walked by itself among these shavings. It moved hesitantly, zigzagged, occasionally hopped.

A man appeared, dressed in a tin-coloured boiler-suit, wearing a helmet that resembled the dustbin lids. The general in command of this army of dustbins, perhaps, or a mere sergeant? He surveyed the ground scattered with holes and stray kisses, put his hands on his hips and in furious voice yelled, 'What is all this mess? Who unearthed this trash? And who's going to sweep it all up, eh?'

Then I replied, 'Me!'

I found myself right there in my dream, broom in hand, sweeping up piles of kisses. The foot frolicked at my side like a playful little dog. In the distance I could see the earth, of a dazzling blue.

I stood there for a long time, leaning on the broom, admiring the brightness of the earth. An indistinct sigh escaped from all the mounds of kisses I had swept up. I turned round and saw the little girl a few paces away from me. She had aged by

several decades. Her hair was white, her face deeply wrinkled, the colour of terracotta, her eyes were puffy with sagging brown pouches. She gazed at me absently, with a sadness it seemed that nothing could console. She gently took the broom out of my hands and walked away, batting the little piles to left and right. The kisses scattered once more. The old woman lent towards the ground, blew on all these relics. The kisses flew off in a greyish cloud, leaving a long opaline trail in the galactic darkness. A nebula of unclaimed kisses.

The old woman, all hunched up from the length of time she had spent blowing over the ground, shuffled along, taking tiny hesitant steps. 'I'm thirsty!' she sighed. There was so much water down there, on the earth, so much blue water. . . I reached towards the earth to scoop up a little water; all I collected were a few blue reflections. The old woman came over to me. She stood at the level of my outstretched hands. She tried to drink from my cupped palms, but her lips remained dry, cracked with thirst – just tinted blue by the oceans' distant reflections. On the inside of my hands she left the imprint of her face. A fiery mist on my skin.

Upon this wavering vision I reopened my eyes. My fever had gone, and my terrors with it. I was safe. Death and madness had been content to graze me, tickle me, then turn away. I felt very thirsty. I was given something to drink.

I gazed at my hands. My palms were chalk white, scored with fine lines. I thought I could still discern the old woman's face. I was sure I knew that worn face, it was familiar. But I could not put a name to it. Though I mentally reviewed all the aged women I had been close to, or merely encountered, none of them corresponded to this image. And suddenly I knew where I had seen that drawn face contemplating on the farthest reaches of the unthinkable, steeped in sorrow, weariness, and silence, and so naked in its solitude: in the newspapers, dozens and dozens of times over the course of recent years.

The face of that old Vietnamese woman, as tiny as a child,

carried in the arms of a GI during the evacuation of the wounded after a bombardment. The face of that Angolan survivor of a massacre. The face of that Cambodian woman fleeing Pol Pot's killers. The face of that Chilean mother holding the portrait of her two disappeared children. The face of that old Bengali woman whose husband and sons had just been executed by guerrilla fighters. The face of those young mothers of the Sahel, so skeletal that they looked a hundred years old, clutching to their wrinkled empty breasts their starved-to-death babies. The face of that old lady propped up like a drunk on the pavement, her Sunday overcoat stained with blood, in a Belfast street strewn with dead and wounded. The face of that Kurd, that Lebanese woman, that South African, that Salvadorian. . . who had all at a stroke lost their house, and sometimes their neighbourhood or village, their children, and sometimes their entire family, the people around them, everyone related to them. Lost their reason for existence, any enjoyment of life, even the smallest glimmer of light in their hearts, the slightest breath in their souls.

Whether from Europe, Africa or Asia, they were all alike, these women, in the starkness of tragedy. There was no end to the succession of their anonymous portraits illustrating such and such an article in a magazine, such and such a flyer handed out in the street by activists. Madonnas, more often than not old women, or prematurely aged, dressed in rags, bundled up in immense garments stained with mud or blood, or else half-naked. Madonnas of every country and every religion, all alike, and yet unique. Madonnas that sometimes brought a prize to the war reporter who had been able to capture their image, to stir public opinion for a day or two with the expression of their distress, but who fell into oblivion almost at once. One eclipsed the other. And since then, countless others have succeeded them, and cohorts of little girls are preparing to follow in their footsteps. They are mass-produced.

At last I was able to leave hospital, after a stay of nearly two months. I had lost a lot of weight, I was a little unsteady on my

heron-like legs, and my voice continued to sound like a double-bass.

I came out of hospital as destitute as a prisoner released after years of detention, for whom there is no one waiting outside the gate, or anywhere else; who has nowhere to go to, and no work. All I could do was collect my suitcase and few belongings from the caretaker who had kept them for me. The owner of Philomène's apartment and of the maid's room had reclaimed his property as soon as the seals the police had put on them after the crime were removed. He had everything cleared out and new locks installed. The caretaker gave me an address in the Belleville area where I might be able to find a room to rent very cheaply, until better days arrived.

*

So it was that I emigrated to Belleville and moved into the attic of a small house. The ground floor was a café, my land-lady lived on the first floor. This drinking establishment was more like a waiting-room, where the local tramps came to seek refuge when it rained at night, or when it was very cold. There were no tables, just a few chairs, two decrepit armchairs, and some tall stools at the counter. The walls were covered with shelves, filled with tinned food, packets of biscuits, pots of mustard and jam, bottles of lemonade, oil and mineral water. An emergency supply store for the absent-minded who a little late in the evening or on Sunday afternoons found their cupboards bare. A shop for the hard-up, most of all, the proprietress often giving credit, and only complaining about it for form's sake. There were also some books lying about on these dusty shelves, paperback detective novels, all dog-eared. These were not for sale, just put out for the benefit of the customers, who in fact kept this meagre library stocked, by contributing old books they wanted to get rid of. One of the regulars, a tramp called Turlute, would spend his evenings reading morosely, with his chair pushed up against a wall.

The clientele that drank at this bar consisted of locals, students, artists scraping a precarious living from the sale of their works, the downcast in search of comfort, the seriously

idle, young bohemian couples, and a few windbags assured of finding an indulgent audience.

The most indulgent and cordial person in the place, despite her big mouth and corrosive sense of ridicule, was the owner of the bar, my landlady. She called herself Fanfan, preferring her childhood nickname to her Christian name, the christening never having taken place in fact, as she told me with pride, atheism and anarchism being an old tradition in her family. And she gave me the name Lolo, regarding Laudes-Marie as having too much the whiff of the sacristy about it.

Fanfan had two passions. The first was very congenial: she adored champagne. Whenever she popped a cork, with an expert hand, she would swank a bit, saying that since there was nothing funny about poverty, we might as well make it sparkle. It was very rare that she would open vintage bottles to make it sparkle, which was just as well, since she often drank her champagne flat or insufficiently chilled, and always in a horrible pyrex flute glass. Her other fad posed more of a problem, because it affected me. She was obsessed with Scrabble. As this wretched game required at least one other player, I was frequently called on. That said, these Scrabble games of hers were not without a bit of an edge to them, she fiddled with spellings and the rules of the game with surprising casualness, and had a very personal conception of vocabulary. 'I'm crazy about words!' she told me one evening, as she drew her letter counters with relish. I promptly gave her a dictionary, and told her how much I used to like picking out words I didn't know, when I was I child, savouring them like sweets.

Fanfan had a tumultous love affair with her dictionary, shouting at it when a word was not written the way she thought it was, or had the downright nerve not to appear in it at all, hugging it when she found a rare word composed of letters worth a lot of points, like 'yucca', 'zek', 'klystron', 'xystus' or 'zythum'.

My stay in Belleville was of short duration. Thanks to the grapevine that operated continuously within the Fanfan club,

149

I heard about a job. I was told of a writer looking for someone trustworthy willing to work in a dual capacity: as housekeeper and secretary. A somewhat literate servant, in other words. Relying on my long past life as an all-purpose maid and my recent experience as a reader with Philomène, I tried my luck.

But I had to undergo an initial ordeal that almost eliminated me from the outset: the telephone call. I dialled the number I had been given. A man answered. I introduced myself, trying vainly to clear my throat. There was a silence. I imagined my interlocuter knitting his brow, hard put to know whether he was dealing with a transsexual or a mutant. But with what sounded to me like sarcastic politenes, he asked: 'Is that Mrs or Miss?' And plumbing the most sepulchral of bass voices, I replied, 'Officially, it's Miss.' He arranged to see me the next day.

*

The writer lived in the outer suburbs of Paris, but a rather rural suburb, with individual houses scattered in green surroundings. There was something mean about these patches of fenced-off gardens, closed like fists round their houses, most of them deserted during the day, their inhabitants having to leave for work, in Paris, early in the morning.

When I reached the address I had been given, I rang at a gate, wrought like moucharaby lattice-work The house I could see through the iron curlicues looked like a thatched farmhouse in Normandy. The gate opened, by itself, noiselessly, and closed behind me in the same way. A man of medium height but solidly built came out on to the steps and watched me walk towards him. The irregular features of his face gave him an ambiguous charm. 'Bruno-Pierre Estampal,' he said, extending a beefy hand, and observing me in the manner of an entomologist first laying eyes on a big white grasshopper.

He received me as if I were a visitor, offering me the choice of a drink or a cup of tea, and asking me in a social kind of way a few questions about my literary tastes, to get some idea of what kind of person I was. I mentioned Maupassant, Balzac, Flaubert, Octave Mirbeau, Lautréamont. He repeated these

last two names with a trace of a smile – I could not have said whether of approval or amusement.

'What about twentieth-century writers?' he said.

That left me stumped, as I had not yet had time to venture beyond the territory marked out by Philomène.

He handed me three books that he had published, and gave me another appointment for the following week, which allowed me time to become acquainted with his work and to select a chapter that he would like to hear me read aloud. He also gave me a list of the tasks I would have to fulfil if I were to work for him – keeping the house tidy, filing, sorting his mail, taking clippings from newspapers.

I plunged into the glaucous ink of his books in which crimes and sex rollicked along at a cracking pace but without any precise direction and above all without much originality. I came to the literature of my own century through a tiny door. There was in these stories of his, cooked up in the flames of very smugly conventional infernos, the occasional passage that jarred, as if he had inserted sentences taken from else-where, or some unexpected ideas had popped into his mind of which he had not bothered to make any sense. It was one of these discordant passages that I chose for my next confrontation with the author. It was taken from his last novel, entitled *Beyond the Pale*, in which a character by the name of Sorgo, a sexual innocent of indeterminate age overwhelmed by the world's frenzy, makes plaintive protests in a tone of sincerity, of candour, that I found disturbing.

'Oh, my head hurts so much! A hand, just a hand on my forehead, to regain contact with humanity. . . I'm destitute of love. Who will lend me a smile, a look?. . . My heart has no protection, always in the blaze of loneliness. . . Mother, I call you, I look for you everywhere, I cry out, but you don't answer. . . To dry my tears in the open air, I would have to turn my body inside out like the cloak of a drowned man . . .'

I found in Estampal's other two novels some characters very similar to Sorgo, his brothers in desolation. A certain Angus, who was both mentally and physically crippled, and

engaged in confused soliloquies with the dead, and a certain Grok, who was convinced he was pregnant, carrying in the goitre swelling on his throat a baby Messiah striving unsuccessfully to be born and whose wails issued from his mouth. Like Sorgo, the bandy-legged Angus and Grok the talking-goitre were hopeless losers, scorned by everyone, in the first place by their author, who mocked their anguish even when he succeeded in conveying it; unwittingly, it would seem.

The reading session, attended by two female friends of Estampal, was a partial success. My grating voice gave a lento-largo rhythm to Sorgo's wailing supplications, which the ladies were moved by, and which indirectly flattered the author. But at the same time, he seemed vexed by my choice. I confined myself to saying that I very much liked the minor characters, the poor wretches lurking in the shadows. This earned me a pitying smile from one of the ladies, and a downright patronizing one from the other, these two broads, and Estampal too no doubt, clearly thinking, 'birds of a feather flock together'. The novelist nonetheless gave me the job.

★

I left Paris for the suburbs. I moved into a little cottage built at the bottom of the garden, the very long garden, of my new employer's property. A doll's house buried under wild roses. After decades spent in attics, this small dwelling in the midst of greenery seemed very strange. I rediscovered to some extent the smells and myriad sounds of the earth that had marked my childhood, and the company of night-birds.

One summer's evening shortly after I had moved in, I heard a persistent husky hooting under my window. A small barn owl with a wounded wing was stranded there. I carried it into the kitchen and took care of it. For several days it lay exhausted in the makeshift nest that I built for it. I fed it as best I could, not having any shrew mice or frogs to offer it. Its face was a big concave heart, very pale, edged with reddish-blond feathers. In the middle of this pale heart, its eyes, reduced to a pair of slits, formed two delicate commas. The whole time it

was convalescing, I lived in darkness. Then it opened its eyes. Two big golden disks, with a very fixed gaze. When it had recovered, I set it free. Just on the off chance, I made a nest for it on the edge of the roof of my cottage. It took up residence there. I called my co-tenant Flamine.

Flamine was my nocturnal mascot. Estampal had a daytime one, called Iris, in honour of the messenger of the gods. This was not a bird but a very basic simulacrum of a woman: a tailor's dummy of stuffed canvas, headless, armless and legless, but with ample bust and rear. Iris was not dressed in the colours of the rainbow, but draped in a slate- and charcoal-grey satin damask shawl with long black fringes. Even better than a mascot, this torso in deep mourning, stuck on a pole by his work table, he regarded as the figure of a muse. In fact I was forbidden to touch it.

The relationship I had with my boss was actually quite comparable to my relationship with the barn owl. We cohabited at a respectful distance from each other, each operating in a separate world. The small bird of prey and the writer were familiar strangers to me. At night, I would hear the silken rustle of Flamine taking flight, then the whistles she released in single sharp notes over the surrounding gardens in her hunt for rodents and insects. This monologue of hunger interspersed with long silences overlaid the darkness with a crazed surface, and my sleep as well. The daytime I spent in Bruno-Pierre Estampal's company, and worked alternatively in the kitchen or the office, peeling vegetables for his meals, or sorting his mail and going through the newspapers. The letters I filed under different categories – bills, invitations, proposed articles for magazines, criticism and praise from his readers, some of whom fancied themselves as writers. As for the newspapers, Estampal paid great attention to the miscellaneous news items, and circled in red ink, for me to file, articles that might provide him with material to work on. In the final analysis, he fed his imagination the way Flamine fed her voracious stomach, by swallowing bits of flesh, then regurgitating them after digestion.

So it was that one fine morning, as I was leafing through the press, with a pair of scissors in hand, I came across a photographs of two killers who specialised in murdering old ladies, and who had finally been arrested. But for the headline, and the caption identifying their faces, nothing would have distinguished these two young men in a crowd. Killers rarely advertise their violence by the way they dress, at least not in peacetime. I noticed the name of Philomène Tuttu in the list of victims, the date and place of her death, a brief description of her ordeal, and I averted my eyes. The image of her body sprawled in her armchair like a rag-doll, her thighs bared and her head in a bag, resurfaced, intact, beneath my eyelids. For a few seconds I remained blinded, burned by this vision. And this burning spread throughout my body, charring everything in its progress, laying bare my grief and giving rise to a terrible anger.

I felt my anger spread to Estampal who was collecting reports of this kind of crime, relishing their details, much more fascinated by the darkly sinister personality of the torturers than by the often more subtly shaded personality of their victims. If he were to get hold of this story, he would take great pains in working up the characters of the thugs he would elicit from it, like pus squeezed from a boil, and neglect the victims left with dislocated jaws on the bloodstained floor tiles. It was hateful to me to think that he might pen in some feather-detailing round Philomène's dead body. I sliced across the article with my scissors, scalping the murderers just above the eyebrows, then I made hole in the line in which Philomène's name appeared, to make it illegible. Even as I did so, I was aware of the absurdity of my gesture, which at least had the beneficial effect of giving vent to my anger.

Let Estampal write as he wished, after all, let him rummage to his heart's content in the trashcan of daily news, and let him mess with the dung heap of the human heart in order to fill his novels. Many had done so before him, sometimes with brilliance. The brilliance of a jet-black lava stone, streaked with sulphur and vermilion. The colour of the mysterious forbidden fruit that Adam and Eve tasted in the garden of

Eden, perhaps, and whose poison entered their blood, their seed, even the mother's milk that Cain must have greedily sucked. But their countless descendants, and murderers first and foremost, had no more succeeded than they in fathoming the mystery of the evil that plagued them, infatuated them. They simply went on committing this evil, prostituting all their intelligence and energy to its service. And even the most penetrating of analysts and chroniclers of this perplexing mystery have been unable to elucidate it. Perhaps only a few innocents, chafed to the soul by it, have come near to doing so, but then found themselves at a loss for words capable of expressing their extraordinary intuition.

As for myself, I could not really claim to be any different. I had backed out of Philomène's apartment, driven away by nausea and terror. I had left her alone amid the desolation of her ignominious death. I had behaved with the same cowardice as at the time of Léontine's death, then that of Auguste Marrou. On each occasion I had fled, the first time into the woods, the second into a river, and the third into madness. It was only with the Baroness Elvire that I had been capable of making my presence known at the last moment. Philomène I had abandoned. From the hands of her torturers, she had passed into those of a forensic pathologist, then she was cremated, and her ashes scattered I did not even know where. No one had closed her eyes.

I was left high and dry with my anxieties and ill temper; Estampal staked no claim over Philomène, showed no interest in the saga of the serial killers despite the fact they were hitting the headlines at the time. His thoughts happened to be elsewhere, because carried away by the beginnings of success. His latest novel, the famous *Beyond the Pale*, which had appeared a few months earlier without causing the slightest stir among the critics at the time of publication, suddenly came to the fore in a crowded field of books released on to the literary market. He even won a prize, and was subsequently made an offer for a film adaptation. This made him more talkative and sociable, he began to go out frequently, to travel.

He flirted with fame. He even favoured me with his confidence by recounting to me one day the obstacles he had to overcome in his literary career. He had lived for a long time in the South where he ran a business as a dealer in second-hand goods. He had been married and divorced twice. After the death of his mother, five years ago, he wanted a change, of environment and lifestyle, and decided to devote himself full time to writing, an activity he had until then been able to pursue only in his free time, of which he had too little to allow him to complete his novel-writing projects. He had chosen to settle in the Paris region, a fair distance from the city whose noise and bustle did not suit him, but to which he enjoyed having access for its cultural benefits. The recognition he was now getting at over fifty years of age justified the risks he had taken, and was a reward for his efforts, his pugnacity; in short, for his talent. And he intended soon to display the resplendence of his talent in a dazzling new novel that would eclipse the mediocre asteroids wandering aimlessly in the Parisian literary firmament. Getting his foot in the door had made him too big for his boots.

*

From the days of being a second-hand dealer, Estampal had retained a taste for old furniture, and unusual objects and curios. He even had some stored at the back of his garage, as well as in a little circular room adjoining his office, closed off behind a sliding door, before which Iris stood guard. His sitting-room was a cleverly assembled jumble of bric-à-brac. But I had eyes only for one thing, a barrel organ made in the same year that Philomène was born. It was a tall wooden box painted with varnish, and with gilt scalloped edging, mounted on two big wheels that creaked as soon as you touched the instrument, and whose clogged pipes sputtered out music of a kind, as pleasing as a consumptive's cough. I wished that Estampal would have it repaired, but he had other fish to fry, completely taken up as he was with looking after his interests as an up-and-coming writer. He even neglected the great opus he was supposed to be throwing in the faces of his

open-mouthed contemporaries. I was alone most of the time, and apart from a little housework and sorting his plentiful mail, I did not have much else to do any more. His muse was left to languish all day long.

One afternoon as I was getting ready to go out to do some shopping, I noticed a figure standing outside the gate, holding a bouquet of flowers in his arms. I thought it must be a deliveryman from a florist and I went to meet him. He did not stir, or even lower the bouquet that concealed his face, and when I spoke to him he asked in a strangely unmodulated and thin voice, 'Where's my brother?'

An absurd dialogue then followed, I unable to understand any of his questions, he persisting in not giving direct answers to any of mine, and hiding behind his spray of purple irises. In the end I told him there must be some mistake, but the floral-headed buffoon squeaked, 'Not at all, not at all, I know perfectly well where my brother lives, right here. Bruno-Pierre lives here. Here.'

This familiarity took me aback, and also his voice's jerky delivery of the repeated words. I suspected him of being a crackpot. I explained that Monsieur Estampal was away, but that he could leave his bouquet with me, and Monsieur Estampal would find it on his return.

'Not at all, not at all,' the crackpot insisted, 'the flowers aren't for him. They're for mother.'

I just managed not to give way to uncontrollable laughter, and explained to him there was no woman other than myself living at this address. And the refrain began again: 'Not true, you're the stranger here, otherwise you'd know that mother's in the house. She's in the office, waiting for me.'

No easy task getting a lunatic like this to shut up. On the off-chance, I said: 'Oh yes, and what does your mother look like?'

The reply left me dumbfounded.

'She's very beautiful. She used to be even more so, when she was young. And still alive. Now she wears an ash-grey shawl.'

'Ash grey?'

'Exactly. With black fringes.'

My astonishment only grew as the self-proclaimed brother of Estampal and son of a stuffed dummy finally revealed his face to me. He had the colouring and features of a mulatto, frizzy greying hair, bronze-coloured eyes as fearful as those of a fawn. Not easy to lose your temper with such a vulnerable-looking creature, no matter how exasperating. He began to sway slightly, backwards and forwards, his face full of distress.

'I must speak to mother. I have to tell my brother everything, even if he isn't here.'

'What do you mean, "everything"?'

'Everything mother says to me.'

He had a way of going round and round in circles that confused me. Again, I tried to reason with him; it was a waste of breath. His distress increased, his swaying accelerated, and he began to moan.

'My head, my head hurts. . . there's confusion, shouting, scheming. . . help me put a stop to it . . .'

I was afraid he was going to lose consciousness. I opened the gate and reached out my hand, to support him. He grabbed my hand and put it to his forehead.

'There, there. . . can't you hear, can't you feel?'

'What?'

'Words, they're hairy, they have a damp dog smell, they bark inside my head . . .'

The situation was not only ludicrous, it was becoming critical. I carefully withdrew my hand, but he caught hold of it again and once more pressed his forehead against my palm. He was trembling. I led him to the house at a gingerly pace. I wanted to call a doctor. But as soon as we reached the steps, the ailing visitor recovered and, disappearing into the hall, without hesitation made his way towards Estampal's office and stood there in front of the tailor's dummy. Obviously, he was familiar with these premises.

'A vase,' he said. 'We need a vase.'

I brought him one. He put his bunch of flowers in it and set it down at the base of the dress stand. I was a little too hasty in

158

thinking that, his mission accomplished, he was going to calm down. But pointing over Iris's shoulder to the sliding door behind her, he formulated another request: 'We must open the door. That door, there.'

I replied that it was locked and I did not know where the key was. But the nutcase knew where the key was – pinned between the muse's rounded breasts, underneath the shawl.

'But who are you?' I asked, as if he had just that moment turned up in the office.

'Gabriel, my name's Gabriel. I'm Bruno-Pierre's older brother.'

Despite the striking lack of resemblance between the two men, I was beginning feel less certain. This Gabriel was raving, of course, but with some direction to his rambling thoughts. There being no way out of his labyrinth, it must lead to some kind of secret chamber. The discovery of the little key roused my curiosity, dispelling the thought of asking a doctor to come to the rescue.

So I joined in Gabriel's game and obeyed every one of his cranky instructions.

I slid the key into the lock and opened the sliding door. A fairly large deep alcove was obviously used as a boxroom. One wicker trunk was filled to the brim with bolts of shimmering-coloured fabrics, another with threadbare teddy bears, rag-dolls and china dolls; an oil lamp stood on a shelf next to a table with a cabled pedestal. An enormous wardrobe, or rather a dark wooden kiosk, took up half the space. It was a confessional. A small circular window with slightly tinted frosted glass diffused a orange light over this jumble.

I turned to Gabriel, now elevated to master of ceremonies. He resumed his peremptory monologue in fits and starts.

'The lamp. It's got to be lit.'

You could see very well without it, but I complied.

'The lamp, there.'

I put it where he was indicating. Some detail must have eluded me, for he repeated, 'There, there. . .', pointing to the door of the confessional. I opened it and was taken aback. A

plaster mask hung above the seat meant for the priest, at the level of the grilled hatchway on each side of the cubicle. A death mask with closed eyes, thin nose, and pinched mouth. No doubt that of the once-beautiful mother. I set the lamp on the seat-bench, casting a harsh light on the mask. Standing aside, obviously extremely agitated, Gabriel said no more. I closed the door. Then he went and knelt on the little knee-rest of one of the two booths on either side of the confessional, and rested his forehead against the grille. Then he tapped on the partition and began to speak in a yet more faltering, imploring voice. I followed his example and slipped into the other booth, but remaining silent. The sharp-featured profile of the mask gleamed white behind the lattice screen. Gabriel, whose doubly obscured face I could barely distinguish, spoke to his mother.

And I recognized Sorgo, Angus, Grok. The same words, the same lamentations, the same anguish in the face of evil and of his own helplessness in arresting its progress. Gabriel went running round in circles, gasping for breath, amid the chaos of violence, in the freezing desert of love. He stumbled, grazing himself on the words, on the images that haunted him. He felt responsible for all the world's evils and misfortunes. He was no more able to restrain the hand of the assassins than he had been capable of keeping his mother alive. He asked his mother forgiveness for the wrong that she had done to him by aban-doning him over half a century earlier, and for all the crimes he had not committed. He begged her pardon. One word from her, a look, a kiss on the cheek.

I had difficulty following what he was saying, a monologue more fragmentary than morse code signals, I was lacking too elements many to be able to decipher it all, but I understood at least one thing: he was Estampal's muse. A muse in a constant state of disquiet, entrapped in a ghoulish gimcrack stage-set so that his brother could calmly plunder his muse's suffering whenever he needed to.

I crept out of my booth and into the centre cubicle. I laid my hand flat against the screen on Gabriel's side, and spoke to him, in the name of his mother. I lent my voice to the dead

woman's uncommunicative soul, I said to the aged orphan the words he dreamed of hearing, and in the end I told him that now, thanks to him, I rested in peace. That he had enabled me to attain the light, not of a lamp but of the heart, and that the dead woman's face I had left behind on earth had now melted away in this filial light. Which was why he was never to return to this place, for he would no longer find me here. He had released me, at last I was going to be able to rest in the invisible. We were both released. Released and reconciled, reunited in the peace of silence. All was forgiven.

'Yes, yes...' stammered Gabriel, whose tears I could feel through the thin wooden grille trickling against my palm.

I spoke at length, without reflection, without really knowing from where I spoke, from what tenebrous zone of my imagination and intuition, suddenly illuminated by compassion and rebellion. For both vibrated in me in unison, dictating every word, every gesture. And the most amazing thing was that, the entire time this dialogue lasted, my voice became gentle, soothing, acquiring almost melodious modulations.

With my free hand I took down the mask, then reduced the brightness of the lamp to a very dim glow. Finally, I emerged and joined the penitent huddled in his corner. I told him he had been right to insist on speaking with his mother, she had told him many things. He could go away now and keep all to himself everything that had been imparted to him. For those words were intended for him alone, not for his brother. He rose, took a few steps within the alcove, his wrapt gaze contemplating the horizon of some wonderful dream. The oval of golden light cast by the bull's-eye window shimmered at his feet. The bull's eye at the crib, I thought, and he, Gabriel, a simple soul who had come down from the hills, being assailed on the way by demons, to lay his suffering in the warmth of the manger.

But where was the child? Surely not in this old sin-box transformed by Estampal into a morbid puppet theatre. The child was Gabriel himself. And the prayer I had left behind with my own childhood came stealing back to my lips. 'Abide

with us, Lord, for evening falls.' And that evening without end, in which so many foundered, stirred in my heart like a wounded animal at the bottom of a ditch.

<p style="text-align:center">★</p>

Gabriel was living at a so-called rest home, close by. He was there for an indefinite period, in supervised care, but free to come and go as he wished. When Bruno-Pierre Estampal returned the next day, I informed him of his brother's visit.

'What brother?' he asked, raising his eyebrows.

He had got so used to charting a course between deception and lies that he had lost sight of certain shoals of reality, and for a moment his surprise was not even feigned. I put him straight by naming Gabriel, then I showed him the bouquet and mentioned the confessional episode, omitting a few details. Estampal turned pale and grew angry, reproaching me for having let a stranger into his office. I reminded him that, being his brother, Gabriel was not really a stranger, and that he had turned up with a bunch of irises as a tribute to the mother they shared.

'So what? The man's a crackpot none the less, a lunatic! You had no proof he wasn't fantasizing. As it happens, he is raving the whole time. Couldn't you see for yourself? What havoc did he wreak in my office? What yarn did he spin you?'

The more he raged, the more I displayed calmness with exasperating ingenuousness.

He was anxious to know what had happened in the boxroom.

'He communicated with his mother. They said farewell to each other. A very serene farewell,' I said.

I saw in the look he darted at me that he suspected me of having been infected by his brother's madness. He went to inspect his alcove, furious that I should have dared enter it in his absence.

'The mask! Where's the mask?' Now he was repeating his words, like Gabriel, but shouting at the top of his voice.

'What mask?' I said with surprise, without ever relinquishing my air of ingenuousness. He was beside himself, rum-

maging through the wicker trunks among the fabrics and the threadbare teddy bears, searching under the seat-benches in the confessional. I claimed to have stood aside, in the doorway of the lumber room, and to have heard nothing of the private conversation between Gabriel and his mother. I acted dumb with unrelenting sweetness, denying having seen the visitor remove any object whatsoever, and emphasizing once again that he had gone away smiling, calmed by the farewell blessing given to him by their deceased mother.

In the end Estampal removed, or at least lifted, his own mask, and revealed to me some family secrets until then hushed up. He told me how he had suddenly learned of Gabriel's existence in the aftermath of his mother's death: she had had two husbands, two sons, but had erected a dividing wall between her two lives. Her death brought down this wall, and behind the rubble he who had always thought himself an only child discovered the existence of a mixed-race half-brother, eleven years his senior. Their mother had walked out on the husband and child of her youth, in order to follow another man who was to become the father of Bruno-Pierre. And she had completely blotted out her past, so it appeared. She had waited till the hour of her death to wrest her son from the shadows, leaving to her lawyer the task of breaking the news to the younger son at the reading of her will. News whose effect on the person concerned had been like that of a scorpion bite on his neck. At nearly fifty years of age, he felt as cheated by his mother as Gabriel had at the age of nine, when abandoned by that same mother. But while the younger son felt resentful, the elder had slowly foundered in a betrayed child's tears, and a little boy of nine years old continued to weep inside his sixty-year-old body.

What bonds could Bruno-Pierre form with this stranger catapulted so late into his life? A threefold stranger: by virtue of his long unknown existence, his African origins on his father's side, and finally his mental disturbance.

For want of any fraternal bond, he had created one of dependency and exploitation, having quickly realized how he

could take advantage of this delusional depressive. And their mother, the beautiful two-faced Iris, the fugitive and the dissembler, had been elevated post mortem to the status of muse. A genuine feline, this Estampal: once he got over his initial shock, he had recovered his equilibrium with rebounding flexibility, while his brother remained like a chick fallen from its nest, dying of cold and hunger. And the cat had played with the aged chick.

I left Estampal in a state of extreme perplexity with regard to the death mask that had disappeared as if by magic. I refrained from telling him I had tossed the wretched plastercast into the Seine. After all, it was the younger son's turn now to go in search of his mother, and anyway this puzzling disappearance might provide him with a good story for his next novel.

I reckoned that my collaboration with my employer, the writer by unauthorized proxy, had reached the end of its term. I left the little cottage and the barn-owl Flamine with regret. I returned to Paris, and moved back with my suitcase to Fanfan's.

But Fanfan had lost her cheerful ebullience, she was in desperate straits: her house, like several others nearby, was under threat of demolition. Too decrepit, insalubrious. Too unprofitable, above all. The intention was to build in its place an apartment block several stories high. So I was lodging on an ejector seat, and once more I was out of work. But I was getting on in years and had acquired a certain ability to temper my anxieties. I scoured the small ads again, and had a few job interviews, all just as fruitless as Fanfan's battles with the local council to save her humble dwelling.

VIII

When you cannot find a job the best solution is to invent one for yourself. Which I did in a flash of inspiration worthy of Archimede's Eureka. And my idea worked.

It was thanks to Scrabble that this idea came to me. We played a game in which Fanfan got rid of her last letters, G, R, and N, by using vowels in two words already on the board, 'mouse' and 'ankh'. And that made the word 'organ'. This was the trigger: I pictured Estampal's old barrel-organ, and said to myself, I could have a go at being a wandering organ-player.

The very next day I went in search of an instrument. I eventually found one of average quality and less finely decorated than Estampal's, but in excellent condition and available on credit terms. I also bought myself a long hooded raincoat, of steel grey, some black lace-up boots, and several pairs of gloves of various colours – bright red, lemon yellow, purple, royal blue, almond green – by way of kitting myself out with a street-performer's outfit. I learned a dozen songs; I went down to the cellar at night to train my voice, to attune it to the organ.

'You bellow like a sea elephant in distress,' commented Fanfan. I found this encouraging; such exotic sounds would surely attract the attention of Parisian pedestrians, who were always in such a hurry.

The first time I took up a position with my instrument close to a market, I felt very ill at ease. I began with just the organ, standing stiff as a statue, with a yellow glove on my left hand and a purple one on my right, having been unable to make up my mind which to wear that morning. I cranked out the tune of '*La Valse à Dédé de Montmartre*[1]' then that of '*Mon amant de*

[1] Dédé of Montmartre's Waltz

la St-Jean[2]. I turned the handle faster as '*Marinella*' played, since I found it irritating, and restored the tempo for '*L'Hirondelle du faubourg*[3]'. The passers-by slowed their pace, casting looks of amazement at me, and moved away with a touch of hesitancy, my shrill notes a bemusing drizzle to their ears.

The first coin that clinked in the tin cup placed at my feet made me jump, as if a pebble had dropped into my brain, and in a fright all of a sudden, I wondered, 'What on earth am I doing here? What game am I playing? Who am I?'

Indeed. Was I a melancholy busker, a good-for-nothing making a public spectacle of that very nothing as if it were some curiosity worthy of interest, a beggarwoman disguised as a mime musician? All of these things to some extent. Moreover, my first donor was a kid of about three years old whose mother had given him the coin, and he stared at me open-mouthed, his eyes like saucers. We found each other equally alarming.

The child had given the signal, other coins clinked in the cup. Especially after '*Froufrou*', 'The Third Man' and '*Le temps des cerises*[4]', old favourites you could count on. This finally gave me the courage to sing, and when the tune of '*Le Piano du pauvre*[5]' began to play, I launched into it.

> '*Le piano du pauvre se noue autour du cou,*
> *La chanson guimauve Toscanini s'en fout,*
> *Mais il n'est pas chien, il le lui rend bien,*
> *Il est eclectique,*
> *Sonate ou java,*
> *Concert ou polka,*

[2] My Midsummer's Eve Lover
[3] The Outer City Swallow
[4] Cherry Time
[5] The Poor Man's Piano

Il aime la musiquel . . .
C'est l'Chopin du printemps . . . [6,]

I did not have the lilting, caressing and mocking voice of Léo Ferré, I sang in sepulchral tones that in no way could be described as foot-tapping. People nevertheless stopped, listening and eyeing me incredulously. Was I a man or a woman, a living creature or a zombie escaped from the catacombs, my audience must have asked themselves. Unperturbed, although sick to my stomach with nerves, I sang my song. I continued with a rendering of '*Les Roses Blanches*[7]' fit to make the pigeons, and even the paving stones, weep, then with Charles Trenet's '*L'Ame des poètes*[8]'.

At the end of my recital, a few people clapped. My cup filled in the twinkling of an eye. A man came up to me and dropped a compliment in my ear and pressed a large note into my hand. 'Yours is not a lovely voice . . . it's unnatural!' he exclaimed in a murmur. I accepted the compliment with circumspection, and the note with gratitude.

And the barrel-organ became my livelihood, as well as my companion. I called it Léo, in honour of Ferré. It was my poor-man's organ, my all-weather Bach with its pavement chorales. We strolled the streets at a leisurely pace, stopping as the mood took us. I would work the cylinder and the music flowed, at once fitful and montonous, so simple and entrancing. Windows would open and people would lean out, some resting their elbows on the railing to listen at their ease. Hands would wave to catch my attention, and throw down

[6] The poor man's piano is tied round his neck,
 Its corny song Toscanini makes fun of
 But it's not mean, it doesn't care a damn
 It's eclectic,
 Sonata or java,
 Concert or polka,
 It loves music. . .
 It's the springtime Chopin
[7] The White Roses
[8] The Poets' Soul

coins hastily wrapped in a piece of paper. My pockets were always filled with small change. I also collected smiles, applause and thank-you's. It sometimes happened too that some foul-mouthed individual shouted at me to get lost, because my music got on his nerves.

On one occasion I returned to Philomène's street. I left a flower on the pavement outside her building, beneath her window, and I sang some nineteenth-century love-songs for her. I owed her a memorial, since she did not have one. And that memorial was me, with my wandering minstrel's voice, and my companion Léo.

In fact I was more than a memorial – I was a family vault. A very disparate family, whose members had no other blood tie between them than the blood that ran in my veins. I welcomed into this vault all those men and women who had crossed my path and who had stretched out a hand, even so much as a fingertip, to me, a bastard. As I did not know, or had forgotten, the date on which each of my tenants had died, I followed my instinct in celebrating their memory. Some mornings, emerging into the street, I would select one or other of my departed tribe, depending on the mood of the sky or that of my thoughts, I would mentally salute them, and make them my guest of honour for the day. I would buy flowers to put in my buttonhole or in my belt, and I would attach some to Léo's casing. But a few of the living were also entitled to being fêted in my thoughts, such as Gabriel, to whom I dedicated a little tune now and again, to hail him in the meanderings of his tear-misted dreams. Loulou too would pass through my mind every so often; for Baby Owl, I would play lively tunes, humming under my breath, as if frightened of scaring him, even in a dream, with my funereal voice. And for Pergamon, I sang, even more quietly than for Loulou-Elijah. In the end, I played and sang more for my own private audience than for the anonymous strangers who listened to me on the pavements or in the public gardens.

★

168

The developers won, Fanfan's house and those adjoining it were condemned, doomed to imminent disappearance. I had to make up my mind to search for a new home. I found a room in the neighbourhood, on the ground floor at the back of courtyard that got little light and smelt strongly of cat's piss.

Fanfan did not search at all. She took her eviction as banishment, she was being sent into exile, outside her own walls, outside the cradle of her memories and her way of life. She was born in this house, she had always lived here, grown up and begun to grow old behind this worn counter, among the glasses, tankards, and bottles, the smell of dark-tobacco cigarettes, amid the hum of gossip and laughter, of confidences shared, of arguments, and popular fourteenth-of-July melodies. She never dreamt that she would end her life anywhere else.

She rejected all offers, all advice, she entrenched herself in her anger. Right up to the very end, she resisted, holed up in her deserted dive with the salvoes of her invective for sole weapon of defence. She was no match against the forces of law and order, or the bulldozers.

She disappeared from one day to the next, no one knew where she had taken refuge. Several months after she had been routed, I caught sight of her one afternoon in Boulevard Ménilmontant, reduced to beggary. She was lumbering along the wall of Père-Lachaise cemetery, stooped, and filthy from head to foot. She was dragging a shopping cart packed with the few belongings she must taken with her from her lost paradise. I walked towards her, but she did not recognize me. Her tongue was furred and she was glassy-eyed. It was clear, she was no longer pepping up her poverty with champagne bubbles, or even sparkling wine, she was drowning her misery in cheap plonk.

Was she ensconced in some corner of the cemetery? Was she dragging round her dictionary along with her rags and tatters and her litres of wine? Did she play Scrabble in the evenings with the spirits of the dead? At Père-Lachaise she was spoilt for choice of illustrious opponents.

I followed her for a while, pushing Léo, and in the hope that she would stop and finally recognize me I started to turn

the handle. I called out to her with the tune of '*La plus bath des javas*[9]'. She scuttled away, growling curses, as if her underskirts were on fire. I never saw her again.

Some people are like that, on no account should they be moved, they are not transportable, they can only thrive and survive in the soil in which they originated, otherwise they sicken and die. As long as they are left in peace in their native plot of ground, whether it be earth, sand, rock or vineyard, snow or forest, or even asphalt, they are kings, queens, lords of life. Fanfan had been a great lady of Belleville, running her bar for the hard-up like a princess holding court. But outside her realm of just a few square metres, no happiness or nobility, no hope. No salvation. A drop into nowhere.

The local tramps must have gone in search of a new haven, without great success. Some came back to prowl round 'Fanfan's', which already was no more than an enormous hole in the ground fenced round with hoardings. Every time he passed by, Turlute, grumpier than ever, with a beard down to his waist, would piss on the building site signs – 'Keep Out', 'Danger', 'Hard Hat Zone'. He had nothing to read, and not having an address he was not allowed access to the public library. I had the idea of vouching that he was resident at my place, and I accompanied him to the library where he was able to register. He took great care of the books he borrowed, wrapping them in plastic, gingerly turning the pages. He would settle down anywhere, sometimes on the edge of the pavement, both feet immersed in the water in the gutter, his boots standing beside his bag. He would casually place a little box beside him, just in case some passer-by might want to relieve himself of a few francs. When the weather was too cold, or it was pouring with rain, he would take refuge in the metro. But as he was subject to violent fits of misanthropy, he would sooner retreat into churches, which are generally much less crowded than the metro. He would then pursue his reading of detective novels, in silence, by candlelight, under the

[9] The coolest of javas

170

protection of saints of plaster or marble. And when he got to the end of a book, he would snap it shut, raise his eyes to heaven with a slight squint, and purse his lips in a sceptical grimace. There was probably nothing that could surprise him in matters of crime.

Being out and about all day long with Léo put me in the way of meeting many people. So it was that I came across other former patrons of Fanfan's. We exchanged a kaleidoscopic range of news, about Fanfan, the disappearance both of her bistrot and herself, the various goings-on in the world, and more particularly the bloody attacks that had been taking place in the capital over the past few months. With some of those I encountered, these pavement contacts were prolonged at café tables; a few became friends.

Damaso had left his native Peru nearly twenty years ago. Having come to Paris for a year to study French, he had never gone back. The revolution of May '68 had taken place towards the end of his student visit, and he had abandoned his classes for demonstrations and meetings. He enthusiastically took part in the events, determined to carry the flame of protest back to his country when he returned there. In the streets of the Latin Quarter, where the paving stones had been taken up, he shouted the lines José Angel Valente had written in homage to the great Peruvian poet César Vallejo:

El mendio da nada
O de justicia.
El roto, el quebrantado,
Pero nunca vencido.
El pueblo, la promesa, la palabra.[10]

But another revolution, a very private one, put an end to his plans for importing anarchy. He encountered God, personally,

[10] The beggar of nothing
Or of justice.
The poor man, the law-breaker,
Yet never vanquished.
The people, the promise, the word.

no less. Actually, he told me this meeting, as unexpected as it was disruptive, had occurred in an unusual way, through the intermediary of a very modest messenger: a rabbit. I could not help asking whether his divine rabbit was an albino. No, it was a beautiful russet-brown, nice and plump, with honey-coloured eyes. And he had come across it neither on the barricades, nor at a butcher's, but near the Châtelet, in the window of a pet shop on Quai de la Mégisserie. One of his shoelaces had come undone and he bent down to tie it up again; it was then that he had seen the copper-coated rabbit, huddled in a cage on the other side of the window. They were both at the same level. The caged animal, with its long ears flattened on its back, watched him through the wire netting and the pane of glass. Eyes like mirabelle plums, gleaming with a gentleness so intense, so penetrating, it was urgent, heart-rending. Resounding in the density of its silence, vibrant in its stillness, it was a gaze that arrested Damaso, took his breath away, and left him half kneeling on the pavement, with his hands dangling over his shoe. This silent gaze felt like a caress to the innermost part of his being, suddenly baring him to his very soul. And the thought of God, which had not bothered him in the least since his early childhood, engulfed him like a tornado. A wordless thought, primal, incandescent. Without reflection, he rose and entered the shop to buy the rabbit. Driven by his inner tornado, he hurried over to the Ile de la Cité, entered the cathedral of Notre-Dame with the cage under his arm, and walked briskly up the nave. He came to a halt in front of the altar steps, waiting. He was not waiting for anything in particular. The shock of illumination he had just received overwhelmed all expectation in him, and at the same time whetted and raised his expectation to infinity. He was not looking for any miracle, not even a little sign – the revelation had been accomplished for him, in a momentary flash, once and for all. He did not even know what had really happened, or at least he was at a loss for any word equal to the event. He was brimming with such joy it gave him an obscure sense of panic.

Someone eventually came up to him and in a low voice asked him to move away from the altar as a service was about

to begin. It must have been a young priest, or a seminarian. The sight of the rabbit ruminating in its cage had not in any way illuminated this young man, not even amused him, it had rather annoyed him and he reminded the nuisance visitor that it was forbidden to bring animals into the cathedral. Damaso did not know what to say, he was as much hurt as outraged by such lack of understanding. He stammered a few words about his heavenly messenger, but the other young man dismissed him with icy politeness. As he was walking back down one of the side aisles another, older priest approached him. The young guardian of the temple who had just sent him away must have recounted the incident to his colleague, and the latter, far from classifying him straight away as a crank, wanted to hear more. He accompanied him to the church porch and suggested they went and talked for a few moments in the square nearby. He listened very attentively to the zany story of this debutant convert, and by way of commenting burst into hearty laughter. Finally, resting a hand on Damaso's shoulder, he said, in between two chuckles, 'God's surreal! More invent- ive than the most impudent surrealist! Your experience is magnificent, but you now have to transform this sudden infatuation into a long-lasting love affair, and that's the most difficult thing of all.' Then he asked to see the famous rabbit. Damaso took it out of its cage and put it on the priest's lap. Stroking the animal snuggled in his lap and shaking his head, he repeated several times, 'God's crazy!'

Damaso went home with his surreal companion, but the presence of animals was no more permitted in the university's hall of residence than it was in churches. So he moved out, subsequently abandoning his studies. He made his living from odd jobs, devoting his free time to nurturing the fire of his inward revolution. He coddled his rabbit, gravely called him 'Amigo', while the latter, more leporine than angelic in its everyday conduct, chewed everything that came within reach of its incisors and shamelessly left droppings on the floor. But the life of a rabbit, even one tenderly cared for, is relatively short, and one spring morning Amigo gave up the ghost, a

humble and very reticent ghost. Damaso decided to live on the street, since he was now on his own and it was only for the sake of Amigo's welfare that he had worried about having a roof over his head. He interpreted in his own way those other lines of José Angel Valente – 'Let us go and sing the unsingable,/Let us finally offer the enigma an Oedipus. . .' – by acting as a Franciscan electron released on to the streets of Paris in joyful freedom, always on the lookout for the '*mendigos de nada*' who had ended up homeless, sharing with them whatever he collected from begging and from the dustbins.

Anthim was the complete opposite of Damaso, whom he nicknamed 'Rabbit's arse'. He was dualistic in every respect, even in his disparate-coloured eyes, one pale blue, the other black. The blue eye he had inherited from his mother, an Estonian, the black one from his father, a Tartar from Zelenodolsk on the Volga, who claimed to be descended from the Mongols of the Golden Horde. Anthim was a shortened version of his two first names, split in half and reassembled: his mother had called him Anton, in honour of the writer Anton Hansen Tammsaare, advocate of his country's short-lived and thwarted independence, while his father had named him Ibrahim. The son opted neither for his mother's Lutheranism nor his father's Islamic faith, nor for either of their countries of origin. He fled his homeland and professed a virulent atheism, regarding the human race as a load of diarrhoeic farts produced by the earth, or of drunken belches in the face of the deceptively lovely azure sky.

Anthim was a sculptor, but he preferred to describe himself as a wrecker. To see him at work, grinding down clay, attacking wood, smashing stone or twisting metal, was an impressive spectacle. He would lay hold of his materials, every time, as if his life depended on it, as if he were having to tame a wild animal. He turned them into monstrous hybrid bodies, bristling with nails, splinters of animal bones, glass, bakelite, iron rods, bits of electric wiring. He scoured dustbins and rubbish dumps as thoroughly as Damaso; two panners of trash, one seeking to give substance to his visions and demons, the other

seeking to give sustenance to the local down-and-outs. In fact they would sometimes go scrounging together. I would occasionally join their night-time expeditions that had something of the treasure hunt about them.

Anthim was subject to fits of depression at regular intervals. He would then turn his back on sculpture, at least in its monumental form, and start making flowers out of paper or fabric – nebulous peonies, sunflowers as lightweight as balls of fire, crystalline hellebores, quivering poppies. He retired into a corner of his studio and worked in gloomy silence: he looked like a convict sentenced to lacemaking. When his fit was over, he went and sold these flowers of depression and resumed his battle with iron, wood, stone and refuse. Ultimately, some good came of his bouts of depression, there being a bit of money in it for him, as he sold his pretty flowers with their whiff of poisonous languor far more easily than his sculptures, whose beauty was much harsher, more strident.

<p style="text-align:center">★</p>

I was mugged twice during my years as a street minstrel. On each occasion at nightfall, on the corner of a deserted street. One evening, there were two guys, who appeared out of nowhere, it seemed, so sudden was their attack. One of them brandished a knuckleduster in front of my nose, sneering at me, while the other one helped himself to my day's takings. As they were wearing woollen hats pulled down to their eyebrows and had the collars of their jackets turned up, I did not even see what they looked like. The next attack was more drastic: there were three of them, very excited, one of them grabbed me by the shoulders and pressed a box-cutter to my throat. He hissed threats and obscenities in my ears and kept kneeing me in the back while his associates searched my pockets. Then they attacked Léo. This big wooden box without even any money inside it upset them and they laid into it with iron bars. Then they slashed my raincoat with the box-cutter, before beating me up. When I fell to the ground, folded into a Z shape, they ran off.

I could not move, they had fractured my ribs, and I felt intense pain all over. Not only did I not lose consciousness, my mind remained completely alert, but it fastened on to some ridiculous ideas. I thought that Léo and I would make an excellent subject for one of Anthim's sculptures. The organ was smashed to pieces, my raincoat was in shreds, and my body in zigzags. If he had come across us lying in the road, he would surely have loaded us on to the little trolley he always used on his nocturnal rounds, and he would have carried us off to his studio to make us undergo a final metamorphosis.

This time I got a very good look at the faces of my attackers, they remained before my eyes as if engrained in my pupils. One of them had hazel-coloured eyes with magnificent curved black eyelashes, another had an attractive dimple that appeared in his right cheek when he laughed. These lingering traces of childhood in their faces only heightened the ugliness of their expressions, the viscous brilliance of their eyes. Philomène's assassins, whose pictures I had seen in the newspaper one day – two ordinary-looking guys I would not have recognized by now – must also have acquired that same cast of features distorted by convulsive brutality, the veins of their temples and neck too must have been swollen like big purple slow-worms, and their lips curled bestially as they indulged in the pleasure of humiliating, terrorizing and destroying. In a frenzied lust of violence and hatred, any face becomes obscene, even that of a child. I could better understand Damaso, to whom the god of mercy had been revealed in the eye of a caged rabbit. God is sometimes short of human beings suitable for revelationary purposes.

I came out of this mugging with a neck brace, an archipelago of dressings all over my body, and an arm in a sling. My barrel organ was a write-off, I gave it to Anthim. My misadventure inspired him with a fruitful idea, he embarked on a cycle of sculptures dedicated to broken voices, be it by the blight of alcohol, drugs, madness or death.

While I nursed my arm and vertebrae, he administered vigorous treatment, with saw, hammer and blow torch, to my

demolished barrel organ. He entitled this work 'Léo of Belleville'. When I saw my instrument transformed into an enormous eruption of mineral ore spilling obliquely from its half-burned wood-gangue, it put me more in mind of the voice of an angry prophet, or the belling of a stag frantic with desire.

Anthim gave me a photo of Léo post mortem, inserted in a frame made of the organ's residue. It was a great consolation, certainly, but the fact remained that I had lost my livelihood. Not being endowed with a bold Franciscan soul, like Damaso, and not having mastered the art of destitution, like Turlute, I did not at all envisage going and living on the streets. Besides, the streets had lost their charm, fear had taken root inside me, and as evening drew near I would feel it quaking deep in my stomach. Moreover, I was tired of looking for a job, and I no longer had the energy to invent one for myself. I had just turned fifty, and I said to myself that it might be time to return to the mountains. When I left, it was like moving away from some huge dark body that had taken the place of my mother. A quarter of a century later, I no longer thought of the mountains in that way. It was more like turning to a sister, an age-old sister, with an arborescent body, streaming with shadows, icy waters, quivers of light, wind and silence.

While the mountains slowly rose from the long oblivion in the west of my memory where I had let them slumber, while they reasserted within me their shapes, forces, colours, great upheavals rumbled in eastern Europe. When the Berlin Wall came down, Anthim celebrated the event in his studio. His party lasted several days, with anyone free to join in. It was a very rowdy coming-and-going with lots of dancing, the hub-bub of those revellers rivalling the music of Tom Waits, Czeslaw Nieman, Janis Joplin or Wladimir Wysocky, singers with whom Anthim felt selective affinities. Even the police invited themselves, but because of complaints from the neighbours.

This party marked the beginning of the round of departures. My friends left one by one. Unable to put up with the cold Parisian winters any more, Turlute felt the desire for a change

of climate: he headed off for Marseilles. Never having bothered to regularize his position as a foreigner on French soil, Damaso received an expulsion order. He did nothing to avoid it, reckoning that he could just as well play his part of 'useless servant' on the streets of Lima as on those of Paris. And anyway, it would be an opportunity for him to see his family again, if they still remembered him and accepted him the way he had chosen to live his life. As for Anthim, an art gallery took up his works, which finally became a lot more valuable than his flowers of melancholy. He went off to New York to blow his newly acquired fortune and to find new sources of inspiration.

Fanfan's Belleville was a thing of the past.

So it was that my friends, the few friends I had at last managed to make, disappeared in the space of a few months. And my closest, dearest friend, Léo, had undergone radical transformation. He would never play music again, nor invite me to sing. I felt more alone and bereft than at the dual deaths of Léontine and Antonin, above all more exhausted. I could not even say, 'Abide with me, Lord, evening falls', for even if the Lord had deigned to cross my path, he would soon have lost sight of me, as I zigzagged all over the place, with a dry dusty wind constantly driving me here or there, chasing me away from myself. With whom was he to abide?

I repacked my suitcase, gathered together my savings, and took the train to those mountains that were sending me obscure insistent signals. I identified the Pyrenees with my unfulfilled, unconsoled childhood. The Basque childhood that had clung to me for half a century, without my being able to shake it off along the way, still less assuage its sorrow and anger. I might as well confront it on home ground.

IX

I stopped first at the village I was sent to just after the war. I did not recognize anything much, and not too many people. Antonin's house had been levelled and the ground on which it stood left abandoned. Léontine's had undergone a disastrous makeover, with pink pebble-dash and metal roll-down shutters of spotless white. The cemetery had moved, consigned to the outskirts of the village, away from the church to which it used to be attached. In its place, around the old church now kept locked other than during services, stretched a closely mown lawn. A few ancient tombstones had been stood up against one of the church walls, as both souvenir and decoration. Those from Leontine's grave and from Antonin's were not among them.

So I went in search of them in the new cemetery. The graves were quite well spaced, the dead being few and far between. Not that people had stopped dying, but they had gone to end their days elsewhere. There was no school any more, no shops, no café. A village in the slow process of extinction. I found Léontine's grave, green with moss. A ceramic bouquet of roses, of a purple that had faded to coral, all crackled and speckled with patches of white, sadly graced the tombstone. I noticed three little pebbles in front of the bouquet. As I was about to remove them, thinking that a gust of wind had blown them there, I realized they were far too well aligned to be there by chance. Then I noticed a piece of paper half tucked under the bouquet. A sheet of paper folded in four, puckered and yellowed by the rain. I carefully extracted it and unfolded it. The message was doubly illegible: written in a strange alphabet and all faded. I guessed they must be Hebrew characters. And at once I was seized with hope: Loulou had come! He might still be here, somewhere in the cemetery, sitting on a bench. . . But it could just as easily have

been Esther, or some other person that Léontine had helped during the Occupation. My thoughts nevertheless kept returning to Loulou-Elijah, and, holding the sheet of paper that was now as brittle as glass, my heart pounding as when awaiting my parents as a child, I began to inspect my surroundings.

I wished I knew what the contents of the message were, and for a while I thought of taking it away with me and finding someone capable of deciphering it, but I changed my mind. This note was destined for no one but Léontine; it was undoubtedly a prayer. You do not steal other people's prayers, you must not keep them as relics; you must leave them alone, to be consumed, slowly, in silence, in the rain, snow and wind, to be nibbled by insects, pecked by birds. . . just as you must not blow out the little flames of lighted candles placed at the feet of saints' statues in catholic churches. You must not interfere in the tenuous and faltering dialogue that other living souls try to establish with the invisible.

And anyway I had after all received a sign myself: the oblivion that seemed to engulf this depopulated village, this cemetery expelled beyond the church walls, was only apparent. Others apart from myself remembered the past. I refolded the sheet of paper and replaced it under the bouquet of chipped roses.

I went in search of Antonin's tomb. As I wandered slowly through the rows of graves, reading every inscription, an old woman came up to me and asked me, defiantly, what I was looking for. At Antonin's name, she softened, and scrutinizing me, she exclaimed, 'You wouldn't be the kid who. . .?' Who what? She did not complete her sentence. The pale thin kid who never laughed, played with no one, did not go to school, ran off into the woods like a wild thing, perched in the trees and scoured the horizon in the foolish hope of seeing two splendid white eagles appear? The kid who walked like a robot behind Léontine's coffin, and then Antonin's, and afterwards that no one in the village would take in, who was sent off to live in a mountain hamlet with some obscure plantigrades? Yes, that was me.

The old woman told me her name, but it meant nothing to me. I in turn questioned her, to find out whether she had encountered any other visitor near Léontine's grave recently. No, she had not seen anyone. Although, growing animated, she then told me she had seen some very strange visitors indeed – a disgrace, a scandal! Dozens of garden gnomes scattered among the graves, some lying on the tombstones, or even suspended from the crosses. In fact, she had actually found the five bearded dwarfs, the fawn and the pretty Dutch-style windmill that had been stolen from her a week before this heinous crime. Now, she dared not leave them on the lawn in front of her house any more, for fear the thieves might return. She had arranged them one behind the other on the flight of steps leading from her kitchen to the hay loft. But, she added with a sigh, these figurines are not meant to be kept indoors, they are for brightening up the lawn. The practical jokers who jumped over fences and hedges to abduct plaster gnomes and other little folk adorning flowerbeds, in the name of a charitable 'movement for the liberation of garden gnomes' had failed to achieve their end. After the trauma of abduction, the poor gnomes now found themselves confined within, deprived of sunshine and rain, moonlight and wind. More captive than ever before.

The woman led me at last to the place where Antonin was laid to rest. He had no faded roses or religious dedication, but two plaques hailing his gallantry in the spare and impersonal style of veterans' associations. What would Antonin have thought of these young iconoclastic and mocking guerrillas who attacked garden statues, holding everything – and war first and foremost – up to light-hearted ridicule. Would he have detected in this the baleful influence once again of Gavrilo Princip, or would he have laughed?

<p style="text-align:center">★</p>

I continued my pilgrimage, methodically, in each instance recognizing almost nothing of the places of my childhood. The Great Bear Inn had become the holiday home of wealthy city-dwellers who had completely restored it. The manor

was no longer owned by the Fontelauze D'Engrâce family. Fulbert had proved incapable of preserving his fine heritage, or of persuading his children to go on living there. The property now belonged to an Austro-Dutch couple who had remained hippies through thick and thin, and who, according to their brochure, offered 'guest rooms of original charm'.

Adrienne's house alone had not changed, or the surrounding countryside. There, time stood still, breathing deeply.

And there too my pilgrimage ended. I had no intention of going all through the valley, then along the coast, revisiting the various hotels where I had worked. Those memories awakened in me neither nostalgia nor curiosity. But for all that, my life was not yet over, though I did not know how and where it was to continue. I took one last look at the shuttered house with its ivy-streaked walls pitted here and there with tufts of ruby-pink saxifrage, and I made my way down to the village.

I returned to the Blue Thistle Inn where I had left my suitcase that morning when I got off the bus. The place was almost empty in that early afternoon, just a few old men playing cards in a corner of the room.

They broke off their game for a moment when I came in, to observe this stranger carrying a suitcase. I sat by a window and ordered a sandwich and a glass of white wine.

I had a peculiar, unpleasant feeling I was being stared at. One of the old men fixed me with a piercing gaze. Eventually I cast a glance of annoyance at him, but this did not bother him at all. He rose, and leaning on a cane came over towards me. He was extremely thin, a disjointed skeletal frame, sheathed in mottled skin, worn to the bone. He asked me if he could sit at my table. I reluctantly consented. With his chin resting on his hands, he said, 'So you don't recognize me?'

At my more than uncertain look, he explained, 'Martin. . . do you remember? Adrienne's godson. We met up there, one autumn . . .'

Inside my head, things started to spin wildly, like the vanes of a windmill thrashing the fog.

'Yes, yes, of course. . .' I acquiesced without conviction.

'You've changed too, you know,' he added, 'but less than I have. And for the better, what's more. Of course, we two are not the same age, and there's my illness to take into account.'

No matter how closely I examined the features of the person speaking to me, I could see nothing of the man, lying half-naked on the grass beneath a glorious October sky, who in a flash had seduced me. I really did not know what to say. I forced myself to give a faint smile, but I felt it must be pitiful, that helpless smile. Martin defused the awkwardness by bantering: 'We look like a couple of ghosts. We were a lot more red-blooded last time, and more fun, weren't we?'

'Well, if we're not to remain two ghosts, you'd better tell me what's become of you,' I said.

And he told me: of his quiet life, his happiness in marriage, which he discreetly supplemented with the odd inconsequential infidelity, his two children full of promise. Until the day disaster struck. A car accident in which his elder son was killed. Far from strengthening the bonds between him and his wife, grief eroded them, severed them. Eventually his wife left him, taking with her their younger son, Michel. When, after years of separation, he saw Michel again, the meeting was a fiasco. All they had been able to do was to blame each other, both of them regarding themselves as having been betrayed, abandoned by the other.

'In the end, I lost that son too,' Martin concluded with bitterness. 'He never tried to contact me again, I've never heard from him since. And you, did you get married, have children?'

I kept the details of my life to a mininum. I did not mention Pergamon. Martin was suffering from his twofold paternal loss quite enough already.

'So you're no better off than I am,' he commented, 'you don't have anyone either, you're homeless.' He fell silent for a moment, then said to me, in a confidential tone of voice, 'You

know, the cottage is empty. Michel certainly isn't going to come and live there! I've no use for it any more. If you want to move in, until you find something better. . . It's not in perfect condition, but it's sound.'

★

So it was that I took Adrienne's place. At first I felt quite at a loss, I had not at all foreseen that my return to the scenes of my youth would lead to this, and besides, after all those years in Paris, I had to get used to the silence again, to the isolation. A barren solitude in the company of the wind, rocks, trees and beasts. Sheep, cows and horses were put to pasture on this plateau, from spring to autumn the sound of the bells round their necks rang in the air. There were also donkeys, used for giving rides to holidaymakers during the summer season. One of them, with a thick coat of a beige colour verging on ivory, kept coming to roam round the house. He would swing up his heavy head whenever I emerged, and approach me with a deceptively humble and submissive air; he actually expected me to give him bread. His greed was insatiable. But he was above all eager to be stroked. A donkey affectionate of heart and stomach.

I often went down to the village to visit Martin. His health was slowly deterioriating. The prostate cancer with which he had been ailing for years had eventually spread. One day when I was visiting, doing a few chores for him, he interrupted me at my task. 'Just leave that, come and sit down. I've something important to tell you. And it's not an easy thing to say.'

I sat facing him and listened. Nor was it an easy thing to hear.

Knowing his death to be imminent, he did not want to face it in a hospital bed, or any bed, not even his own. And moreover, he refused to be buried, or cremated. He wanted to depart this life far removed from everyone, to disappear both from the face of the earth and from its humus womb. Yes, to quit the earth, utterly, without flowers or wreaths, without grave or urn, without the slightest trace. And he needed my collaboration to die the way he wished to.

I found it quite hard to understand what he meant. Was he intending to go and drown himself in the ocean? No, he replied, the sea was not his element, and besides it was not reliable, sometimes it would wash bodies up on the shore. He was absolutely determined to depart this life incognito, without leaving any proof, not even the slightest evidence, of his death. So, had he found some way of getting himself rocketed to another planet? More or less, he said. And he explained his plan.

His idea first struck me as chilling. It was simple, and frightful. But he had harboured it for a long time, he had given it careful consideration. Nothing would make him abandon it. I realized, from the tone of his voice, the tension in his whole body, the dark glow in his eyes, that whatever I said, I would not succeed in dissuading him. And despite the horror that his plan inspired in me, I consented. It was his choice, his last wish. I was the only person who could help him, and whom he trusted. He had fixed the date of his disappearance for the following day.

Everything went according to plan. Having told his neighbours that he would be away for quite some time because he had to go into hospital again, he slipped out of his house after nightfall and joined me outside the village where I was waiting for him with the donkey that was so docile with me. I helped him hoist himself on to his mount, and we set off.

It was a dark night, but there was enough visibility to make slow progress. We proceeded for a long time, climbing uphill. It grew colder and colder, trails of frozen snow covered the ground. Exhausted, Martin half lay on the animal's back. We went in darkness, in silence, like contrabandists. Martin was smuggling his own death.

Day was breaking as we arrived at our destination: a rocky area with scattered patches of snow. He dismounted with great difficulty. He was as white as I, his lips blue with cold.

'This is the place. The end,' he said, out of breath. 'There's nothing more to be said. Let's spare ourselves the goodbyes,

regrets, thank-you's. Go home, now. And keep my secret. It's time to leave the birds a clear field.'

I walked away, with deliberate steps. As I was about to take the path down, I could not help turning round. I saw him, lying on his back, his hands crossed over his stomach, his face turned to the sky in which great swirls of whiteness tinged with blue eddied about in slow motion. He had removed his jacket, hat, shoes and gloves. So that the cold might do its job more quickly.

Halfway down the slope, I stopped and turned round once again. I could no longer see Martin, lying flush with the sky. But I saw a great comma emerge from the dawn mists, rise easily through the air, then hang motionless above the spot where Martin lay. Other commas, of dark grey in dawn's milky-whiteness, came to punctuate the sky's emptiness. They were of various sizes: eagles, griffons. They were there to meet him, just as Martin had hoped, and were awaiting the right moment to swoop down on the mortal remains he offered them. For such was the tomb he had chosen.

'And when they've torn me to pieces, devoured every last strip of flesh, there's bound to be some bearded vulture to break up my skeleton and carry my bones off to its eyrie, to smash them against the rocks, and finally eat them. Then all of me will have been consumed. And I shall be at peace in the raptors' savagery, in the warmth of their entrails,' he had said to me the previous day, overwhelmed with bitterness and weariness.

The birds dived down on their prey. Martin's clandestine passage to death was under way.

<p style="text-align:center">*</p>

A few months after this nocturnal expedition, I returned to the scene. The birds had done their work thoroughly. I found some shreds of clothing, wool, a shoe, a bit of Martin's skeleton, including his smashed skull. I collected the scraps of cloth and leather to throw away elsewhere, and gathered up the remains of the bones left by the raptors and buried them under a bush, among the stones and roots.

Martin was reported missing. 'Reported missing': the expression suited him well. Neither his ex-wife nor his son bothered to organize a search for him. The people of the village speculated a great deal about this disappearance – the old man must have lost his marbles and gone wandering off in the mountains, fallen into the torrent or into a ravine, been attacked by some wild beast, stray dogs that had regained their wolfish instinct, or else a bear. . . Recently reintroduced into the area, the bear inspired heated arguments.

The mountain, with its caves and torrents, its crevasses and densely wooded slopes, its unfamiliar beasts and also – who knows? – its evil spirits, is a vast cemetery dotted with anonymous graves. No one doubted that Martin was dead, but it will be years before his absence can be deemed officially a death. Then Michel, the son in breach of filial love, might perhaps come and reclaim his heritage and evict me, living here like a cuckoo in a house that does not belong to me.

Until recently I worked as a seasonal waitress in the local spas or ski resorts. On New Year's Eve when the digital clock displayed a row of three fat zeros pregnant with fears and thrills of every kind, I was serving in a restaurant. At midnight the revellers whooped, yelped, clapped, laughed and sang to the sound of popping champagne corks and, in the distance, fireworks. A beautiful log fire burned in the hearth of the large room. Corks and festive novelties thrown into the fire burst into crackling flares. The tables were pushed back to allow the guests to dance. It was all a whirl, Medusa-headed people with green, yellow and purple streamers floating in their hair, clouds of confetti and tiny crepon balls of every colour, hands brandishing flutes of champagne, bubbles in the flutes, particles of light enclosed in these bubbles that burst in irregular volleys with a pretty piping sound. And the embers in the fireplace.

Outside the bay window immense bouquets of vermillion, gold, bright blue, emerald or silvery white were to be seen blossoming in the sky. Bouquets as resonant as they were fleeting, that drew oohs and aahs from their admirers in every

pitch of voice. Even the stars paled at each flowering. But between the dazzling moments, the night recomposed itself, seeming even darker. And the windowpanes through which we were watching the spectacle, becoming silvered with darkness, turned into mirrors. A long intermittent mirror in which the Medusas with glowing faces whirled. These reflections all at once disappeared when the multicoloured flowers burst open, dissolving in noise and showers of motley light, as if having torn themselves from the surface of the glass and leaped into the sky, resplendent for a moment, and then dying magnificently, for a time.

As a result of watching the play of all these evanescent reflections, these sheaves of light exploding like shattered stained glass, I ended up having flurries of kaleidoscopic visions, at first brief, then more extended.

I saw the faces of the midnight revellers, including mine, as flashes of brightness in the dark, their eyes and mouths opened immensely wide, I could not tell whether in amazement, joy or panic. But their eyeballs leapt out of their sockets and, adorned with glimmering plumes of sprinkled light, rolled across the sky, while spiralling nebulas composed of myriad kisses disappeared into their mouths. These faces blazed and writhed in their own flames.

I saw tall figures advancing along the Milky Way; they carried panniers on their backs. They put up lines between the stars. The sky took on the appearance of a gigantic spider's web. From their baskets they took out washing. Before hanging it up, they vigorously wrang every piece of cloth, then shook it out to smooth the creases.

I saw the washing hung out to dry on the gossamer threads, flapping in the astral wind. There were shrouds upon which quivered the shadow of the faces that had blazed a moment before, and great sheets of human skin. The faces moved almost indiscernibly on the cloth's surface, with a vague suggestion of the slight pouting manifested by sleepers disturbed in their dreams.

The skins came from various bodies – of men, women, young and old, small children. Some were brown, swarthy, white, sepia of shades more or less pale, black, copper, honey or saffron yellow, ivory and milky-coloured. . . Some bore wounds, scars, evidence of beatings, whippings, thrashings, or simply birthmarks, beauty spots, signs of old age, wrinkles. Some were decorated with tattoos, or incrusted with pearls, or jewels.

Apart from these various markings, no matter how vigorously the washerwomen scrubbed them, rubbed them, wrang them, you could still detect, here and there, traces of blood, sweat and tears.

These were the skins of all the human beings there have ever been, since the very beginning. Billions and billions of skins whose lives dripped in eternity . . .

Another salvo of fireworks exploded, tearing to shreds the washing lines and the sheets of skin fluttering from them. In the darkness that followed, I saw a thick pale-grey streak appear; it travelled diagonally through the night, like the trail that an aeroplane leaves in flight. But there was no aeroplane, and no sound. It was a cable, held taut all by itself, there was no pylon to support it. It was huge. It stretched so far, so high, that it must have penetrated the confines of the sky. Where did it reach?

What looked like whitish metal swing-chairs appeared. They glided along the interplanetary cable, very slowly, one behind the other. Seats like those on a mountain chairlift, but their passengers were not skiers, they were animals.

Although this scene was unfolding far away, I could distinguish the details very clearly. The animals had adopted positions totally incongruous for their species: seated, with their backs very upright, heads held high, their front paws resting on their knees, their rear ends hanging in space. There were oxen, cows with hides of brown, sable or russet, or black and white; sheep and goats, lambs squeezed in beside ewes, pigs, horses, as well as geese, turkeys, chickens, ducks, with

their necks vertically extended, like hieroglyphs. All these creatures were mixed up together, sitting quietly side by side in their gondolas. But their stillness did not express calm or docility, but rather anguish. The animals allowed themselves to be carried through the clouds with the hopeless resignation of those under a death sentence to whom all pardon has been refused, and who know they have been abandoned by everyone. They stared straight ahead into the pale night. Their eyelashes were white with frost, their ears fringed with ice; the beaks of the poultry seemed laquered.

They uttered no cry, no bellowing or whining, no yelping or hissing. Their silence was deafening.

Their silence fell on the earth in a solid block, and grew progressively more oppressive as the animals sitting in disparate pairs on the suspended seats went by. A smell of burnt flesh became correspondingly more intense, as if this chair-lift led to a giant furnace into which it tipped all of its silent passengers, one by one.

The procession was endless. The air was unbreathable. Copious trails of ash fouled the emptiness of space. And the silence only increased.

Another vision was about to appear out of this ashy magma, when someone, tapping me on the shoulder, told me that the spectacle in the sky was over, but the party was continuing at the inn. This sudden intrusion put paid to my vision. But the silence of those sad beasts, those gentle domestic animals condemned to execution without recourse, without the least compassion, resounded painfully inside me.

I had to get back to work; my heart was no longer in it. The spectacle in the sky was indeed over, but much more so for me was the party. Too many images danced beneath my eyelids in slow motion, diverting my attention from the festivities. I felt an intense desire for solitude.

★

And that is how I have ended up desiring and even conquer-

ing the solitude that was imposed on me since birth, and which had for so long tormented and assailed me, driven me from one place to another. My view of it has changed, I live at peace with it, that is to say, with myself. If I cannot appreciate my own company, I adapt it to the earth, trees, elements, birds and animals around me. I have a goat and a few chickens. I rise at daybreak and go to bed at nightfall.

I do not receive any mail and I do not write to anyone. What happens in the world, I follow on the radio. I have no television set. The polyphonic voice of the radio, coming from every corner of the world, every level of society, is enough for me. It renders in different tones the restless murmur of time passing.

I surf the wavelengths and I capture voices. There are some fine ones that talk elegantly, with wisdom, integrity – those that are capable of wonder at the sight of a fruit, a nail, the trace of a footstep in the dust, the recurrence of the seasons, a ray of sunshine quivering on a wall, and who turn it into a poem, a song, or even an entire story, or an object of meditation. Those that discern marvels in the slightest of things, that caress the grain of time, that take nothing at face value, nothing for granted. Those that dawdle attentively in the arcana of language and know well that the right word is always on the tip of your tongue; who do not want to have the last word, knowing it is given to no one, which is why we keep on talking, tentatively, sometimes stammering, often catching our breath. These voices have a sense of grandeur, which they recognize as indissociable from goodness, simplicity, patience and humility. A humility matched with humour. This is the only grandeur of any value.

There are dismal voices that are terribly boring even when they trumpet, vituperate or coo, believing themselves to be funny, irreverent, and claiming loudly an illusory originality, a spurious relevance. But why should these hollow and pedantic voices keep silent since they are celebrated and titillate a large public desperate for easily digestible emotions, feeble

admirations and ready-made scandals? These gold-plated voices revel in a grandeur in which they are thoroughly lacking, and the stink of their pretensions is on their breath.

Then there are poisonous ones that distil hatred and scorn, corrupt all words, and rouse the sleeping assassins almost everywhere who only await a signal before they set to work; they incite the brutish and dope the assassins in the perverted name of 'liberty', 'justice', 'nation', 'God', which always pays dividends, in blood. These voices wish to invest themselves with the greatness they readily confuse with vengeance, all-powerfulness and the most conceited pride. There are days when it seems to me, hearing them grow shrill, that an icy shudder runs down the ever so undulating spine of time, that something grows knotted and stiffens in the world's flesh, and a tumour forms. That something breaks in the world's spirit, like a vessel bursting in the heart or the brain. Then I sense this preliminary tremor of death, this obscure bleeding, spreading even to my seemingly so peaceful solitude.

All these voices – the gentle and violent, the beautiful, vain, arrogant, the venomous – are so much the more suggestive for being stark, divested of the bodies from which they issue. With no face and no picture to burden them. I listen to them unencumbered, with no dramatic images. They describe to me the world at the present time, like some crazy bard constantly retelling the legend of how it all began, reworking it over and over again. I hear a syncopated story, increasingly convulsive, rent with gaping holes, that speaks of a wildly irascible and illogical world. They come to me from far away, these multiple voices, but they touch me very closely, they break my heart at times, set my mind reeling.

Do those who are daily crammed with televisual images know more, learn and understand more about them than I do? I doubt it. They look at them without seeing them. These images of wars, tragedies and catastrophe get mixed up with images from crime and disaster movies, from advertisements, they blend into them, lose their impact. And when they are too violent, too dreadful, they plunge their viewers into a state

of fascination. A morbid fascination from which the viewers emerge semi-stunned, semi-incredulous. And the great ghastly funfair goes on, evil laughs its public to scorn and with renewed determination to impress is ever more outrageous, ever more tasteless.

Fascination paralyses thought, incapacitates reason, leads astray the imagination, leaving it stunned, fuddled; it hypnotizes. The flood of images that have several times in the course of my life come to me in a state of wakeful consciousness have never struck me like a blinding thunderbolt, put me in suspended animation, for I know that on each occasion these visions were born of the sudden connection between forces abroad in the world, destabilizing it, more or less seriously rending it, and the extreme tip of my heart offered up to the mystery surrounding the world, the mystery that by turns dazzles or darkens it, invigorates or alarms and wounds it. The visions we have, however crazy and bizarre they might be, do not leave us uninvolved like those images of extreme violence imposed on us from outside via the television screen or newspaper photographs, even if these latter inspire and give rise to our visions. There is in these visions a decanting of reality, a breaking-up of the too compacted images that derive from real life, and this breaking-up allows the mind to get back into motion, albeit haltingly, picking its way through ruins. But beneath the debris lies some meaning, amid the broken fragments are some glimmering signs, perhaps.

<p style="text-align:center">★</p>

So I surf by ear the dark murmuring of the world, while others navigate by sight. But I have no one to talk to, and my own voice is failing, eroding in its isolation. My thoughts are increasingly strewn with points of suspension and questions marks, they taper into sighs. From time to time, I exchange a few words with a villager who has climbed up to the plateau, or a greeting with some ramblers. The little that I utter is addressed to the chickens, the goat, the donkeys, or to the shepherd dogs with the flocks that have come up to pasture; to the birds too, eagles and kites

some of which have perhaps fed on Martin's flesh. And to the trees.

Even if I were to receive a visit all of a sudden, I would have nothing to say. I have lost that enjoyment of conversation that Philomène revealed to me, and Fanfan, Damaso and Anthim revived.

Yes, even if they appeared under my roof, I really would not know what to tell them. How am I to tell them about the wind, the patterns of light in the sky and its hazy flux on the mountain slopes, its shimmering on the grass and leaves, its golden, mauve, amber, pink or silvery splashes on the rocks? About the water of the mountain torrents, of a beauty as elusive and fugitive as that of the light, ever moving, ebullient, effervescent. About the breath, the gaze, the warm and pene-trating smell of the placid beasts all day long chewing tufts of grass steeped in rain, wind, sunshine and snow. I am no poet.

And how am I to translate the echoes raised in me by the vast and tireless voice of the outside world, of time on the march? And the progressive detachment I sense establishing itself inside me, that discreet forgetfulness of myself that comes to me through being in contact with this rugged earth, this limpid and exhilarating air, this always icy water, everywhere gushing, trickling, atomized into foam, or sculpted by winter freezing, and these slow beasts with their constantly ringing bells that only serve to accentuate the silence?

And finally, how am I to tell them of the vision that has very recently visited me, while collecting wood in the forest? A vision so stark, so magnificently spare, it was more like a caress of the invisible. A smile.

I saw a faceless smile come into being and grow to fullness in the blue-grey of the evening, radiant in the chill air. A smile as ample as the heavens, fragile and gentle, and undisturbed by the flying predators gliding on currents of air. A smile, nothing more, in its infinity. The smile of grace, of such beauty to prompt tears of gratitude.

If my friends were to appear before me, sit at my table, I would serve them food and drink, and I would listen to them talk to

me. As I listen to the polyphonic bard of the radio recounting the story of the world, the cruel and crazy story of the real world. And if my visitors had no desire for conversation, weary of having talked a great deal in their lifetime, of having used a great many words, often to no purpose, well, then I would simply listen to their silence. And I hope that a tiny part of the luminance of that smile of grace I saw the other evening, softly lighting on the world, would shine among us.

But no one comes, neither ghosts nor any living person. My solitude is played out under the open sky as at my birth, amid the indifference of my fellow men. Now it is played out slowly, and the little bit of history that has constituted my life is in the process of melting into oblivion. The text is fading as I recall it and reminisce. A text written in mist. At least trees and birds lend some grandeur to the setting of this final act without characters, with no apparent action, without dialogue. Just an increasingly tenuous monologue gradually eroded by silence. But there remains so much to listen to in the silence, so much to see even when everything has disappeared, and still to love when all have gone. The curtain may fall on the empty stage, the spectacle continues, differently.

And then, when the silence has entirely consumed me, hollowed me out, perhaps the prayer that clawed at my heart every time I thought I had forgotten it for ever – *Mane nobiscum, Domine, advesperascit* – will rise to my lips again, for the last time.

That's not quite the way it will come back to me – this prayer I have never been able to say, for want of understanding and pondering its words, for want of loving them, truly desiring their fulfilment. For want of believing in them, in the depths of the dense and harsh dusk in which the world groans on and on and the Lord scintillates by his absence, obscurely, intensely.

If ever it is to return, it will be in a new inverted form: it will be addressed to me from within, released in a breath round my heart to rise to my lips like the sigh of a child waking from a long sleep.

No, it is not I who will utter this phrase, so unsettling behind its apparent innocence, but the Lord himself, in a whisper. He will ask me, as he asks everyone, to abide with him and keep vigil in the cold and darkness of the earth where so many misunderstand or betray him, deny him, or ridicule him, dismiss him as nothing, as a delusion. He will ask me to abide with him, discreetly, patiently, in the evening that reeks of the tears and blood that have fallen upon the earth; to abide with him, with others scattered all over the world, keeping vigil for the coming dawn.

Is that not what I was asked the other evening, through that immense smiling brightness glimpsed in the slate-grey sky, resting upon the earth?

My whole life will have been but an approach — so zigzagging that sometimes I have gone backwards — towards this smile of deliverance.

Now I have to try and hold steadfast.